Aircraft Nose Art

# Aircraft Nose Art

*American, French and British Imagery and
Its Influences from World War I
through the Vietnam War*

ANDRETTA SCHELLINGER

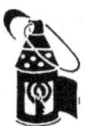

McFarland & Company, Inc., Publishers
*Jefferson, North Carolina*

LIBRARY OF CONGRESS CATALOGUING DATA ARE AVAILABLE

Names: Schellinger, Andretta, 1982– author.
Title: Aircraft nose art : American, French and British imagery and its influences from World War I through the Vietnam War / Andretta Schellinger.
Other titles: Aircraft nose art, American, French and British imagery and its influences from World War I through the Vietnam War
Description: Jefferson, North Carolina : McFarland & Company, Inc., Publishers, 2016 | Includes bibliographical references and index.
Identifiers: LCCN 2016003090 | ISBN 9780786497713 (softcover : acid free paper) ∞
Subjects: LCSH: Airplanes, Military—Decoration. | Airplanes, Military—History—20th century.
Classification: LCC UG1240 .S36 2016 | DDC 358.4/183—dc23
LC record available at http://lccn.loc.gov/2016003090

BRITISH LIBRARY CATALOGUING DATA ARE AVAILABLE

ISBN (print) 978-0-7864-9771-3
ISBN (ebook) 978-1-4766-1932-3

© 2016 Andretta Schellinger. All rights reserved

*No part of this book may be reproduced or transmitted in any form or by any means, electronic or mechanical, including photocopying or recording, or by any information storage and retrieval system, without permission in writing from the publisher.*

Front cover: "Command Decision" nose art on a B-29, 1952 (United States Air Force photograph)

Printed in the United States of America

McFarland & Company, Inc., Publishers
Box 611, Jefferson, North Carolina 28640
www.mcfarlandpub.com

To Jon and Summer,
I love you both with all of my heart

# Table of Contents

*Preface* 1
*Introduction* 5

## Part One. 1900–1913: The Beginning
1. Expression 11
2. Planes Emerge 22

## Part Two. 1914–1919: The Great War
3. Roaring 29
4. Cavalry 46

## Part Three. 1919–1939: Lull in Fighting or a Continuation?
5. The Roaring and the Depressed 57
6. Mickey and the Gang 69

*Between pages 74 and 75 are 8 color plates containing 10 images*

## Part Four. 1940–1945: Same Adversaries, Same Place
7. Ration and Save 77
8. Cartoons 93

## Part Five. 1945–1953: The Start of the Cold War
9. Rock a Billy 111
10. Transition 121

## Part Six. 1965–1973: The Political War
11. Swinging 133
12. Skulls 150

The Future of Nose Art 160

*Conclusion* 163
*Chapter Notes* 167
*Bibliography* 171
*Index* 175

# Preface

This book has been a labor of love for almost a decade. It was originally self-published as *From Knights to Skulls: A Cultural Evolution of Nose Artwork* in 2013; to have it republished with double the images and more content is something beyond my wildest dreams. I hope that everyone who reads this understands that culture is important, as this book is important to me. The inception of this book came from my grandfather Charles Stolsig, who flew a PBM in the Korean Conflict. His openness about the conflict sparked my interest in military history, which has continued to grow.

Without my family's love and support, this adventure would not have been possible. I want to thank my family for letting me work when I needed to and making me have fun on those off days. My amazing husband Jon has been a rock and pushed me past those days when I thought I was done. My immediate family, including but not limited to my grandparents, parents, and my brother Dana, have been constant supporters and assisted during those dreaded writer's blocks. My mother, Terry Journey, did the majority of the editing, which I cannot thank her enough for.

I would be remiss in not thanking the other wonderful people who have assisted me along the way. My professors at Hawaii Pacific University: Dr. Mike Pavelec for starting me down this path and Dr. Russell Hart for pushing me though the tedious task of revising. During the formative years, my co-workers at JPAC stood by my side and helped support me when I thought it was a lost cause. Through this all, my former classmate and friend Ryan Dannenberg has helped me stay grounded while supporting me from rough draft to publication.

This personalization is the center of my research into the effects that civilian ideas have on the beliefs of military personnel. Studying the societal events that occur can give us an understanding of the development of artwork adorning the side of military aircraft. This is an important means to better understand the way that civilian reactions to governmental decisions and culture affect the military. This process is cyclical in nature, as a military action incites in the general population a response that then affects military actions.

There being little scholarly research on this topic, the topic is important to the academic community interested in a connection between civilian and military cultures. This question set is fundamental to understanding the power that culture wields. These questions are also important in understanding the desire to place artwork on planes. The specific questions that need answering are these: Does culture affect military aircraft artwork? If a connection

does exist, how strong is the connection? If there is no connection, what prompted the changes in aircraft artwork? Why did the pilots and flight crews paint nose art on aircraft? What changes occurred to nose artwork over time and during cultural changes? To what extent does a nationalistic pride and society's cultural difference affect nose artwork?

To answer these questions I will compare the events and culture of the civilian world to what the military personnel were painting on the aircraft. If there is a correspondence in the events that occurred to what was painted, the suggestion that these two cultures are interconnected has credibility. Comparing events to the aircraft artwork will not effectively prove the interconnectedness, though. Rather than looking at the events primarily, I will be viewing the artistic representation of events though political cartoons, propaganda and civilian advertisements.

Four periods of the 20th century that encompass wars that changed the world are discussed in this book. During these time periods, many countries fought alongside each other for a common purpose. Each period shows a different purpose and a different reaction by the public remaining at home. This reaction to the conflict is important to understanding the way that civilian beliefs can affect military views.

The conflicts that will be included in this research are those that involved more than two opposing nations. World War I, World War II, the Korean War, and Vietnam were conflicts that involved multiple countries; therefore each war had more than two military and civilian cultures participating. By comparing countries and their militaries during the same conflict period, a possible connection between cultural changes and the evolution of nose artwork may appear. A way for this connection to be seen is if a change in culture is followed by a change in the artwork. This change does not necessarily require a complete transformation of the artwork. By closely looking at the artwork with regards to what is occurring in the civilian world, we may see small changes. These conflicts are also important in another way: During all four of these conflicts, conscription was utilized in one form or another. Conscription brings people together from all socioeconomic groups, and therefore experiences from civilian life merge with the military training and indoctrination. A conflict brings the nation together like no other event. During this time, civilian attitudes affect the fighting capacity of the military. If the civilian population agrees with the rationales for participating in the conflict, they will be more supportive of the military. The opposite can be said for the conflicts that had negative civilian support.

While civilian and military cultures change during conflicts, the span of one conflict is not enough to show an effective pattern. The best way to look at this is to compare multiple conflict periods. An effective way to present a complete argument is to show nations during conflicts that were concurrent. A pattern throughout multiple countries and conflicts will show if a correlation exists between civilian, military cultures, and aircraft nose artwork. While each country experiences events and conflicts differently, looking at the same conflict periods gives a lens through which to compare both the culture and the aircraft artwork.

The specific approach to my questions is to look at allied nations during the same conflict periods. Allied nations historically have more in common ideologically than warring nations. Looking at the way that pilots painted their individual planes may give insight into

## Preface

the nation's cultures and beliefs. Looking at one conflict will not provide the depth of research or evidence that is necessary to show if there is a connection between the civilian culture and beliefs and the military artwork. One conflict will also not show how cultures transformed over time or the differences between nations during each conflict.

The countries that I have chosen to use in this research are France, Great Britain, and the United States. These three countries were in conflict during the same time periods. They were also in the same geographical area during each conflict time period. World War I had all three countries participating in the same area as allies. During World War II the United States was fighting in both Europe and Japan. Korea and Vietnam saw the United States actively fighting in both countries; France did not actively participate in these conflicts, as it was continuing to fight in Indochina. Great Britain did participate in Korea, but its military was heavily involved in Malaysia and Aden during the American involvement in Vietnam.

It is evident that these countries were not fighting alongside each other during each conflict period that I have chosen to examine. The geographical location of a conflict is essential in determining if conflict location causes a change in aircraft artwork. The three countries that I have chosen to compare had the same level of aircraft technology during each conflict period due to technological agreements. (The only exception, which will be discussed in further detail, is World War I.) This is useful as while culture differed between countries, the technology remained stable across national lines. Technology changed drastically during the time periods, yet all three countries remained roughly comparable in knowledge.

My topic, while emphasizing the individual, also concerns larger organizational structures. Military policy has attempted to make nose artwork a thing of the past. Many people are unaware of the real stories and individuals behind nose artwork. The percentage of books published on World War II artwork is greater than aircraft artwork books of other conflicts. This discrepancy causes many to associate nose artwork with World War II. The World War II artwork of women known as the "Bomber girls" is the most commonly depicted when discussing nose artwork.

On a more sentimental note, as time is passing, the number of surviving soldiers and airmen who fought in World War II and Korea is diminishing. A concern is that as the soldiers are getting older, the wealth of personal experiences and history will be lost. This is especially true of personal histories, and artwork is primarily personal in nature. There are museums and historical organizations attempting to record the histories of World Wars I and II. Most of these projects center on specific units or missions. The particular emphases of their projects are different from my project. My project essentially breaks down the art and the motivations behind it. By looking at the artist or idea, a view of how culture evolved may become apparent. This evolution is important as allied nations have planes, service members, and nose art currently in combat.

# Introduction

Long before the Lilienthal brothers started building aircraft and the Wright brothers made history with the first manned flight, the desire and drive to fly was seemingly ingrained into the hearts and minds of humans. Icarus died attempting it, and Leonardo da Vinci drew it. This desire, once fully realized by the Wright brothers, changed the way the world thought about travel and what was possible. At the beginning, aircraft were used for purely experimental reasons.

When the world went to war in 1914, the use of aircraft for military actions was unknown. World War I was a time of great change. There was a transition from horse cavalry to a form of cavalry in the air. The inclusion of aircraft fundamentally changed the way that militaries fought wars. The new method of warfare soon led to crews' wanting to personalize the airframes they entrusted their lives to. This was not unlike the decorations on shields. What began as making small markings to distinguish friend from foe evolved into using the planes as canvases for aircrew artwork.

Art has always been important to societies as a way to visually remember events and people. This method of history collection also shows a snapshot of cultures. This book will explore this cultural application. As planes became important in World War I, so did the artwork with which pilots and flight crews adorned the sides and later the fronts of their planes.

The term *nose art* encompasses all the various graphics that flight crews and others painted on planes. The term is misleading, as this artwork was painted in a variety of places on the aircraft—the tail and main fuselage, as well as the nose. The definition is needed, as each conflict showed a change in the method and location of the paintings.

There has been little research published to add to the wealth of historical knowledge. The history on the transformation of nose art from 1900 to 1972 is primarily written by hobbyists. The non-academic quality does not discount the value of the research or the knowledge. The few academic publications that look at nose art do so from an anthropological point of view, focusing on the personal reasons behind the imagery on the planes. Nose art is primary understood by the pilots and crews, but not the public. The reason is that distance from home and loved ones creates an atmosphere that makes specific artwork meaningful. Three books that are good overviews or histories of this type of nose artwork are *Vintage Aircraft Nose Art* by Gary M. Valant, *Aircraft Nose Art: From World War I to Today* by Jeffrey L. Ethell and Clarence Simonsen, and *Nose Art: 80 Years of Aviation Artwork* by J.P. Wood.[1]

## Introduction

*Vintage Aircraft Nose Art* is more about the actual paintings than the crews behind them. Valant specifically looks at heavy bombers, while including few other types.[2] Big bombers did account for a large percentage of the painted planes during World War II. Valant also discusses the Confederate Air Force in Texas, credited with having the largest collection of authentic nose art in the United States. Valant states that at one time the bone yard where the CAF salvaged the nose art had more planes than the United States Army Air Corps.[3] The CAF continues to acquire nose art for historical preservation.

Valant considers the motivation and experiences of the artists. Two notable examples are Alberto Vargas and Phil Brinkman, who Valant believes advanced nose art in World War II. Valant's book has hundreds of rarely seen photos. Some include aircraft serial numbers and the plane's last known disposition. The captions show the source of the photos, mainly aircraft organizations and other authors. There are some primary sources: both the CAF and men who fought in World War II contributed photos.

In *Aircraft Nose Art from World War I to Today*, Jeffrey L. Ethell and Clarence Simonsen manage seamless coverage of the nearly 100 years that aircraft have been utilized for warfare, offering insightful analysis of nose art and what it means for the crews.

Ethell has written more than 60 publications, some with co-authors. Ethell was not only a prolific aviation writer, but also a pilot of vintage aircraft. In 1997, while flying a P-38 "Lightning," Ethell lost control and was killed in Tillamook, Oregon.[4]

*Aircraft Nose Art* divides the history of nose art into combat eras, allowing for quick reference and showing the progression of artwork and differing techniques. It also gives a closer look at the crews attached to certain planes. One aspect that makes this more than a picture book is the chapter by George Klare, and personal narratives by the men who flew or worked on painted planes. While Ethell and Simonsen took a scholarly look at nose art, this book still falls well within the category of hobbyist books.

*Nose Art: 80 Years of Aviation Artwork* by J.P. Wood also covers a broad span of time, from World War I to the 1991 Gulf War. He strongly believes war artwork actually started much earlier, drawing a clear connection between warships and war planes. While Wood believes that World War II was important for the conception of large scale artwork, respect is paid to all of the conflicts. Wood clearly defines the characteristics and motives associated with nose art, attributing much of the imagery to the loneliness felt by the flight crews.[5]

Wood uses a multitude of photos from each conflict. These provide examples of both his themes and his classifications. Wood indexes not only by plane name, but also by unit, plane type, and individual's name. Many items are cross-referenced and easy to find. Most books of this genre speak of one country and/or one conflict. Wood not only spans five conflicts and the intervening years, but also discusses multiple countries and branches of service.

The above-mentioned books are good as secondary sources to begin the exploration of nose art. However, this book is not only about the history and visual attributes of nose art; it is also about culture before and during the conflict periods. This research cannot look strictly at military culture, but must also examine the civilian culture providing the manpower for the militaries.

## Introduction

Culture is loosely defined as the customary beliefs, social forms, and material traits of a racial, religious, or social group. This definition is essential, as the beliefs of civilian populations are important for my research. The military has its own culture due to its training and camaraderie. The military, being highly structured, develops a culture that is different from civilian culture while still maintaining some of the fundamental nuances associated with civilian culture. It is therefore important to also look at the writings on culture. Culture is a topic that is fluid and therefore the definition is ever changing. The cultural applications of nose artwork have not been written about. The three secondary sources that provide not only a solid definition of culture but also take this fluidity into consideration are *Introduction to Theories of Popular Culture, Culture and Foreign Policy,* and *Like Sex with Gods*.[6]

Culture can be viewed at both micro and macro levels, both of which are important to understanding the effects that culture has on nose art. Macro-level research is beneficial to understanding how change occurs nationally and internationally during times of conflict and peace. While change at this level is often slow and minute, it affects large populations. Cultural changes at micro and macro levels can affect each other.

*An Introduction to Theories of Popular Culture*, by Strinati's own admission, is strictly focused on theories and perceptions of popular culture and does not discuss research and methodology.[7] Strinati is adamant that this book is in no way comprehensive regarding the range and detail of popular culture.[8] While mass media can and does affect popular culture, Strinati accounts for the connection yet attempts to separate the two as much as possible. Strinati admits that particular theories are deeply entwined with mass media. He chooses to simply state, "Insofar as a difference has arisen between theories and studies which concentrate upon mass media, and those which concentrate upon popular culture, this will confine itself to the latter."[9]

To some, military conflict is no more than handling foreign policy issues physically when verbal methods have ceased working. Culture is how an individual looks at the world; a connection between culture and foreign policy is evident. Many academics downplay this connection. Valerie M. Hudson, however, decided to edit a book about it. *Culture and Foreign Policy* is a collection of chapters discussing the benefits and pitfalls of viewing foreign policy through cultural attitudes, and it brings new ideas to how culture is applied to foreign policy.

The author believes that the key to understanding how countries react to each other is to understand the cultures of the counties involved. Hudson noticed that culture was mostly studied by anthropologists and sociologists. She realized that culture is as important to foreign policy makers as to sociologists. By first displaying how culture is negatively viewed by political scientists, Hudson explains that "all human activity including foreign policy becomes a product of and a component of culture."[10] The author wants to show how influential culture is on politics and specifically foreign relations by using examples.

There are some books that specialize in the culture surrounding flight and humans' desire to fly. One of the best books on the subject is *Like Sex with Gods* by Bayla Singer.[11] This book is a brief look at the history of flight from a cultural perceptive. Many flight histories look purely at the history of how flight came about and evolved. What sets this book

apart from other flight histories is that this one looks at both the literal and figurative aspects of flight. Singer looks at more than just the daily grind of event history, examining the way that people perceived these events. This work in conjunction with writings on popular culture will set a basis for understanding what flying represents to culture.

The previous two categories of secondary sources used for this book are not inclusive. There are more specific subsets that will be discussed in the main body of the text. These books may briefly discuss the cultural applications and implications of artwork during warfare. As this book is about a wide range of geographical locations as well as chronological periods, there are not many books that encompass both completely.

PART ONE

1900–1913:
The Beginning

# 1

# Expression

Culture is a fluid element that influences all areas of society. It also is affected by fluctuations such as those between times of conflict and times of peace. Culture had been ever changing prior to the Wrights' first flight. The flight, however, added a new element to how people viewed transportation and ingenuity. During the years leading up to the First World War, culture affected the combat pilots and artwork that was used. While nose art was affected by culture, this chapter's main goal is to set a foundation on which to build in future chapters. This chapter displays the changes to fundamental elements of culture that occurred leading up to World War I. Culture influences and is influenced by all sections of society.

French culture, while appearing to slowly change during the early 19th century, was in fact rapidly evolving. The conflict between France and Prussia in 1870 began to bring cultural change to France. In addition to the government, the arts, literature, and clothing were also affected by France's involvement against Prussia. Following the conflict's end in 1870, France went though political turmoil, as it had in 1830, 1848, and so on. The defeat of France at the hands of Prussia ushered in a new French republic. This republic was initially accepted as a temporary fix until a permanent solution was put into place. However, with other issues at hand, the republic remained in existence. Many believed that France should be governed by a monarchy and were uncomfortable with the idea of a senate and ruling body. As with many governments that radically changed, the next twenty years produced political upheaval. Unlike in other countries that were in a state of unrest, the general population was mostly unaffected in daily life by political shifts that occurred. Following infighting within the French government, France along with fellow European countries entered into a period of time from the late 19th century to 1914 later known as the Belle Époque (Beautiful Era).

France and most of Europe saw a chance for a period of relative calm among neighbors. This aspiration manifested itself in the Exposition Universelle. The exposition was a collaboration of artists, engineers, and politicians showcasing multiple aspects of countries' growth. This included but was not limited to new methods of producing clothing. Although the Exposition Universelle was created to bring together officials in many fields, many French religious and political officials chose not to attend. France invited neighboring and distant countries, including Prussia, to partake in the festivities.[1] Even though France was in a time of relative peace, a feeling of ill-will towards the newly created German Empire

## Part One. 1900–1913: The Beginning

led to a watchful France during the exposition. Many French still felt uneasy with the increase in industrial and military might that the German Empire showed during the exposition.[2]

During the years of peace and prosperity, France began to strengthen its power overseas. Many countries in Europe, specifically France and Great Britain, wanted to expand their borders in this time of peace and economic wealth. Since Europe was already occupied, France saw a chance to expand in Africa and soon occupied more than all the other European countries. Colonization did not stop at Africa but also included parts of Asia, the Caribbean and Pacific regions. The European nations quickly cut up Africa for their own purposes.[3]

This colonization was not primarily for immigration purposes, but mostly for exports and raw materials. France saw this colonization as increasing its status among colonial powers. This expansion brought new people to France, which affected the previously homogenous cultural movements. It was during this time that France began to be recognized as the cultural epicenter not only of Continental Europe but of the world. The changes that were seen in this era were important at both an individual level and for the countries' overall attitudes towards events. During the European land grab, political cartoonists in the United States saw England as an octopus with an enormous and never-ending appetite for land as seen in figure 1.

Great Britain's imperialistic motivations did not directly affect the majority of the citizenry. Things such as the development of a literary class and an increase in artistic expressions allowed the mass public to become more integrated into higher culture. Great Britain experienced two significant cultural periods prior to the start of World War I. Both of these defined how citizens saw themselves and how other countries saw Great Britain. The Victorian era, so named for the ruling monarch Queen Victoria, was one of contrasting morals and belief systems. This was an era of both relative peace and constant warfare every year of Queen Victorian's reign. Many of the attitudes that are later seen in the United States have foundations in pre-1900 Great Britain. Great Britain's culture was strongly influenced by the sovereign. The next cultural period before World War I was the Edwardian period, so named for King Edward.

Queen Victoria believed in chaste behavior and therefore demanded such things as prostitution be outlawed. During the 1840s and 1850s British officials and clergymen became worried about the increasing amount of women engaging in prostitution in and around London. When the census showed that there were more women than men in the population, prostitution came to be seen not only as a moral issue but also as a socio-economic issue. Morally, the country believed women should marry and tend the home. As many women did not desire that type of life, Great Britain actually created laws and institutions that prevented women from leading "superfluous" lives and strove to "reform" women into domestic professions.

King Edward VII succeeded his mother, Queen Victoria, as the ruler of Great Britain. King Edward had strong opinions regarding how people should live and dress. Edward did not conform to his mother's morals and led a more hedonistic lifestyle than his mother. Due to his personality, Edward lacked his mother's distaste for society and strove to increase

his presence in society. He influenced art and fashion not only in Great Britain but in continental Europe as well. This influence extended to political realms. Edward's era historically is characterized by an increase in arts and entertainment and a change to the class structure in Great Britain. The lower class's separation from the working and upper classes started to widen during the Victorian era. This division became greater and more rigid under Edward's authority. With this rigid class system, many started to consider the rights of the lower class and women. Towards the end of the Edwardian era and the beginning of World War I, many believed that increased social mobility was not only possible but plausible. Edward's influence extended past the political sphere into the arts and literature.

Also important to British cultural development were the industrial improvements that occurred. Industrial improvements permitted many people to move into the city from the

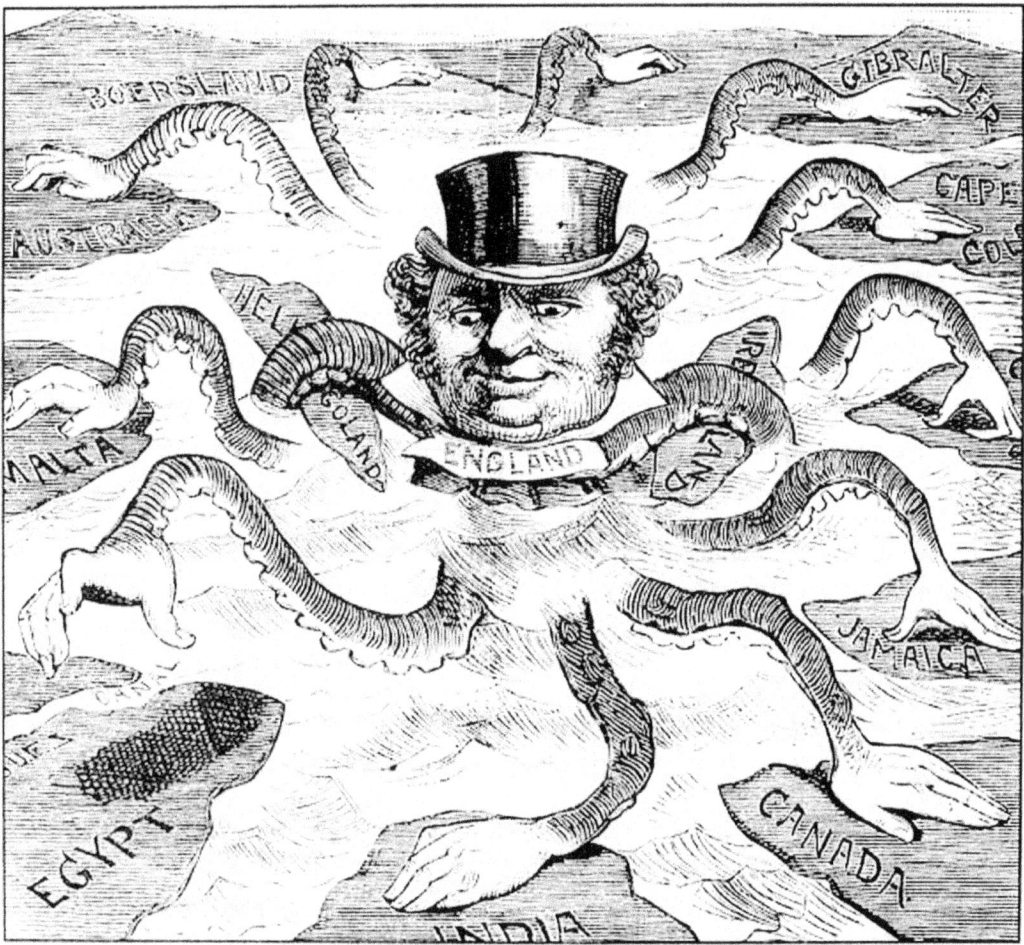

Fig. 1. Although the United States was not actively engaged in the power grab, political cartoonists created imagery depicting how many saw Great Britain: a power hungry, land grabbing octopus (courtesy National Archives).

## Part One. 1900–1913: The Beginning

country to form a large urban population. While the middle class and wealthy were benefiting from imperialism, the lower class—with the increase in population to cities—became more distanced from the wealthy in both location and status. This distance created an atmosphere of haves and have-nots. While the lower class had previously been in the country and did not desire or need the amenities that an urban environment provided, it soon became apparent that many who had moved to the urban areas were not happy. Sensing this unhappiness, manufacturers began to create replications of amenities previously reserved for those of wealth.

The United States during the 19th century was trying to find a sense of identity following the turbulent 18th century. Many believed that the country was finally beginning to come together as a cohesive nation with a unified government. A moral issue began to arise that soon led to war among United States citizens. Slavery was common and many considered it a part of life in the 1700s. Many in the North began to question the morality of having slaves. Many African Americans in the North were free or working towards freedom, while brethren in the South were treated as property. When Abraham Lincoln was first elected president he makes slavery a political cause by stating, "Government cannot endure permanently half slave, half free."[4] It did not take long for states whose economy was largely based on slavery to secede from the nation. This secession was not taken lightly, and leaders on both sides began to prepare for war. The Civil War, along with increased freedom for a section of the population, enhanced culture by allowing for a greater dissemination of information and artistic expression.

The United States was changing not only politically but also socially. Prior to the Civil War many Americans began moving from rural areas to urban communities in search of jobs. Education and religious practices changed as families moved into the urban areas. Rural families taught children over the dinner table and in the fields. Educational and religious lessons centered on the family and natural occurrences. Everything in nature could be explained by religion. In the urban setting, education and religion were taught away from the home. Formal schooling and churches in cities took over the education of children. This allowed women and older children to start moving away from the home and search for work in offices and stores. It was not long before women became a larger part of the working world: "in 1870 14.8 percent of women over the age of sixteen were employed."[5] Women started to want greater visibility not only in the professional world but also in the political realm. The Civil War had both short term ramifications and long term socio-cultural affects. With the increase in urban population there came an increase in workforce, which led to an increase in invention.

Following the end of hostilities, the newly rejoined country went though a progressive reform in the urban and industrial areas. This reform was mainly initiated by workers who believed that they were being unfairly treated by corrupt businessmen. The workers began to organize in protest of the unfair labor practices. These organizations were called unions and began to organize strikes against companies. Workers believed that they finally had some control over the hours worked and their personal safety while at work. Unions not only affected companies, but changed how churches looked at poverty and corruption.

Churches in the United States previously had related poverty to personal corruption, not outside influences. Due to the rise of unions and the realization that life was becoming generally better for those who were union members, a movement began that took three forms. These three forms were the rise of the institutional church, the creation of private agencies engaged in social work, and the social gospel.

Professional and religious change were not the only kinds that occurred during this reform period. Social and political reform was closely related to the belief that if political reform was initiated and successful, social reform might follow by necessity. Social reform was needed to protect those who were unable to protect themselves. Mother's assistance programs, regulations regarding food and drug safety, public education aid, and school attendance laws were just a few of the programs that social reformers wanted to create.[6] With the political structure as it was, these social programs were unable to receive the funds and support needed.

Political reform was therefore needed to produce an environment conducive to social change. There was corruption regarding who was put into political power, and rules regarding how voting occurred and who was able to vote helped to alleviate some of the issues. Individuals were essentially able to buy their way into positions of power without worrying about the voting population. Commissions were created of individuals who were knowledgeable in specific areas. These commissions created some of the social legislation that was needed.

During this time of political and labor change there were cultural changes as well. These changes were extremely beneficial but not outside the reach of satirists. The United States was moving steadily forward economically, politically, and socially. Although the United States was relatively young, many countries already saw the United States as a worldwide police force. Figure 2 satirizes how the United States government reacted to being seen as the world's constable.

Citizens started to be aware of what was occurring in their cities and states more than before. Due to the French Revolution and the rise of Napoleon to power, France regained its status as the lead textile producer in the world. This not only allowed France's economy to boom but also allowed France to determine what fashion was. The fashion industry in France was divided in two categories. The first was referred to as made-to-measure, created by seamstresses to fit a particular person. This method was also considered "couture" or high fashion. The other type was ready-made or "off the peg." These styles originated with the invention of the sewing machine and were sold in boutiques or large clothing stores. During the early 1900s, France was the leading exporter of couture fashion. This was partly attributed to fashion magazines' being mainly published in France. *Vogue* magazine allowed international populations to stay current with new French styles. Fashion is an element that can change quickly or slowly, depending on the population concerned.

The dandy style was popular with European men in the 1800s. This style consisted of short pants, laced shirts, long hair, and feminine waist lines. In the mid–1800s this style evolved towards a smaller waist, shorter hair, high waistbands, and protruding chest. In the late 1800s men began to dress more conservatively, with open necklines and ties with over-

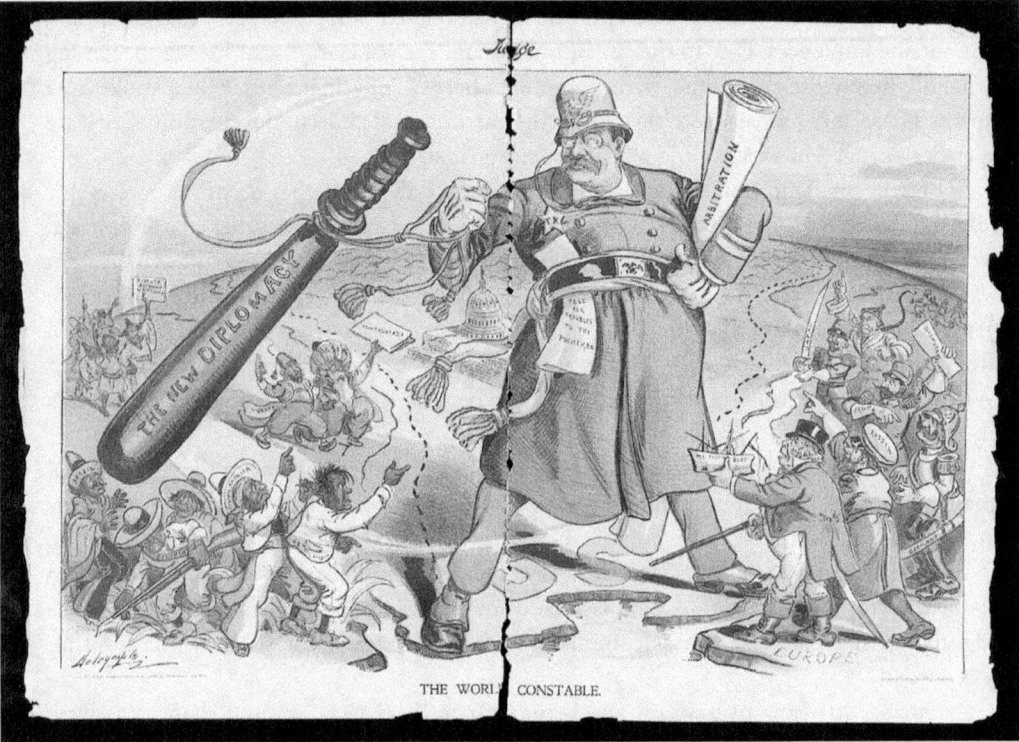

Fig. 2. While many saw Great Britain as imperialistic, imagery depicting the United States as the world's police force also started to appear. Theodore Roosevelt brought about "The New Diplomacy," which many countries felt could assist them in times of disagreement (courtesy Library of Congress).

coats. Many also added hats and walking sticks to complete the style. The styles that became popular for men during the late 1800s changed slightly during the early 20th century. Many designers felt that men's clothing lines were stable and desired, so no change was needed. All designers and couturiers wanted to be in women's fashion.

Overall, women's clothing had maintained a similar design since the Renaissance in Europe with only few exceptions. While many small elements changed, the hourglass frame was a stable element for the fashion industry.[7] Due to designers such as Jacques Doucet, Paul Poiret, and Mariano Fortuny, drastic changes occurred to women's clothing in the late 19th century. These designers changed not only the way that clothing fit women, but also the fabric and overall appearance. Sheath dresses, sack dresses, and undergarments all started in clothing stores dedicated to the wealthy and were soon adapted for all economic classes.[8] Due to the reputation that Paris held in the fashion industry, many designers travelled to France to promote their designs and to gain acceptance. When the designers felt they were accepted into the fashion industry, they returned to their native countries to manufacture and sell these designs.

Clothing also changed greatly from Victoria's era and Edward's. Due to the public's increased activity in sports, clothing became form-fitting and corsets went to the wayside.

*1. Expression*

All of the layers were gone and replaced with a looser fitting bodice. Women, specifically young women wanting more professional legitimacy, dressed as men, complete with tie and high stiff collar. Women began slowly gathering together to push for increased political and professional rights. The majority of women that were part of the women's rights movement prior to World War I were from wealthier families. This was partially due to the status these women held in the community but also to the fact that daily requirements were not as great for those of wealth.

During Queen Victoria's era, clothing styles for women changed multiple times. During the early 1800s women wore large dresses that hid any form of a female body. This fashion style was not popular with everyone; in fact, even political cartoonists commented on it. Figure 3 satirized the newest fashion in both France and England. The conversation on the image states:

> "This woman, with her large breasts, is ridiculous."
> "It seems that they are still doing that in the provinces."

The tops of evening dresses were bare-shouldered, while day dresses completely covered the wearer. In many instances, bare shoulders were acceptable during certain social situations. Soon, however, hoops became popular, as they gave a rounder look with a larger skirt.

— Est-elle ridicule, cette femme, avec ses seins énormes?
— Il paraît que ça se porte encore, en province.

Fig. 3. In the early 20th century, fashion in France began to transition into form-fitting clothing that created a flat chest. When women arrived in Paris, the epicenter of forward fashion, wearing dresses that allowed for a natural chest shape, they were at times ridiculed, as this satirical cartoon shows (courtesy National Archives).

Shoulders were still bare during the evening, with more modest behavior during the day. Due to the weight and inconvenience of hoops, a desire for clothing that allowed more movement and less weight was expressed.

During the early 19th century, many men wore short, tight pants with long coattails. Undershirts were frilly and gave a look of a puffed-out chest. In the 1830s this style was heightened with thinned waists and coats that took on a dress appearance. The elite chose this look for business purposes. Night wear consisted of shorter coats and more elaborate shirts. This fashion was refined, and the quality of the cloth showed the economic status of the wearer. As the century continued, men's clothing showed a change to the length of day coats and length of the pants.[9] Men's pants lengthened to rest on the ankles, and jackets became closely tailored. Both the wealthy and poor wore similar fashions. The only difference between their clothing was the quality of cloth used in the creation. The evolution of clothing was closely associated with Queen Victoria's moral beliefs. With the death of Queen Victoria, many social changes occurred that led up to the beginning of World War I.

The fashion industry in the United States attempted to create a distinction between European and American clothiers. With the invention of the sewing machine, clothing that had been previously unattainable was recreated for the general population at a percentage of the original price. Fashion in the United States during the 1830s, according to Frances Trollope, was "strange" and generally unattractive.[10] Trollope comments that American women were still partial to false hair, which in Europe was a fashion of the past. The general belief was that American women tried too hard to be fashionable instead of being fashionable and comfortable. This was manifested in the clothing they wore out of season and the improper use of lace and thin fabrics.[11]

An example of the difference between Europe and the United States was the use of color in clothing. European fashions were characteristically somber in the colder months and pastels in the spring and summer. Colors in the United States tended to be vibrant all year around, and as Trollope stated that the main color desired was red.[12] While Trollope's distaste for American styles may exaggerate the propensity for certain characteristics, his overall belief was that Americans, particularly women, were not fashionable. Those of wealth imported cloth and wore similar fashions to those of their European counterparts. These individuals were able to have clothing handcrafted in the newest styles. The middle class attempted to appear wealthy by wearing past fashions and cheaper cloth.

Clothing for men followed similar cultural curves as did women's clothing. Men in the United States seemed to wear clothing worthy of their classes, while women wore clothing of higher social classes. This was partially due to the women's rights movement, or in hopes of attracting a man from a wealthier family. Unlike in Europe, where the poor wore simplified versions of the expensive clothing, in the United States the dress for many was of a rough cloth that had no embellishments. The dress length for most women was shorter than ankle length, which astounded many European travelers. It was not long before Victorian ideals started to show through in American clothing styles. Clothing for both women and men of all social classes presented with high necklines and full sleeves at the turn of the century.

The cultural changes that occurred in France originated with young adults not only

from neighboring countries but also from far reaching places such as Eastern Europe and the United States. The field of art and literature exploded during the Belle Époque. Impressionism and Expressionism both became popular in art and theatre. Impressionist painter Edouard Manet not only gained acclaim for paintings such as *Le dejeuner sur l'herbe* but also was criticized by classically trained painters.[13] Manet's paintings exemplify Impressionism, with their broad, visible paint strokes and the perception of movement created for the viewer.

Great Britain prior to the early 1900s had a long and illustrious history of producing artists from its numerous, large institutes. The 1900s continued the trend of Pre-Raphaelite paintings, with the addition of three groups. These three all fought for control of the popular market prior to World War I. These three groups were Sickert's Camden Town Group, the English Postmodernists, and the Vorticists.[14] While Sickert's group and the English Postmodernists were both painting in a Postmodern method, the Vorticists were the *avant garde* of the time. Due to the popularity of Postmodernism, the Vortic movement was short lived in Great Britain. However, later methods of art resemble Vortic methods.

Artistically the United States was influenced by Europe. To be trained properly, artists travelled to Europe to be educated by the leading painters of the time. Many came back to the United States to hone their talents. Painters were as diverse as authors in their chosen methods. Naturalism and Realism were two main methods that gained artistic popularity. American painters such as Martin Johnson Heade painted detailed paintings of flowers and wildlife in their natural surroundings. *Rio de Janeiro Bay* is an ideal representation of the popular Naturalism.[15] This painting style used real-life actions to allow viewers to experience an event.

Art was not the only avenue for artistic expression. Prior to the Belle Époque, many French elite wanted "flowery" literature which allowed readers to remove themselves from reality. The majority of pleasure readers did not want to read about the lives of a lower class. During the Belle Époque, however, many writers began to express themselves though Naturalism and Realism. Naturalism attempted to depict reality, whereas the previous methods of Surrealism and Romanticism sought to heighten everyday reality. Surrealism and Romanticism both attempted to distance the reader from the gritty experiences of daily life. Naturalism embraced those harsh realities in an attempt to deliver a more complete story line.

Novels and short stories were not the written media that most French citizens preferred. The dominant position in literature was held by newspapers. On any given day there were 70 dailies published for viewing. Weeklies and periodicals were also popular. This amount was more than anywhere else in the industrial world.[16] The change in the arts did not end at literature and printed material, but extended to the film, theatre, and music. The new novel, full of modern issues such as greed and the questioning of faith, became popular among those who were literate. This was used to educate many about current issues in a format that avoided political attention. Novels were complex and lengthy; at the same time, poets strived for a return to simple, medieval methods of prose. Literature at times discussed political issues and the ramifications of an increase in wealth and social avenues. Due to Queen Victoria's morality, language that discussed sexual feelings or emotion was considered taboo. Instead, many writers chose to write about poverty and political problems. Writers

unable to directly express topics used euphemisms to describe sexuality and emotion in writing. Homosexuality was strictly forbidden, so writers used this topic to spark attention and criticism.

Many writers understood that the United States was a rough place to live and therefore wrote surreal literature. The writers believed that the population wanted to escape reality when they picked up a novel, not be reminded of their hardships. Like European writers, an increasing percentage began to explore the social concerns that affected the county's citizens. These writers, including Mark Twain, wanted to investigate not only social concerns but also the human experience. No aspect of human life was untouched by the writer's pen.

Artists in all genres became more concerned with human rights and new technologies such as the automobile and electric power. Literary artists started to spread out from books and poetry to newspapers and other forms of printed material for mass audiences.[17] This allowed for a greater percentage of the population to become interested in events occurring around them. Political satirists and cartoonists continued to express criticism though the newspapers in the form of political cartoons. These cartoons allowed critics to express themselves artistically. Another positive aspect of political cartoons was that it allowed citizens who were not highly literate to receive some information on current affairs. The artists and musicians took this time of uncertainty to express themselves artistically regarding what was occurring around them.

Theatre and music were also affected greatly by this expansion of artwork and acceptance of change that occurred in the last 1800s. The Victorian era did not affect France as much as it affected Great Britain. For this reason it did not take France as long to move on from Victorian morality and begin to forge ahead. France therefore was more open about sexuality and the hardships of life. Playwrights picked up on this and began to frankly depict the turmoil faced by the common citizen and sexuality. The cabaret allowed the majority of the population to experience music.

British music thrived in the music halls. Established in the mid–1800s, music halls gained popularity with their combination of music, specialty acts, and comedy. These halls became so popular that entire streets were dedicated to them. In addition to presenting shows with theater-style seating, music halls branched out and gave performances during meals. These halls even went so far as to hold recruitment activities prior to the First World War. Music halls drew large crowds and entertained them with music that was popular in the early to mid 1800s, including American folk music with spirituality mixed in, the English jig, the Central European waltz, and the Bohemian polka. Aside from these lively tunes, classical was still popular among the elite. Classical composers were still requested for special events and gatherings.

The late 1800s to the early 1900s saw an explosion in musical diversity. Almost every large city had an orchestra. Many musicians believed that qualified teachers were not available in the United States, and so many musicians travelled to Europe for education. Some stayed in Europe, while others returned to join orchestras and music halls. Music in the United States was decidedly European in sound. The tendency for musicians to be educated in Europe stunted the evolution of American individuality in the musical arts.

## 1. Expression

Cinema, not having the geographical constraints regarding education that musicians experienced, led to an increase in individual artistic expression. Films used their actors and actresses not only to develop a plot but also to spotlight fashion. Movie stars were considered to be ambassadors for the fashion industry. The audience wanted to dress like the movie stars and demanded these fashions be available. France was the leader not only in literature and art but also in film. The Lumière brothers were arguably the first to create film in 1895 with *La Sortie des usines Lumière*. The Lumières charged for public viewing of their short film. The Lumières, along with Georges Méliès, were the first to commercially produce films. Film became a commercial enterprise with Charles Pathé and his film *The Perils of Pauline*.[18] Pathé created fictionalized films and also newsreels of current social and political concerns. Soon Pathé controlled approximately 33 percent of the world's film industry.

Film was becoming popular in Great Britain during the Edwardian era. The late 1800s and early 1900s showed an expansion of cinematic inventions. These films were short, no more than 15 minutes on average, and silent. During cinema's infancy the leading inventors were in France and the United States. Many theatrical professionals in Great Britain chose to stay in music halls and the theater. Many audiences chose to continue to visit live performances.[19]

The United States during the late 1800s was the one of the leading exporters of cinematic technology. In 1878 one of the first "movies" was produced in Palo Alto, California, showing race horses. Cameras at this time were unable to capture motion, so this film was made from separate photos pieced together. When played back on a projector, it appeared that the horse was moving. Following the first American film, inventions began to propel movie-making forward. Thomas Edison created the Kinetograph, which was a motor-powered camera that captured motion. Many of the first movies created were non-fiction creations that showed small snippets of ordinary life. The invention of sound-capturing technology again transformed filmmaking. The first film to have sound was made in the United States in 1894. New York monopolized the film industry with the first cinema arcade, which opened in 1894. Films soon gained popularity and citizens were paying up to 25 cents for adults and 10 cents for children to see films about dogs chasing rats, and contortionists.[20] Edison and Dickson, along with other filmmakers, began to create films depicting scenes from musicals and theatrical plays popular during the time. This adaptation of previously exclusive shows to a wider audience brought about a change in who was able to enjoy artistic expression.

All three countries saw changes occurring in culture at the turn of the century. Even though transportation between the countries was slow, elements of each country's culture were able to transfer and be adapted by different regions as they saw fit. What this meant was that as transportation and communication became easier and faster, similarities should increase between countries. This cultural shift allows for an in-depth look at how one culture's heritage can be another culture's beginning. Elements of European culture could be seen in altered form in the United States in the early 1900s.

# 2

# Planes Emerge

It may have taken over 200 years to achieve powered flight, yet less than 20 years following one of mankind's greatest achievements, powered flight became an instrument of destruction. Military organizations saw airplanes as useful, but the full impact of combat-related flight was not realized until World War I. Following the first flight, planes were primarily used by the wealthy as a tool for leisure. During the early years the race to build faster and bigger planes took precedence over anything else. This race was escalated after the Wright brothers first flew. This race involved three nations in particular for over a decade: France, Great Britain, and the United States.

The first flight had its genesis in 1900 and reached fruition in 1903. Although the Wright brothers were bicycle builders by trade and plane builders by hobby, they thought themselves to be the ideological pupils of Sir George Cayley. The Wright brothers were pupils of Octave Chanute. Chanute, while never conquering the air himself, pursued the theory of flight with a vengeance. Like the Wright brothers, Chanute started flight research with birds.[1] Chanute's desire was to connect airplane developers from around the world to assist them in achieving manned flight.[2] To achieve this Chanute wrote articles that had a wide audience and inspired others around the world to study flight. In 1900 Chanute received correspondence from Wilbur Wright that affected the history of flight. Wright wrote, "I make no secret of my plans, for the reason that I believe no financial profit will accrue to the inventor of the first flying machine."[3] Chanute agreed with this assessment and welcomed helping a pair of young inventors achieve what he could not. Chanute immediately wrote Wilbur back regarding further articles to read and a location that might prove successful for flight trials.

During this time, there was another pair of Americans who were attempting to be the first to prove powered, manned flight was possible. Samuel Langley and Stephen Balzer dedicated all of their time to building an engine that could bring life to the airframe they had created. Langley believed that the engine needed to push 12 horsepower to create the lift desired.[4] While Manly, the actual builder of the engine, produced a workable engine that ran at 360 revolutions per minute, it only produced 8 horsepower. Langley was busy tweaking the engine while Wilbur was building bicycles.

Chanute suggested to Wilbur that Kitty Hawk, South Carolina, had geographical features and weather that favored what the Wright brothers hoped to achieve. Wilbur began to write to officials in Kitty Hawk to determine if this was a suitable place to perform flight

## 2. Planes Emerge

trials. The response was warm and confirmed what Chanute had suggested regarding the suitability of Kitty Hawk. Wilbur felt that he had found a location that was both accessible and had favorable conditions for success. By using their past designs and the research of others, Wilbur was able to build his glider. During this time Wilbur essentially worked alone, due to Orville's other hobbies.[5] When the bicycle business naturally declined during the fall months, Wilbur was able to spend more time on the glider. Soon Wilbur felt that the glider was ready for a field test. Following the first successful flight of the glider, the Wright brothers started to build a frame that could hold an engine.

Unknown to the Wrights, the race for flight in the United States was close. Langley had already produced the airframe, yet was still working on an engine. The Wright brothers had a rudimentary airframe but no engine. Due to the complications with creating an engine that performed up to the specifications that Langley desired, the partnership between Langley and Balzer started to break down. Langley decided to give the Balzer and Manly team one more chance to create an engine that met his expectations.[6] Langley at this time also travelled a great deal to learn more about flight in hopes of becoming the first person to create a powered plane that could carry a person.

Octave Chanute asked if he might visit the Wright brothers to further the conversation. The Wrights agreed, and during the visit Chanute started to believe that the brothers were more concerned with themselves and personal achievement than with sharing ideas with others in the field. Chanute, hoping to gain information for the global community, suggested to the Wright brothers that they allow fellow flyers handpicked by Chanute to accompany them to Kitty Hawk. Unable to completely parry Chanute's request, the Wrights begrudgingly allowed two outsiders to participate in the Kitty Hawk trials.

While the Wrights were mostly staying out of the public spotlight, Langley was doing everything in his power to stay in the media. In 1902 Langley tried to place Manly into the airframe for the first attempted flight of a heavier-than-air, powered plane. This flight did not occur and many in the media thought of Langley as a fading inventor. The Wrights began to build another frame that could adjust for some of the environmental aspects they encountered at Kitty Hawk. These environmental aspects included sand drifts and differing air patterns. Having little money left, the Wrights decided to try one more time in the year 1903, following the arrival of an engine that could be placed in their new airframe.

During that trip, the Wright brothers became the first to perform a manned, powered flight. As few people actually believed the Wright brothers had achieved flight, their hopes of large contracts and recognition did not occur.[7] Figure 4 is an image from 1908 that shows the remodeled 1905 frame with engine.

The Wrights having no money, they continued the trials closer to their home in Ohio. These trial flights usually did not bring in a large viewing audience. However, some investors arrived to discuss future possibilities. These investors allowed the Wrights to gain some international recognition. Prior to Wilbur's travelling to France as a flight ambassador in 1907, Great Britain and France both had fledgling flight programs. France had six inventors who changed the way that France looked at aviation. Leon Levasseur achieved what may be considered the zenith of success in French aviation. Levasseur created the Antoinette

## Part One. 1900–1913: The Beginning

Fig. 4. In 1903 the Wright Brothers from Ohio became the first to achieve powered flight. Here they are in Kitty Hawk, North Carolina, the location of their maiden voyage (courtesy Library of Congress).

engine in 1903 for racing motorboats. While this engine was smaller than later models, it proved popular due to its strength and reliability. Another cornerstone of French aviation was Brazilian Alberto Santos-Dumont. Santos-Dumont was not specifically interested in heavier-than-air powered flight, and chose to study gliders and hot air balloons until 1907. The partnership that was questionably the farthest advanced as of 1907 was that of Henry Farman and the Voisin brothers. Farman teamed up with the Voisin brothers to push the envelope of French aviation technology. Prior to this, Farman had already been testing out different airframes. Their development was slow when Wilbur came to France for a flight exhibit.

The British were slower in achieving actual manned flight, but the trials were extensive and showed progress prior to 1907. The leading English partnership was that of Samuel Cody and Alliott Roe. While many other inventors were creating airframes and engines, it was really the Cody/Roe team that raised Great Britain from virtual obscurity to equality with the French and later with the Americans. Both France and Great Britain were primarily in the developmental phase until Wilbur Wright arrived in France.

Wilbur travelled to France in 1907 to demonstrate the flight superiority that the United States had over the European countries. By this time many Americans believed that the Wrights had flown. Wilbur fueled the minds of those who already had the flying spirit. However, the French general public was less than amused with his claims: they wanted their countrymen to be the first to attain flight. The French, who did not want to acknowledge that an American had flown before a Frenchman, were skeptical of Wilbur's claims. Following Wilbur's exhibit, there were still some individuals who were unbelievers. This exhibition did many things for European inventors, both positive and negative.

2. Planes Emerge

Santos-Dumont, who had never considered the possibilities of powered flight, started researching with a vengeance following Wright's exhibit.[8] Due to his inventions, he became the first European individual to achieve powered heavier-than-air flight, in 1906. A peaceful, loving individual, Santos-Dumont only saw the altruistic benefit of flight and could not believe that planes might be used for military purposes. Due to his nature, following World War I, Santos-Dumont became so disillusioned with the way his creations changed the world that he killed himself.[9]

Farman, having witnessed the claims by Wright, began to push the Voisin brothers and himself to create a prototype to rival the Wrights' planes. The partnership created a frame that withstood the weight of an engine and an individual. However, disagreements soon split the partnership, and Farman went on alone to create the Henry Farman III in 1908, which continued to be the pinnacle of French aircraft until 1912.[10]

Following the French exhibition, the Wrights started to market their product to the United States Army. But, being a ground force, the army did not believe that air was the next realm of combat and declined the Wrights' invitation to purchase prototypes and training. This slightly disheartened the Wright brothers, but during this time they met Glenn Curtiss.

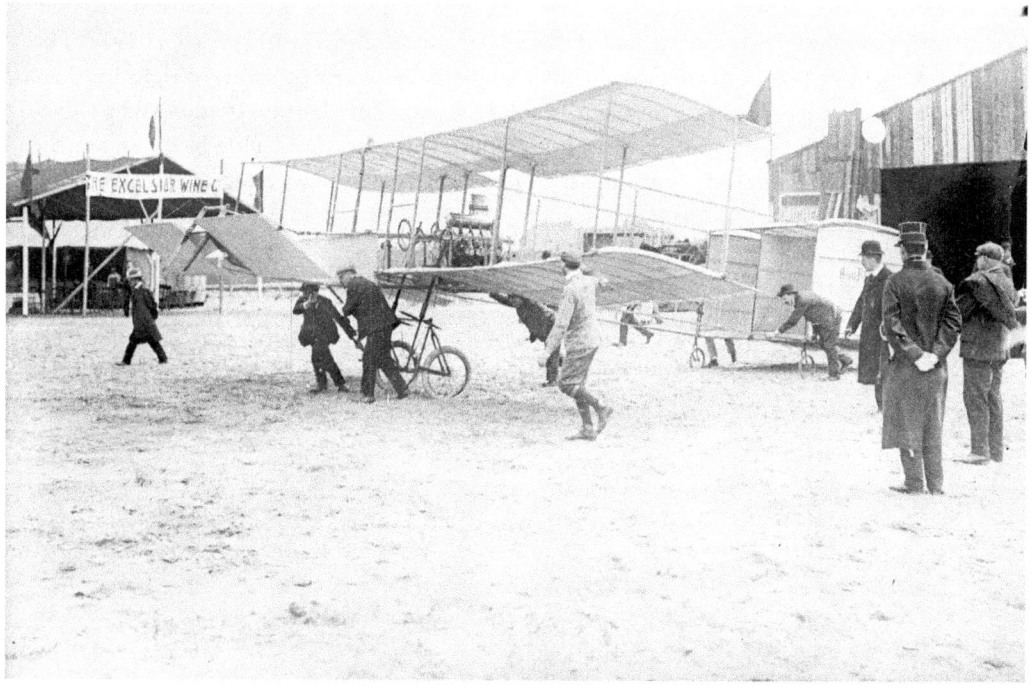

Fig. 5. While the Wright brothers were achieving flight, there were many other individuals struggling to build frames and engines. Not four years after the Wright brothers, Frenchman Henry Farman finally achieved flight with his Henry Farman III, which stood as the pinnacle of French aviation until 1912 (courtesy Library of Congress).

The Wright brothers soon formed an aviation company with Glenn Curtiss and started to participate in newly formed flight competitions. In 1910 the first Dominquez Hills Air Meet was held. Curtiss, who was in charge of the experimental branch of the Wright-Curtiss company, also flew in competitions. At the competition Curtiss not only won $6,500 for excellence in speed, endurance, and quick starting but also caught the attention of a naval official who was watching the races.[11] Soon after, the navy approached the Wright-Curtiss company with a contract for flying boats and pilot training. Not long after that, the contract was expanded to commission a larger multiphase sea plane in 1914. The sea plane was soon cancelled, as the navy realized smaller planes were more desirable.

The United States recognized the military potential of planes before France and Great Britain, who were employing flight for more domestic uses such as mail delivery and recreation. Although the three countries used aircraft for different functions, the air race continued. Due to the different tasks that planes could execute, the air race went beyond concerns of speed and distance and instead became a race to enhance task-specific modifications such as allowing for increased weight or maneuverability. Inevitably, the pursuit for better-equipped planes intensified as the world went to war in 1914.

Planes were not the only thing that changed between 1900 and 1914. The United States was still trying to create a larger place in the world than before. During the years leading up to World War I, attitudes and culture were changing. Each country began to develop an identity that encompassed airplanes that was portrayed on the world's stage in 1914. The development of planes started slowly but exponentially increased as the Wright brothers travelled to Europe. This race for flight affected the future of plane innovation and production. Few of the first inventors saw the future military implications. This, however, was the start of a path that evolved to encompass larger portions of military budgets and more combat planes.

PART TWO

# 1914–1919: The Great War

# 3

# Roaring

The years leading up to World War I did not show a dramatic change in attitudes or fashion trends. Clothing continued to be shortened and tightened following the trend that had started in the late 1800s. Motion pictures on the big screen were starting to gain popularity. The United States was starting to become more conservative in attitudes and culture, while its European counterparts were moving out of Victorian attitudes while maintaining some Edwardian qualities. Music and art maintained many historical elements as the 20th century began. One thing that affected the public was the increased visibility of aircraft and aircraft usage. In the few short years after planes were created, there was an expansive growth of plane usage for private and commercial purposes in Great Britain, France, and the United States. All of that changed when the Great War started.

War, and specifically World War I, was difficult not only for those directly involved but also for those left behind. The intensity of battle along with the closeness of combat affected many soldiers. Family members' only knowing information through letters caused a change in how families interacted at home. Family dynamics and attitudes changed as members of the family left for war. Communication between service members and their families was sparse due to primary method being via written letter. Women therefore became the head of household not having the opportunity or requirement to look to the previous head of household for guidance. That then changed how children perceived the household structure. Women at times also found work outside the home to maintain their state of living. These things changed how the family interacted on a core level which then directly translated to how the individuals interacted with those outside the immediate family. These cultural changes broadened out from the family and home into cities and industrial zones. Industries began to experience the ramifications of personal and group cultural change. This impact did not stop with business but affected both military and governmental sectors. Due to the core changes that occurred at multiple levels, there was a fundamental change in how individuals viewed the world and how they outwardly interpreted these cultural images.

Soldiers enlisted or were drafted to combat the enemy. This created an understandable change in how the family unit was structured, with a large percentage of young men being away from homes and work. France was the first country to be directly affected, due to the Germans occupying part of France. Not long after the deployments began, Great Britain started to experience work shortages due to the deployments. The United States was not affected as severely as the European countries due to late U.S. involvement in the war.

The business sector was affected due to eligible workers being sent to the front lines. Due to the intensity of the conflict, soldiers were not able to return home periodically. This decrease in young men at home created openings for those unfit for service to move into the work force. Men who were unable to face combat quickly replaced soldiers, while women in France slowly started to move into the work force in larger numbers. Due to these aspects, women became the agents of cultural change in local communities and in the family structure. Towards the end of the war, there was such a marked decrease in workers that prices began to rise. This, along with the mandatory rationing, caused consumers to look elsewhere for products. This led many straight to German suppliers of German-made products. Obviously funding the enemy was not in the best interest of the government, and propaganda posters were seen, such as figure 6.

Prior to the onset of war, women were working primarily in the domestic sector and clerical fields. Women moved into the work force to support the economic stability of their families or to aid in the war effort. Women, with a newfound freedom to work and assist in the decision-making process, started to fight for more rights. Women during World War I effected change. Great Britain saw a similar situation. The United States did not have as large a proportion of men serving as other countries did, so the

Fig. 6. Even though the war was over, Great Britain and its allies were quick to denounce any German seeking employment or assistance. Their belief was that if a single German was to get assistance or employment, a Brit did not. This also applied to the importation of German goods (courtesy Library of Congress).

### 3. Roaring

need for alternative workers was less. The United States may have needed fewer workers to replace soldiers, but the ramifications of this war helped to shape the following decade with regards to both women's rights and the effect that women had on nose artwork in the United States.

It was not long before women started taking on more jobs due to the lack of men able to fill the open positions. In Great Britain and France, women started working in heavy industry, filling positions that were historically male-only positions. Women felt that they needed to do this for their families and for themselves. Although the image in figure 7 was targeting individuals with money in hopes they would assist with the Women's War Time Fund to support canteens and hostels, the imagery shows what women were doing when the war was in full force.

In Great Britain a shortage of eligible police officers allowed women to enter the law enforcement field. This was one of the first instances when women were allowed to wear uniforms. These women wore uniforms and only policed those areas frequented by women, to ease the burden on men. These woman-only units were highly successful during the war.[1] This success allowed for more women to enter positions that allowed for uniform wearing. While seemingly mundane, the ability to wear a uniform connected women to their relatives serving on the front

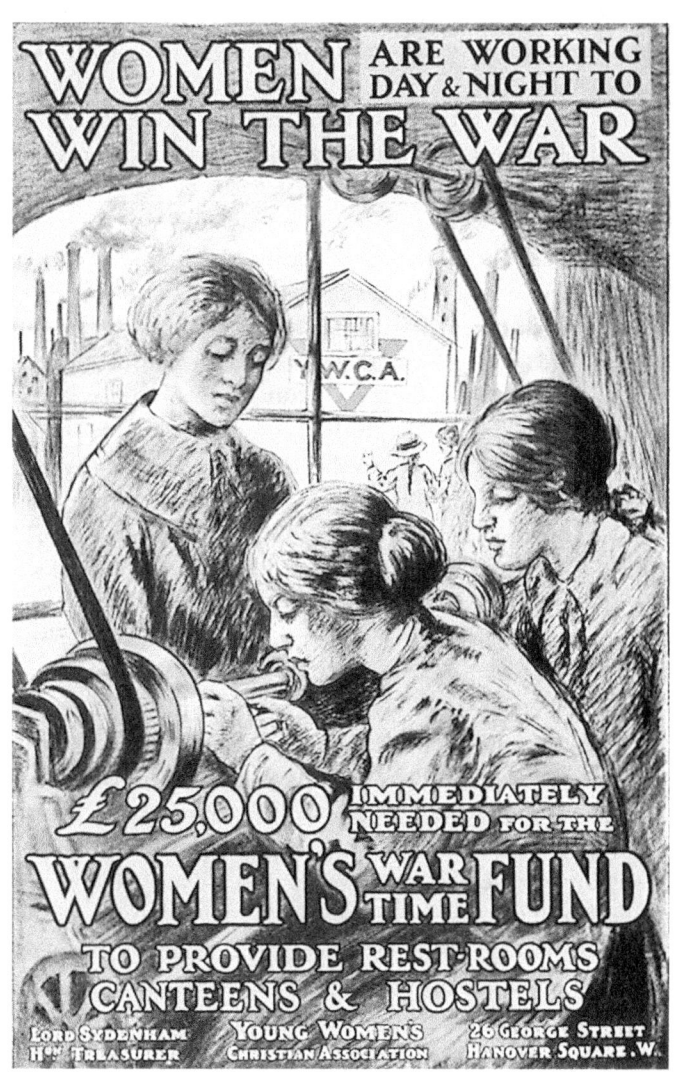

Fig. 7. It is a common misconception that women did not serve in the World War I. It reality, many women served in various positions, both at home and in the field. As the war continued, these organizations, not being top priority, were strapped for funds. To assist with funding these organizations, posters such as these were commonly seen (courtesy Library of Congress).

31

lines. Women believed that the harder they worked, the faster the soldiers might return home safely. Another motivation for working specifically in munitions factories was that workers felt they were directly involved in the war.

It was not enough for some women to work; some wanted to be part of the military. These women truly believed they could make a difference in the outcome of the war. The two primary reasons for women wanting to join the military were to assist their male counterparts that were serving already, and to be part of something greater than themselves. Women believed that they too were part of the national community and should be able to be part of the military. Women were not allowed to be in the military in any of the three countries at the beginning of the war. Historically, war was a sign of masculinity, and the concern was that units comprised of women might not have the urge or drive to fight.[2] Women were thought to be the weaker gender and to be too weak or emotional to kill. Because of the cultural barriers, many women took it upon themselves to join the war effort any way possible.

Women often become ambulance drivers, bringing soldiers into locations that were capable of handling the onslaught of wounded. These drivers were at times subjected to artillery fire, and there were women who were injured in the line of duty. Women who were unable or unwilling to drive were able to volunteer as nurses by assisting the military in hospitals in nearby towns and cities. Many nurses were placed in danger when enemy forces moved into towns. It was not possible or practical to move qualified nurses away from those who needed them if a direct risk to life was not present. Both ambulance drivers and nurses began to wear uniforms that separated them from other elements of the military. Not unlike the police officers, these uniforms gave the women legitimacy and allowed them to be an organized unit serving the war effort. This was only the beginning for women in uniform and in the military. With this beginning also came great hesitation and anger from men, both at home and those deployed. At first many men believed that the women were being used by companies. This changed to anger at the women for stepping up into positions that were "for men." These feelings escalated when men who were injured began to return home. Men returning home injured or otherwise unable to be on the front lines saw a dramatic change in the years they were away from home.

Women moving into the work force was but one of the changes that occurred culturally during World War I. The magnitude of the propaganda utilized during World War I was unprecedented in all three countries. It is not an accident that the increase in women working coincided with the increase in propaganda materials being disseminated. These propaganda materials influenced the growing field of nose art. The artwork and attitudes present in the materials contributed to the attitudes of the general population. These attitudes correlated with the type of nose artwork created during World War I. Due to this correlation it is important to understand the themes and goals for propaganda, both visual and auditory.

Although there was geographical distance between the United States and its European counterparts, many of the general propaganda themes were the same. British propaganda was overall more graphic in its depictions of the enemy and the battles than either the Americans and the French. This is surprising, since the battles did not take place on British

### 3. Roaring

soil but rather on French land. Another surprising factor was that although the United States was the last to enter into battle, U.S. production of propaganda posters exceeded that of either Great Britain and France. Propaganda during World War I had three major themes: enlistment, spending, and send/save.

Propaganda surrounding enlistment spanned many different organizations and presented in multiple ways. The common method for the British was to show either a soldier getting ready to go or that a woman from the family was okay with the enlistment and therefore the man should go (fig. 8). Great Britain in its enlistment posters showed the costs of the war by displaying pictures of what Germany looked like or what the Germans had done to Belgium. The posters implied that unless the men went right out and enlisted, the same thing could happen to their home towns. This led to a strong motivation for eligible men to enlist in one service or another.

France was no different in the push to enlist, but the posters coming from the French government were void of graphic depictions of the war. The French tended to use pictures of the French flag to entice French men to enlist. This worked better than expected, considering the limited variety of posters. The small number may be attributed to the war's being fought in France and everyone seeing its direct implications. Wounded personnel from all allied countries received treatment in France, and so the day-to-day grind of the battle was visible to all.

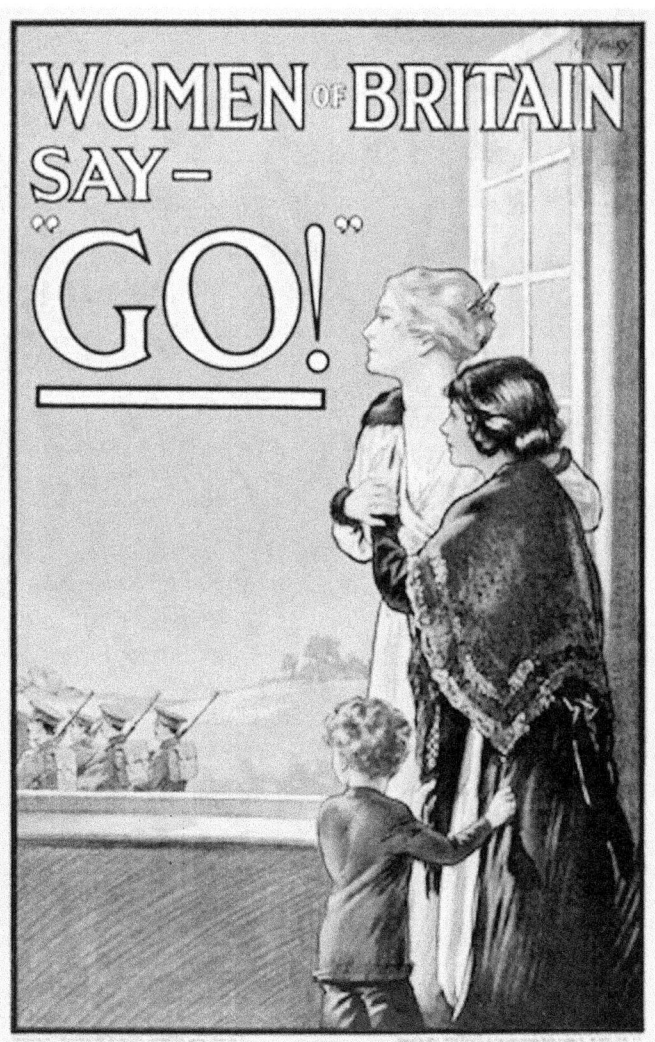

Fig. 8. One reason that the British military was feeling a decrease in enlistment was that men had wives and families. This imagery was commonly used to assure men that their families wanted them to go fight the good fight (courtesy Library of Congress).

## Part Two. 1914–1919: The Great War

The United States enlistment posters exploded with visions of men toiling away in the battlefields and the need for more to be involved. Most of the U.S. posters showed images of the Statue of Liberty or Uncle Sam with the U.S. flag behind or around them. This drew on U.S. citizens' patriotic beliefs. These images were also shown as nose artwork. When the government was not drawing directly from patriotic themes, it depicted slightly less graphic images of the Germans.

Men for the military were not the only group being targeted by the posters and flyers. With the exception of a few posters created by France, Great Britain and the United States were the primary recruiters of ineligible men, women and children into service. These services were not directly military, but all of the services did relate to an aspect of militarism and assisted even remotely with the military effort. The British not only had the National

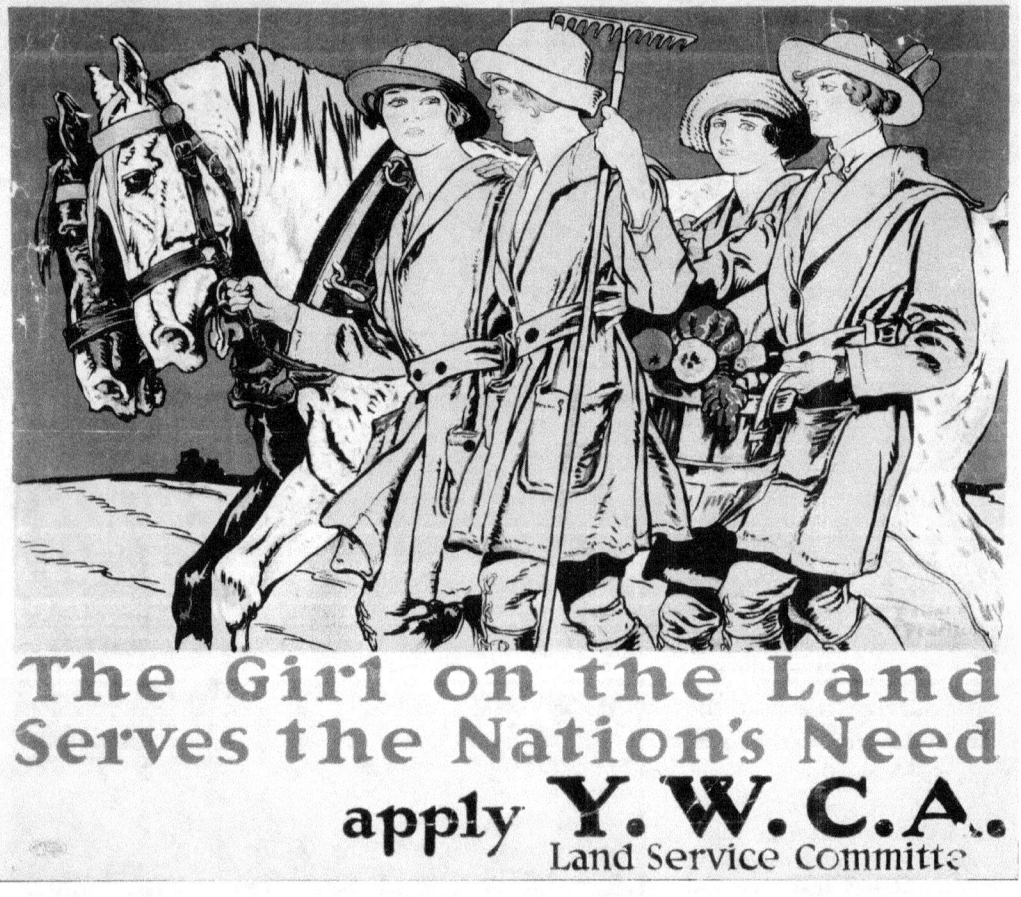

Fig. 9. Although women in the United States did not actively assist with the military effort, many organizations such as the Y.W.C.A had opportunities for women to work. Most of these organizations filled positions left vacant when the men enlisted. These women wore uniforms and in many ways were able to assist the military effort from home by growing crops, knitting clothing, and sending materials to those in the trenches (courtesy Library of Congress).

Service, which was for women and those men unable to be in the military, but also the Women's Auxiliary Corps and Red Cross. The United States also recruited for the National Service, and also for the Red Cross, YMCA, YWCA, Boy Scouts, youth groups, and Farm Service.

The Young Women's Christian Association (YWCA) consisted of women who moved into positions that were left vacant due to soldiers deploying. It was different than private employment, as this was government driven; most of the companies that were involved created food and material goods for soldiers stationed in France. This trend is depicted in figure 9, a poster created in the United States. The YWCA at times connected with the Farm Service in the United States. The Farm Service comprised women and men unfit for combat who moved into farming and food production. The posters not only attempted to recruit women into the Farm Service but also encouraged those not involved to support the women who took up this duty.

The Red Cross was another organization prominent in posters created during World War I. The United States displayed a greater percentage of Red Cross posters and flyers than Great Britain. One poster that the British published was both pro–Red Cross and also an attack on Germany. Great Britain used this poster not only to depict the differences but also to show all Germans in a nega-

Fig. 10. This image was an advertisement for a postcard that directly supported the Red Cross's wartime efforts. During World War I, many nurses and other medical personnel were from the American Red Cross and international Red Cross organizations (courtesy Library of Congress).

tive light, even those who swore to assist the needy.³ The United States did not create negative posters that were associated with the Red Cross, primarily displaying women in nursing outfits tending to the wounded or assisting the war effort in other ways (fig. 10).

The main drive of posters representing the spending aspect was not for organizations looking to support the soldiers, but for the government to fund the war. Using all types of visual depictions, Great Britain and the United States campaigned strongly for war bonds and war stamps. War bonds were cheap to buy into, and the government promised that once the conflict was over the bonds could be sold back to the government for greater than the initial purchase price. War stamps, seen primarily in United States flyers, were essentially IOUs that one could receive from a store or bank instead of cash.

France had different ways to raise money, so war bonds were not prevalent in posters and flyers. France along with the United States and briefly Great Britain presented events that generated revenue as well as showing the general public what life was like in the field. France placed a lot of emphasis on plays and events that corresponded with dates important to the war effort. The French presented speakers and events that charged attendees admission. According to the posters, the money assisted those in need, be it wounded or orphaned. One such event was *Journee du Loir et Cher* (fig. 11).

The United States paid special attention to soldiers and brought in surviving sol-

Fig. 11. In addition to the various methods to increase funding for the military, the French held an event to raise funds for those who needed it the most: refugees, the weak, and orphans (courtesy Library of Congress).

## BE A WAR DADDY = ADOPT A SOLDIER

Father the Movement under direction of the War and Navy Departments to Surround the Training Camps with Wholesome Environment

## DO YOUR BIT TO MAKE HIM FIT TO FIGHT

SUBSCRIBE TO THE

## WAR CAMP COMMUNITY FUND

National Chairman JOHN N. WILLYS
Toledo, Ohio

National Treasurer CHARLES H. SABIN
President Guaranty Trust Co., New York City

Fig. 12. For those men who were too old or frail to enlist in the military there was the opportunity to support the military by becoming a "War Time Daddy." Essentially this was the adoption of a soldier who was going into training (courtesy Library of Congress).

diers to speak to paying crowds. This increased the funds available to the organization that sponsored the event as well as educating the audience about combat. These events were also usually tied into enlistment activities. One organization did not just ask for money as many others did, but went so far as to request that those over the age of 31 adopt a soldier and become a "War-Time Daddy" (fig. 12).

If the population was unwilling or unable to buy bonds, there were posters for them. Sending or saving was also an important element to many posters in both the United States and its European counterparts. Food was an important aspect to save or send to organizations that needed food. Rationing occurred in all three countries, although the United States primarily requested that the population ration in the early years of the war, while Europe demanded it (fig. 13). It was not long before the U.S. government started to mandate that certain foods be rationed, such as sugar, wheat, and red meat, so that food could be sent to the allied soldiers. France was not as concerned publicly as Great Britain and the Unites States were regarding food shortages.

The United States and Great Britain extended their requests to other material goods, too. Posters put up in Great Britain and the United States requested that tobacco be rationed so that soldiers could continue to smoke on the front lines. The thought was that this would relax the soldiers, who were at mortal risk. The other two logical yet unusual requests placed

Fig. 13. Although humorous, there is a lot of truth to the "An Heroic Sacrifice" cartoon created by the U.S. Food Administration. Due to the amount of food and other materials that the military needed to support the war effort, many federal organizations pushed for rationing. This cartoon is specifically geared towards rationing sugar and products made from sugar (courtesy National Archives).

on the general population were for knitted goods and books. The United States even considered the production of knitted goods to be part of the National Service. This is understandable due to the weather conditions and the length of time that the soldiers were in the field. Books were requested so that soldiers could have a piece of home during downtimes. Due to the combat conditions, it is unknown if any of the books were actually read or were used to produce heat during the colder parts of the year. Either way, books were useful to the soldiers.

Due to the rareness of planes in combat during the beginning of the war, the posters that portrayed the military usually showed ground soldiers rather than pilots. There were posters depicting planes from both the United States and England. One interesting poster developed in the United States actually requested that gold be sent in so that it could be melted down and turned into money to assist the pilots. This was one of two posters that directly requested or represented the pilots or planes in general. The other poster was for enlistment purposes (fig. 14). The United States realized some of the potential that planes had, and while not having the specific ability to train large groups of pilots, also needed ground crews that could work on the planes. Although there were plenty of men ready and willing to fill open plane seats, there was still some recruiting, but nowhere near the level of infantry recruitment.

Pilots were glorified both in locations of active combat, and in France, Great Britain and the United States. These were the men who flew and were able to get above the trench lifestyle. Pilots slept on cots or beds and had hot food. Trench living was muddy, disease-ridden, and dangerous. The dangers surrounding the pilots were underplayed by the stories that enhanced what it was like to be a pilot.

The literature that was being written during this time romanticized the glory that came with being a pilot. Literature was affected both by the conflict and by the changes in individual attitudes. Literature was a way for citizens to express their feelings regarding the world and how the conflict was affecting them. Newspapers, which gained popularity in the first decade of the 20th century, increased in readership with the inclusion of political cartoons. Political cartoons during World War I mainly centered on the war, how the cartoonists felt about the conflict and how politicians were reacting to circumstances that arose during the course of the war. All three countries' political cartoonists had different concerns. By looking at the topics of cartoons and the cartoons themselves, we can view how this particular section of the population felt about what was going on in the country and in the war.

The poetry and novels published during World War I continued to rely heavily on Realism. A slight trend began to develop in 1914 that soon became present in the majority of published poems and novels. This change occurred in the writers' perspective. Prior to World War I, poets and novelists were writing about the pain and suffering of others. Many of the poems and books showed reality but it was rarely from the first-person viewpoint. Writers were able to embrace the poverty and helplessness that existed without completely submerging themselves in this socioeconomic class. The start of World War I affected established writers and gave many new writers a voice.

The poems and short stories that were written and published during the war showed

war from a soldier's point of view. The pain and experiences that occurred were recalled on paper. At times this writing showed the survivors' guilt that soldiers, pilots, and even families felt. Poets gained a voice with wartime prose. Robert Nichols was one such individual who found his voice during the war. Nichols' poem encapsulated the different spheres of pain that a soldier felt while on the front. "Fulfillment" discusses not only the pain of leaving home with "Was there love once? I have forgotten her," but also the pain of being injured with, "To shatter limbs! Pulp, tear, blast," and of losing comrades: "Lessening pressure of a hand, shrunk, clammed and stony!"[4] Many writers who volunteered to serve in combat were already established literary figures whose popularity grew with their wartime accounts.

Writers such as Ernest Hemingway and H.G. Wells increased their popularity with their wartime works. For these writers there was already an audience eager and horrified to read poems and stories from the front. This desire to read soldiers' words manifested itself partly in *The Muse in Arms*, a collection of poems published in 1917. Its popularity was so great that multiple editions were published prior to the armistice. Due to the war primarily being centered on the trenches, most of the writings also revolved on this aspect of the war. Some authors chose to look at different aspects of the war for their motivation.

Aerial warfare took over for other types that were less appropriate for this conflict, such as cavalry. Planes took the place of both cavalry and (partially) naval vessels. Great Britain prior to World War I had one of the strongest navies in the world. When it became apparent that this war was to be primarily land based, that the traditional naval skills were not needed, sailors began to reclass into aerial professions. Great Britain's sailors and soldiers considered themselves not just strong pilots, but some of the best, as seen in O's poem "Command of the Air":

> Thus at the ringing gates of heaven's glory
> Begin new chapters of our Island-story,
> And clarion voices of the voice declare:
> "She who has ruled the sea shall rule the air."[5]

This poem specifically refers to both Great Britain and to British power in the air. Another section of this poem details the importance of the man behind the controls:

> Then did the British airman's sea-born skill
> Teach wood and metal to foresee his will;
> In every cog and joint his spirit stirred;
> The Thing possessed was man as well as bird.[6]

To fly was mystical, and this belief led to the mythical and superstitious depictions placed on the side of planes during the conflict. It is surprising that with all of the talk about birds and flying, few paintings during this conflict consisted of birds. Gilbert Frankau also made the connection between plane/man and bird in his poem "Eyes in the Air." The one line that repeats throughout his poem is "The hawks that guide the gun!" In this poem he is referring directly to the individual who is using the gun against the enemy, or "Black Doves."[7]

O was not the only one that spoke of the man behind the controls. In addition to the

man, every facet of the plane, including the air, was focused on in Gordon Alchin's poem "A Song of the Plane." It seems that Alchin believed that without one of the four attributes that he refers to, flight and therefore glory was unattainable. The plane stanza speaks of distain for the plane, with words such as groaning and sobbing. The gun is a strong and evil device whose goal is to maim or kill. Man is slightly more venerated:

> This is the song of the Man—
> The driving, striving man,
> The chosen, frozen man:—
> The pilot, the man-at-the-wheel,
> Whose limit is all that he *can*,
> And beyond, if the need is real!
> Hey ho! For the Man![8]

Following this is a stanza regarding air, contemplating how even though it is sightless and drifting, it may in the end help man. It is clear in this poem that Alchin believes that man is the strongest of the four elements and therefore deserves respect.

Prior to World War I, fashion was primarily dictated by economic wealth. Styles were the same for both the upper and lower class, the only difference being the type of cloth used to create the clothing. Starting in the 1900s some clothing styles were created with activities in mind. Many of these styles were for women, who began to participate in sports and other activities that heavy dresses were unsuitable for. War affected both how people dressed and the way that clothing was designed and manufactured. Women played a large role in the way that clothing changed. Clothing was forced to adapt to the large number of women entering the work force. Extra layers were removed from dresses to ease movement, and the overall dress being shortened. This was the first time that mainstream dresses' length rose to mid-calf. This new fashion necessity caused a newfound disagreement with those who believed women should not be working. Regardless of wealth, the dresses used for daily work were plain and made of cloth that could withstand the constant wearing.

The colors also showed hardship and support. Prior to World War I colors for clothing were vibrant in the United States while somber yet still colorful in France and Great Britain. As previously mentioned, women in the United States went towards reds while European women stayed with purple, blue, and greens. When the war started, daily clothing in all three countries started to grow somber and practical in color. This practice of wearing dark clothing for respect and remembrance occurred in all three countries as the war continued. The United States, having entered the war much later than Great Britain and France, was the last country to modify the clothing colors. Whites were primarily reserved for nurses or other medical personnel, while browns, grays, and blacks were worn by many in the fields and factories. The reasoning behind the separation in clothing colors was threefold. Clothing that was darker showed stains less than colorful clothing. Vibrantly colored cloth was expensive to make due to the chemicals and plants that were used to create reds, blues, and greens. Many people used their money to feed their families and donate to the war effort, not to buy cloth. This notice displayed in England reinforced the idea that the war effort should be paramount (fig. 15):

The third and emotionally based reason was that darker colors show sympathy and anguish over the perished soldiers. When news returned from the front that a soldier had passed, it was not only the family that suffered but the entire community.

Fashion was highly important to France even during the war. France, due to the conflict, was limited in the materials it exported. Clothing and fashion in general was easily exported and brought in much-needed money. France further believed that fashion could spread French culture, which could assist the war effort. Fashion magazines discussed not only fashion but how the conflict affected the fashion industry as a whole. Due to the magazines' far reach, even countries not directly involved in the conflict felt the ramifications of war for the fashion industry.

The United States and Great Britain maintained an element of the prewar fashion industry. Most of the clothing manufacturers chose to create clothes that were more practical than previously created. This decision was due not only to the recession that took place during the war, but also to many fabrics' being utilized by the governments to clothe soldiers.[9] Some of the clothiers even went so far as to manufacture clothing only for governmental usage. This transformation allowed women to move into the fashion industry, which in turn created cultural change. Women such as Coco Chanel began to move ahead

Fig. 15. Not only food was rationed during conflicts; clothing material was as well. This poster reminded everyone that new clothes and those with embellishments were unnecessary and actually "bad form." It wasn't just the materials, but the labor too that was needed to make clothes for the military (courtesy Library of Congress).

of the men in the fashion industry.[10] Due to the increase in women in the fashion industry and in the professional world, new inventions were created that revolutionized women's clothing. New styles of underwear such as the bra greatly affected how woman perceived themselves. The future of clothing was full of possibilities for women.

One artistic movement that took hold during World War I was the Dada movement. Defined by their anti-art and anti-war beliefs, the Dadaists used already-established methods of art to increase their movement. This movement was started by individuals who were anti-war and wanted a medium to channel their beliefs through. Although it originated in Switzerland, it was not long before this cultural movement gained a strong following in Paris and New York, among other major cities. Although it is considered an art form, its proponents argued that in fact it was anti-art. While popular, Dada did not gain wide acclaim until after the war was over.

Art in Great Britain stagnated slightly due to the more pressing needs of the war effort. With Vorticism having a small presence, it was mostly foreign movements such as Fauvism, characterized by wild brush strokes and bright colors; Cubism, defined by objects being broken up, analyzed, and then re-assembled in an abstract form made popular by Pablo Picasso; and Dadaism that were popular during the war. The terrors of World War I were not lost on British artists, and many painted in the trenches to

Fig. 16. "On Ne Passe Pas!" is a French poster that reminds the viewer that the French stopped the German military and that it was the French who essentially had told the Germans, "You shall not pass." It was primarily a rallying cry and reminder of how bad the war was, but also of how the French military had eventually succeeded (courtesy Library of Congress).

pass the time. Upon returning home, some of this artwork was published and used to show the human cost of war. The United States was a refuge for many European artists during World War I. Due to the U.S. attempt at remaining out of the war, many felt that this was a safe place to continue their craft. Although many of these artists were from Europe, the general trend of U.S. artists was to move away from traditional teachings from European academies. Those that came and integrated with U.S. artists brought cubism and abstract artwork. World War I also saw the start of controversial pieces being made by American artists in the United States.

Artwork was drastically affected by the start of World War I. France went from impressionist artwork like that of Monet to realistic imagery from the war. Bright, cheerful colors were at times replaced by dark, dreary colors. Bright colors were usually only found when fire and flames were depicted. Imagery also began to remove individuality, which was also a sign of the war. The war was more about large numbers than about the individual soldier. A typical painting showed enough to detail a soldier but not enough to personalize him, such as figure 16.

Music during World War I centered on soldiers and the war. All three countries created hymns, and songs from other genres were used for dance halls and the radio. Soldiers created songs as well, to pass the time and assist with staying in formation. While it is thought that the United States did not use cadences during World War I, it is documented that Great Britain did sing cadences, or songs, while in the trenches. This was specifically true for World War I, which produced many songs based on their current situations.

While French soldiers sang songs and cadences in the field, it was the songs created away from battle that were most popular. Songs about the war and about lost love were listened to. In France particularly, songs created in the United States and Great Britain were translated for civilians. This shows that although there were French musicians, music created by allied countries was also popular. While France translated music, it does not appear that there were many French songs translated into English.

Great Britain created music not only for those in the field but also for those on the home front. Songs based on love lost and the trials that came with supporting the soldiers rang true for many people. Among those who could afford to, music halls and the theatre were still popular pastimes. Classical music still was heard, but hybrid genres were becoming popular. Songs, rather than music without words, were especially popular with young adults who wanted to lose themselves in the music. Soldiers sang cadences that had been adapted to the new conflict but were hundreds of years old.

Because the United States did not enter the war until 1917, much of the music created during World War I was not based on the war but on what was going on in the United States. However, after the United States went to war, song after song was created with the war in mind. Songs such as "Till We Meet Again" and "Over There" were used to show both sides of deploying. "Till We Meet Again" is a song about leaving love, while "Over There" is an upbeat song about what the military were going to do once they got to Europe.

While songs played a large role in everyday life for soldiers, it was the movie theatres where civilians spent much of their free time. This is not to say that soldiers did not also

watch movies when on leave, but leave came so infrequently that movies were not always a priority for soldiers. In the years before the United States entered the war, many wanted longer and more complicated movies to show more of the realities of war. Due to the extent that war damaged France and Great Britain during World War I, the United States gained the monopoly on movie creation. It was during this time of upheaval that the majority of large production companies were formed and started to produce movies. In addition to having more capital for longer movies, these companies were able to hire both established and new producers. Movies started to be full-length (3 hours) versus the previous standard of 18 minutes. This lengthening allowed for a higher admission fee and more controversial films. Films regarding historical events and intolerance were being shown around the United States and Europe.

Although women in the United States were not able to vote, major and independent film companies alike started to hire women producers and directors. Some of these women started as actresses and found they had additional qualities that were beneficial. Lois Weber is considered to be the first woman to direct a full-length film. Due to her concern for women's social issues and her reformist attitudes, her films were mainly dramatic and controversial. Her movies, along with other large production films, were sent to Europe during the war to be seen by soldiers and civilians alike.

Culture changed dramatically with the start of the war. This war was like nothing seen before in scope and destruction. Due to the continuing advancement of film and radio, there was the ability to watch and listen to reports of events faster than ever before. Include the changing dynamics of culture in Great Britain with governmental changes, and this was a period of great sadness and change. The changes that occurred during this time created ripples that were felt during the interwar years.

# 4

# Cavalry

World War I changed both the way countries fought and the way that the public and militaries thought of war. This was due not only to the type of warfare that existed but also to the technologies that were available. The Great War affected countries and people unlike any previous campaign. World War I saw many new weapons, as well as fighting methods. The inclusion of planes affected how the war was fought and also fundamentally changed both military and civilian culture.

War was brewing in Europe during the Belle Époque, and it was only a matter of time before the tinderbox was lit. That match came on July 28, 1914, from Gavrilo Princip, who killed Archduke Franz Ferdinand and his wife Sophie for Serbian freedom. Prior to the assassination, European countries had planned for war with the creation of agreements for mutual assistance in the event of an outbreak of war. These agreements created the Triple Entente and the Triple Alliance. Due to these agreements, the assassination did not create war between just Austria and Serbia but among many countries.

The Germans, using the assassination as a smoke screen, began to gear up to invade neighboring countries. Germany walked though Belgium with ground troops alone. Belgian citizens put up a strong fight, but it was not enough to stop the German war machine. Germany felt that this was going to be an easy conquest and started to enter France. The French were prepared for the German offensive and soon entrenched themselves and the Germans in northern France. Although the French were able to stop the Germans, the government knew that it was going to be impossible to hold the line forever and started to enlist allies.

Great Britain was quick to answer the call of assistance, while the United States attempted to claim the status of neutrality while being anything but neutral. While the United States government officially refused to join the war, many individuals, feeling it was their duty to help allied countries, travelled to London in hopes of joining the war. The French, with assistance from allied countries, entrenched themselves in northern France. The front line that was created between the opposing forces did not waver much during the war. This stagnation from fall 1914 to spring 1918 led to advances in technology in attempts to create forward movement. Among many of the advances was the use of planes for combative purposes, both directly and indirectly.

Both Great Britain and France were using balloons as instruments for observation at the beginning of the conflict. Many planes were being used at this time for private and military purposes. These planes were rudimentary and were used for observation and training.

## 4. Cavalry

Following the start of the Great War, commanders realized that a new method was needed to perform successful military reconnaissance as well as to provide an advanced system for offense and defense. The cavalry, once highly successful, was hindered by terrain and advances in offensive weapons. This resulted in many fatalities prior to the systematic withdrawal of the cavalry. Due to the increased difficulties surrounding observation balloons, France and Great Britain started to employ aircraft for observation purposes in hopes of having an advantage over the enemy. The planes were not used for combat purposes, but it was soon determined that some form of identification was needed to tell enemy from ally. France in early observation missions began to paint small tricolor roundels to indicate national markings. This was done for nationalistic pride and to distinguish French planes from British planes on the ground and in the air.

It was not long before the European powers realized that planes were useful not only for observation purposes but also in active combat against German forces. Guns were placed on the planes along with the observation equipment. Since the weapons were only useful at short range, the attacking pilot could not easily determine the nationality of the defensive pilot prior to attacking. There was no reliable technology at this time to allow pilots to communicate directly, so nations began to fear friendly attacks. Countries began placing large identifying marks on the sides of planes.

Fig. 17. White arrow: An example of early identifying markings is seen on the tail of this French spad aeroplane. This particular plane was used by the United States military forces that fought along with the French military. As the United States did not actively engage their air forces, pilots and crew members relied on French and British planes for missions (courtesy Library of Congress).

## Part Two. 1914–1919: The Great War

France was the first allied country to employ plane markings. The small tricolor roundels that the French painted on observation planes were too small to be seen while in combat. French planes began to be produced with large flags painted in French colors or large roundels that could be seen from a great distance.[1] All of the French designs were basic and in the French colors of red, white, and blue. Another way for the French to identify their planes was to color the tail, as seen in figure 17, a photo of a scout plane that was used to assist the United States take Cantigny near Montdidier in May 1918.

Great Britain soon joined France in marking its nation's planes. Great Britain did not consider the issue as dire as the French did and refused to paint what were considered "flamboyant" graphics on the planes. The commanders instead allowed serial numbers to be placed on the planes. This was extremely useful on the ground, but lacked visibility in the air. With an ever-increasing number of planes in the air, the British began to allow the Union Jack to be placed in varying sizes and locations. Planes during this time were fragile and did not give the pilot a great deal of protection during air combat. A pilot became part of his plane, and they had to act as one to survive. The more comfortable the pilot was in the air, the more successful he could be. Great Britain believed that allowing design interpretation by the pilot created a closer bond with the plane.[2] As combat continued through 1915, the policies began to change in hopes of increasing troop morale.

Great Britain and France began to allow newly formed squadrons to design unit insignia that could be placed not only on the planes but also as patches on flight jackets. These designs were created in hopes of creating cohesion, increased morale, and unit effectiveness. Planes also started to show personal designs. One early example of a plane design personalized by the pilot was a French Caudron bomber. This bomber had the unit insignia located on the tail section and two small imp-like figures carrying either a wand or a bomb.[3]

Designs such as this were rare this early in combat. The allied countries did not start to implement personal designs until 1916. In 1916 allied pilots were arriving back to base with outlandish stories of the aircraft they were attacking. These stories told of planes were brightly colored, some completely painted one or two colors. These were the part of the Deutsche Luftstreitkrafte, the German air force, specifically Baron von Richthofen's *Jagdstaffel* (Jasta) 11. Germany was one of the first countries to allow personally designed plane art.

Other countries allowed the painting of specific emblems and insignia, while the Germans were not as strict with regards to graphic design. The policy in Germany during World War I was similar to that of France and Great Britain. Germany allowed *Jagdstaffel* 11 to break protocol due to the commanding pilots. Oswald Boelcke and Baron von Richthofen were two of the top combat pilots in Germany. German officials, in hopes of maintaining high kill counts, allowed the crews to continue to design their planes. The plane decorations allowed fellow Germans to easily identify them and the designs intimidated the enemy. Soon *Jagdstaffel* 11's planes all sported entirely covered bellies, and distinctive patterns on the wings.[4] Richthofen's plane was clearly visible to his crew and to enemy forces. His Albatros D III plane was painted completely red. Following April 1917, Germany even encouraged artwork to allow for greater bonds between the pilots and the planes.[5]

## 4. Cavalry

Following the rise of German artwork, a subtle transformation occurred in the French and British flight commands. Many planes began to sport personalized identification on the sides of planes. The Germans especially were adapting paint schemes to show personality and create individuality. Many countries had accepted that air combat was the replacement for the cavalry and the pilots thought they were knights of the air. These "knights" painted depictions of nobility such as shields and swords. The British adapted quickly to this belief and presented more chivalric artwork than France. An example of this is the shield with a lion and crown that was placed on a British plane (fig. 18).

Great Britain may not have been the first country to allow personalization of aircraft, but it was the first country to have planes named by the crews. The No. 10 Naval Flight Squadron was referred to by other crews as the Black Flight. This name was fitting, as all the Sopwith triplanes were painted black (fig. 19). All of the plane names related to the

Fig. 18. Many of the images created during World War I that were not simple roundels or stripes were knightly or nationalistic. This image combined the lines on the tail along with the knight on a horse with a shield attacking a black devil-like figure. This is the essence of the "nose" artwork that adorned planes during World War I. Nationalism, patriotism, and images of knights and shields made up the majority of images present (courtesy National Archives).

Part Two. 1914–1919: The Great War

overall paint scheme, such as *Black Maria, Black Death, Black Sheet, Black Roger,* and *Black Prince.*[6] The Black Flight's planes conveyed how the crews reacted in the air. All five of the pilots were British aces, and Raymond Callishaw, the pilot of *Black Maria,* gained the title of second-highest-surviving ace of the RAF.[7] The Black Flight is an early example of the connection that pilots created with their planes. These pilots might have been as effective in stock-colored planes, but the possibility exists that the color affected the abilities of the pilots or vice versa.

France, with an influx of American pilots, also saw a change in how nose art was used. Small groups of Americans travelled to Europe to join prior to the United States' official entry in 1917. These men believed that the United States should be proactive in the war that was threatening allied nations instead of continuing the governmental isolationism. The volunteers were geographically and economically diverse and shared a belief that Germany was a common enemy. The American pilots tended to stay together due to familiarity,

Fig. 19. The Black Flight, the British 10th Naval Flight Squadron, were aptly named for the color of their fuselages. Although each Sopwith Triplane was painted black, it was the individual pilot who named his plane. Names such as *Black Sheet, Black Death,* and *Black Maria* were seen. Raymond Callishaw, the pilot of the *Black Maria,* gained the title of the second highest surviving ace of the RAF. Not only was Callishaw an ace; all of the Black Flight's pilots were. This squadron is a fitting example of how individual pilots connected with their planes (courtesy National Archives).

and France even created American-piloted squadrons. The belief was that since the pilots were from the same country, they already had comradeship.

France created the Lafayette Americaine to handle the influx of American volunteers. The Germans protested the name, stating that the United States was a neutral country and for that reason Americans should not be actively in combat. The French later renamed this squadron the Lafayette Escadrille. Even though this unit wore French colors and uniforms, the Germans closely watched any American who fought against them. France supplied the squadron commander and commanding officers. The planes and plane mechanics were also French. In total there were 5 French officers and 38 American pilots at its conception. In the months following the creation of the Lafayette Escadrille, the squadron suffered many losses. Due to media reports in the United States, there was a steady stream of Americans to replace the fallen. So many Americans volunteered prior to the official entry of the United States that France created the Lafayette Flying Corps. This comprised multiple squadrons of French and American crews.

Great Britain reacted to the increased American volunteer presence in a slightly different manner. Due to geographical location and heritage, it maintained two branches responsible for aircraft: the Royal Naval Air Service (RNAS) and the Royal Flying Corps (RFC). American volunteers were accepted for combat against the Germans by both organizations. These organizations allowed Americans who did not want to join the French forces to still see combat. Americans that fought for the British did not stand out as much as the Lafayette Escadrille on the ground, but in the air these two groups were very similar. The

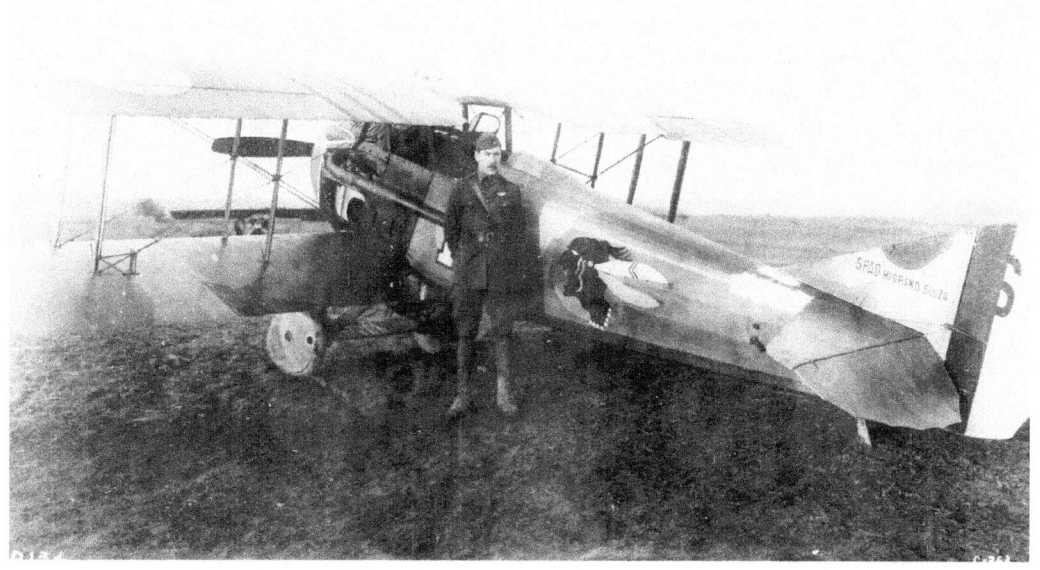

Fig. 20. Wishing to distinguish themselves from their European counterparts and wishing to express their heritage, Native Americans started using their traditional imagery on their planes (courtesy National Archives).

similarities started when France and Great Britain began to allow personalized nose art. The Americans slowly entered the field of nose art, but once the brush touched the plane, the history of nose art changed forever.

The American volunteers' planes initially included small emblems with symbols from the United States as well as host nation colors. This allowed fellow pilots to differentiate planes as well as the pilots to express their personalities. The French wanted to expand on the nationalistic pride that Americans felt for their country. France created the squadron insignia in figure 20 not only to separate this squadron from others, but to strengthen the pilots' purpose for fighting.

This insignia was one that reminded all of the pilots of where they came from and of the fighting spirit that so many in the United States possessed. Many planes sported nose art, even though official policy still restricted certain aspects. Designs were primarily small among the allied countries. This allowed a level of uniformity that many believed was needed in the newly formed branches. This conservatism regarding nose art was effectively rendered obsolete when the United States formally entered the war in 1917.

The United States entered the First World War late and without the combat experience in France that their allies had. The American Expeditionary Force (AEF) wanted to stand out from Great Britain and France, which were thought of as having more established airpower. The AEF commanders perceived nose art differently than their allies did and according to official documents, allowed artwork soon after entering combat.[8] The inclusion of artwork on AEF planes created a new era of nose art that went beyond mostly nationalistic designs and towards more personalized designs. The AEF also used artwork to set itself apart from the other countries. Having come in three years later than the rest of the countries, the AEF felt it had something to prove and wanted to prove it quickly. The audacity of the artwork painted by the AEF shows the cultural differences between Britain, France, and the United States. Pilots painted just about everything on the sides of the planes, but a general trend shows. A large percentage of nose art produced by the AEF were historical images that reflected the United States. These designs came straight from U.S. collective memory. It was not uncommon to see totem motifs, bison, and Uncle Sam adorning the sides of planes.[9]

Pilots who had a strong affinity for the United States also added American colors such as starburst patterns radiating from the official insignia. These designs provided a reference to home and showed their pride in their home nation. Not long after the AEF arrived in France, the command allowed pilots to design unit insignia. The command allowed for artwork in an attempt to distinguish their planes from British and French planes. In addition, certain commanders understood that AEF pilots were far from home and wanted representations to remind themselves of home. These designs showed the individual personalities and group dynamics of a unit. Both unit and individual plane designs were created primarily to show personalization, as well as for patriotic reasons.

Countries such as Germany and the United States understood that to increase combat effectiveness and survivability, a connection between the pilots and planes needed to exist. This connection translated to personalization of the planes to make the pilot comfortable

while still maintaining a level of uniformity. When countries provided room for the pilots to personalize planes and insignia, it placed an expression of the pilot directly into combat. The relaxation of policies regarding nose art led to a heightened sense of duty. This increased sense of duty showed an increased level of maintenance on personalized planes.

The personalized designs on planes varied between countries and specifically between pilots. Designs reflected the heritage and personal beliefs of the pilots and crew. Many pilots during the early years of the war were from wealthy families that still believed in Victorian morality. Therefore men and especially women were modest and proper. Due to these cultural and moral beliefs, few women adorned the side of planes. The women who did were mothers or wives and the painting was respectful and consisted mainly of the woman's name. These simple reminders of the women in the pilots' lives were consistent with the other reasons for nose art.

Humans by nature are superstitious. Pilots were no exception and projected this superstition in artwork. Planes during this time were fragile and prone to accidents. Pilots understood the risks and acknowledged that their lives could be cut short at any time. Due to the inherent dangers of flying, pilots painted imagery in response. Imagery encompassed two themes: mortality and survivability. Paintings about mortality were primarily of skulls and other representations of death. The pilots were not painting skulls to accept death, but as a reminder that every time the plane left the ground, death was possible. The skulls and other related paintings were also created to instill fear in enemies upon seeing the designs in the air. The idea was that if the enemy was scared, it might allow extra time to either escape or gain the upper hand.

Survivability was as important to the pilots as mortality. Many AEF pilots included animals that were thought to have good luck properties. Other creatures and emblems that carried mythical properties were also included. The most commonly represented animals were bucks or dogs. These animals are graceful while still aggressive when needed, which is how pilots thought of themselves. Emblems such as four-leaf clovers and good luck charms were added to enhance a positive atmosphere around the plane. What was missing from most planes was any religious iconography. This is particularly interesting, because the general population felt that to be flying was to be closer to God. Whether it was that pilots possessed more superstitious beliefs than ground crews by nature, or that due to their nature the combat pilots wanted all the assistance possible, is questionable.

Due to the nature of World War I and to the inclusion of planes, it was natural that each country took time in determining how to approach the ever-growing desire for artwork. Planes, still being unknown, caused nations to begrudgingly allow what was considered a violation of official policy. The countries began to adapt policies to accommodate the increase in personalized artwork while still maintaining a level of uniformity. When the war ended, things both in the military and civilian life changed drastically.

# Part Three

# 1919–1939: Lull in Fighting or a Continuation?

# 5

# The Roaring and the Depressed

Soldiers returned home in large numbers, expecting little to have changed. The world they returned to, however, was very different than the one they had left, which initially caused many issues. The major changes that were seen by soldiers in all three countries were in the ways that families lived, in clothing, and in art. Both the war and interwar years saw cultural changes. Some of these changes started during the war. Major cultural changes occurred once the soldiers returned home. Life never returned completely to "normal" for the soldiers due to the cultural changes that occurred during the war.

The United States experienced different levels of cultural change than Great Britain and France. The United States prior to World War II gathered cultural cues from France and Great Britain. During the war the United States culturally began to distance itself and to adapt on its own. Following the war, this cultural gap became wide. Artwork and specifically nose art stand out as two genres that experienced the most differentiation between Europe and the United States following the war. Women played a large role in separating the United States from its European counterparts. In the United States, women began to attend colleges and universities during and preceding the war. In Europe, women had already been attending institutions of higher education. Women wanted to expand their individual spheres of influence and enhance their personal and professional enjoyment. Women upon graduation were slowly accepted by employers and began to enter professional careers. This allowed women mobility that had previously been unattainable for the majority. Women could afford things for themselves and families. This professional mobility and education level resulted in an increase in divorce rates and a decrease in birth rates. The start of World War I caused a decrease in the United States divorce rates. With many men gone, women were able to live the lives they wanted to and remain married. When the war ended, reality set in for many women.

Many women who worked outside the home during World War I were forced to leave their jobs when soldiers came home. Many had the cultural belief that women worked in the home while men worked outside the home for the income. This belief, however, was slowly changing in large cities, where groups of women refused to stand down from their positions and demanded equal rights, including voting privileges. This created uncertainty in men who upon returning from war found female family members working outside the home. These relatives' fighting for equal rights created increased uncertainty.

Women who during the war were serving in military-type jobs also returned home.

# Part Three. 1919–1939: Lull in Fighting or a Continuation?

While some men at the end of the war were able to stay in the military, women were not. All of the small differences began to combine, and women decided that with more rights should come more freedom. This fight for independence may have started prior to World War I, but due to the war it was pushed aside. Following the war, women were determined to have more rights, and the fight for greater independence was renewed. The fundamental right that women wanted in the United States was the right to vote. To fight for these rights, women began to gather. What started as small group protests soon turned into large ones. These protests reached such a level that police were soon forced to arrest and in some cases jail female protesters. The arrests were an attempt to persuade women to return to their homes and forget the independence achieved during the war. The women refused to stop, and the jailing only expanded the reach of the movement. Nothing official was done until President Woodrow Wilson began to urge members of Congress to review their beliefs on women's right to vote. The result of President Wilson's request was that the Nineteenth Amendment, ratified in 1920, prohibited state and federal agencies from restricting the act of voting by gender.[1] The women who fought for these rights rejoiced in this decision. A lot of women felt that opportunities that were available during the war should be available

Fig. 21. Women's ability to vote was not just a personal decision but a decision that many men fought to control. This political cartoon shows how money, combined with the attitude that women should be at home caring for children, essentially ensured that women would not vote (courtesy Library of Congress).

again. France and Great Britain also experienced movements following World War I regarding rights of citizens. Even before the war there were many who disagreed with women gaining the right to vote, as shown by a cartoon from 1909 (fig. 21).

France, directly following World War I, was affected by a high death rate. The war was following by an outbreak of the Spanish Influenza, which ravaged the world from 1918 to 1920. It is believed that this strain of the flu arose partially due to World War I and the close proximity of soldiers who already had compromised immune systems. This flu affected not only France but the entire world, including island chains. These casualties affected the workforce and culture of France. With the high death rates caused by war, many women were able to stay at wartime jobs. France maintained a small workforce without a high possibility of large expansion. Economically, France was never able to entirely recover from the combination of decreased economic growth and a decrease in the franc. Socially France was beginning to stumble. Women in France had more rights prior to World War I than of American women. Women in France therefore did not fight for voting rights or freedom from prejudice. What the women were fighting against was the push from the French government of a pro-natalist agenda to ensure a future full of prosperity and wealth. High birth rates contributed to French wealth by creating the ability to produce large armies, colonize foreign countries, and have enough workers to man industries.

With the exception of a slight spike directly following World War I, France experienced very low birth rates during the interwar years. In the late thirties it was the French government's idea that if more French women gave birth, France would succeed in the long term. The majority of French women, however, did not take kindly to being told that all of their hard work in the fields and warehouses amounted to nothing to the government. The only thing that the government wanted was the birth of a child. Due to the expansion of freedom and independence for women during World War I, it became very hard for the government to persuade women to increase the birth rate exponentially prior to the start of World War II.

Great Britain experienced similar some culturally troubling times following World War I. Soon following the war the British suffragettes gained the right to vote. This was also during the time that many companies that were owned by the government experienced worker strikes. These strikes were similar to worker strikes happening in both France and the United States. Workers in the United States and allied countries "wanted higher wages, shorter hours, and better working conditions."[2] Rather than directly addressing the issues caused by the strikes, the British government sold most of the companies to private parties. This released the government from liability. It was the government's hope that with all of the companies being run by independent groups of investors, strikes would end. Another hoped-for side effect was that the economy might soon rebound with private companies having complete control.

The selling-off of companies just created a band-aid for what really ailed the British work force. It was not long before workers, specifically miners and rail workers, began to strike again. The government was quick to stop the strikes and imposed regulations against sympathetic striking. During this industrial upheaval the government was facing strong

## Part Three. 1919–1939: Lull in Fighting or a Continuation?

criticism regarding domestic policies. The British government was starting to gain momentum with the election of 1929, when the Depression began. The onset of the Depression threw the British government into confusion. During the remainder of the interwar years, Great Britain's government continued to modify small things in hopes of resolving the current economic situation. Great Britain hoped a rebound of the clothing industry would prop up failing economic sectors.

Clothing designers prior to World War I were mainly male, with some influential women working in the field. It was during the war that many women looking for employment started in the clothing industry. Women soon began to influence designs. This increase of women in the clothing industry helped to change the face of fashion following the war. Citizens were beginning to have money for clothing. This clothing needed to suit the women and men of the 1920s. This demand for clothing, along with feminine inspiration, affected the fashions of the twenties and thirties.

During World War I, clothing in all three countries was drab and useful. The years following the war saw an explosion of color. This change in color was twofold: the war was over and many wanted to celebrate by wearing bright clothing. In addition, women returning home were able to wear brightly colored clothing without ruining it. Color played an important role following World War I. Color affects attitudes and emotion. In addition to changes in color came a change of the style of clothing. During the war, many dresses were fitted, had high waists, and had a minimum hemline of mid-calf. After the war the flapper dress began to gain popularity. This style gave women a sense of equality. It was no longer what men wanted them to wear, but what they wanted to wear. With a very low waist and a straight appearance, women's clothing started to gain masculine qualities. Top it off with restricted breasts, lack of waist, and the new bob hairdo, and this was the style of the roaring twenties.[3] The bob hairdo was another shock to men. Hair previously had been considered a treasure and was one of the first things looked at to judge a women's wealth. Now women from all socio-economic groups were cutting their hair short and enjoying it. These styles remained popular until the United States stock market crash of 1929. The crash revolutionized more than just hair length.

Prior to the economic crash, many clothing manufactures were still promoting the prewar ideal of changing clothing multiple times a day. This not only brought in additional revenue but also gave designers and manufacturers more diversity in clothing styles. The three staple outfits for any man or woman were day, evening, and sport. With the crash it was soon realized that patrons did not have the money to continue to buy three sets of clothing. Many clothing stores began to go out of business, which forced the industry to adapt to the economic crisis or risk total failure. The way they adapted was to create outfits for women that could easily work both during the day and evening with the addition of a shawl or different shoes. To do this, a change had to occur from the flapper-style evening dresses of the mid-twenties.

Feminine styles changed to a cross between pre–World War I fashion and the flapper styles of the 1920s. Not to change the styles drastically, designers began to pair thin silhouettes from the twenties with slightly longer lengths and wider skirts. This process was

## 5. The Roaring and the Depressed

by no means drastic. It was not until 1932 that women's clothing started to clearly show the flowing skirts that remained popular until the late thirties.

The 1920s fashion was the decade of rebellious women. The 1930s were sometimes divided into two periods: the stylish and glamorous early 1930s and militaristic late 1930s,[4] in reference to the forward-moving fashions of France and the United States. Wasp waists and bias cuts gained acclaim for the feminine appeal and figure both styles created. This was not the first time that bias cuts had been visible, as many styles during the Edwardian era were created using similar methods. What set the thirties bias cut apart from previous cuts was the lack of multiple layers of fabric. Many times the '30s bias dresses consisted of only one or two layers and created the ability to show off a suntan, which resulted from the increasingly popular pastime of sunbathing.

Following the end of the war, many factories could return to their original function of private clothing manufacturing. This produced many advances in the types of cloth used by designers and seamstresses alike. The adaptation of the zipper to mainstream use by Elsa Schiaparelli revolutionized the way that clothing fit the body and added a novel addition. Schiaparelli's clothing line became extremely popular among women in the '30s. Her styles ranged from designs inspired by Salvador Dali to the "little black dress." Towards the late 1930s, her creation of a tailored suit became preferred over the feminine wasp-waist dresses.

This change in clothing was not specific to women's clothing. Men's clothing also adapted to the economic and social changes of the time. Men's clothing by design changed very little during the war. Slight changes in arm length and collar type were seen following the war. In the mid twenties men's fashion began to shift to more casual clothing with a relaxed fit. Sport clothing for men shortened to knee length, and the legs widened to create a balloon shape. The thought was that with this relaxed fit, men could participate in sports that were hindered by tight, long pants. Men's shirts and jackets also adapted to the new lifestyles of the wearers. When the stock market crashed, men's clothing designers adapted much as women's clothing designers did. Designers, realizing that men were not going to change clothing multiple times a day, drifted to clothing that could easily be adapted to more than one situation. By adding accessories, men, like women, could go from work to dinner out without returning home and changing. This not only decreased the amount of money that families spent on clothing, but also kept many companies from going out of business during the late twenties.

While accessories were being added to clothing, cloth was being taken away from some styles. The bathing suits in the United States during World War I were lengthy and made of heavy fabric. Modesty reigned over comfort, and both men and women wore suits that covered a large percentage of the body. Prior to the twenties, bathing suits consisted of large skirts and were full sleeved. The increase in women who wanted to participate in sports forced the suit to adapt to a form-fitting wool suit that was sleeveless and extended to the mid-thigh, as seen in figure 22. This style was an adaption of the male bathing suit of earlier generations. Some fashion-forward designers began to create bathing suits with cutouts in the late 1920s.

The bathing suit saw real change during the thirties. The leg length shortened and at

Fig. 22. This image depicts what was perceived as a radical change to the style of women's bathing suits. This image shows three young women following a swim race. Revolutionary at the time, these bathing suits allowed more movement of the neck, arms, and legs than previous styles (courtesy Library of Congress).

times ended on the hip. In addition to smaller one-piece bathing suits, the two-piece suit was created, which revealed a bare stomach. This two-piece suit was the predecessor to the modern-day bikini. This bathing suit changed the way that women saw themselves and that men saw women. The bathing suit continued to adapt to cultural changes. This change to clothing was seen on the side of planes during World War II.

The United States was not the only country dealing with postwar clothing changes. France barely scraped though the war; the leader in designer clothing strove to maintain its level of exportation and prestige following the war. It was not until the World's Fair in 1925 that French fashion began to shine again. The fair was held in Paris and gave local designers the chance to show new designs. These designs consisted of simple lines and rectilinear forms. The other two creations that came out of the Paris World's Fair were petaled hemlines and Madeleine Vionnet's dress designs. Vionnet created dresses that rivaled those produced by Chanel and other couture designers.[5] Because of her late emergence into the fashion field, her designs were not touted as being of the French couture culture. France began to market two clothing additions that every woman needed to have. French designers favored the hand-sewn ornate beads that were placed on chemises and undergarments. These chemises were sold as couture and mass marketed. Stockings were another addition that French designers placed heavy emphasis on. While lace and other silky fabrics were used in the creation of stockings, it was stockings made of rayon that were marketed heavily. Rayon, while created in the late 1890s, did not gain popularity until the 1920s.[6]

While France once again claimed elite fashion status, Great Britain's fashion industry stagnated following World War I. Due to the economic woes in which Great Britain was embroiled, many designers moved to France in hope of gaining notoriety and prosperity. For that reason many couture shops closed and fashion in Great Britain moved towards mass marketed, mass produced clothing. The styles that were being created came from two main sources: reproductions of French styles and local designers who chose to stay in Great Britain. There was very little variation between styles produced in Great Britain, France, and the United States. This added to the overall impression that the Roaring Twenties encircled the world.

The Roaring Twenties extended past clothing and into the realm of entertainment. The twenties were a decade of conflicting thoughts and actions. The young generations began to create a culture separate from that of their older relatives. This at times ran counter to what the older generations believed in and strove to maintain. Music, literature, movies, and art were affected by this younger generation in the years following World War I. The most noticeable change during the years directly following the war was in music.

Jazz, with roots in New Orleans, and the blues, coming out of Harlem, transformed how music was played and listened to. With many previous types of music, the idea was to either listen to the music or to dance to it. Jazz and the blues were more about the soul of the music and what music did to a person. These two types of music really were the start of a cultural transformation from instrument-heavy to vocally heavy music. This shift was not without conflict, as this music was considered the "Devil's music" and was not music the wealthy class should listen to.[7] As in other cultural shifts, the younger generations pre-

vailed, and these two music genres became a main part of U.S. culture during the twenties and thirties.

In the thirties another type of music started to be heard on the radio and in dance halls. Big bands started to gain popularity with younger generations, which led to new forms of dance. These dances were considered risqué by many and were even banned in some locations. Older citizens of the community did not want their children to be influenced by the big sounds and the new dance styles. These citizens also believed that this was only a phase that might last a couple of years before a new trend caught the young generation's attention. This was not the case, and the big band sound continued throughout the twenties in two countries. France's musical evolution was not as sudden as the United States'.

French citizens continued to listen to classical music during World War I, as well as opera and regional folk music. During the 1920s a new form of music emerged on the French musical scene: Rai, a type of music brought to France by way of Algerian settlers relocating to France. This genre was a blend of rural and urban Algerian sounds that slowly gained recognition in France in a few regions before World War II. Jazz during the '30s did not gain status in France, but in Great Britain jazz was influential on local artists.

With an increase in urban populations, established dance and music halls started to tweak their music to entice the younger generations. Starting in 1926, British dance bands adapted big band jazz to suit British patrons. As Great Britain already had a longstanding tradition of musical rhythm and style, many artists maintained traditional sounds while adding jazz undertones. Many of the musicians that were successful in the twenties and thirties continued on during the war to entertain troops in major British cities.

Harlem not only affected music but also literature in the 1920s. The United States during the 1920s underwent a literary change. African Americans were moving from southern states to live in northern cities. This migration, combined with the young generation's attitudes towards change, allowed many African Americans to venture into the entertainment field. Harlem writers began to enter the literary field to much acclaim. These individuals wrote poems and books that used both realism and surrealism. This was not the only era of literature that occurred prior to World War II in the United States.

The Lost Generation, or according to the French "une generation perdue," were bohemian individuals who rejected the old ideals and culture directly following World War I. The writers in the United States felt that the war had shattered the tightly held belief that if you attempted to succeed in life, good things would happen. Many of the soldiers returning home injured in one form or another turned to writing to ease their feeling of despair. In the United States the Lost Generation was full of artists who hoped to by writing ease some of their pain. Other writers upon picking up these emotions from neighbors and relatives began to write prolifically. F. Scott Fitzgerald and Ernest Hemingway are two writers who effectively took the pain and were able to criticize the American culture of the 1920s.

French and British literature did not undergo such a drastic change during the 1920s. Great Britain, having gone into the modernist period prior to World War I, was not drastically affected. What did change was who the authors were and what they stood for. Many soldiers upon returning home took up paper and pen to express all the images seen and

## 5. The Roaring and the Depressed

emotions felt during the war. During the 1920s there was an increase in poetry and novels that were directly taken from personal experience. This continuation of battle scenes and pain opened fresh wounds in an already torn country. These novels also allowed the general public to experience some of the events that had occurred and eventually helped Great Britain heal following World War I. Not unlike in France and the United States, surrealism was used when realism was not necessary or not pleasant.

France writers deeply connected with both surrealism and existentialism. These two genres assisted French writers to express the pain, outrage, and overall disbelief in the government and events that had transpired during the war. Surrealist poets and authors paid particular attention to dreams and how dreams related to the conscious mind. It was during this time that ideas regarding the supernatural were more freely talked about. Many surrealist writers went so far as to look into and write about divination.

The French were also known for their movies during this time. Movies gained acclaim in France when other forms of art did not. The movies were the place to be on the weekends. With the advancements in the film industry, the quality and quantity of movies exponentially rose in the 1920s and 30s. An increase in documentaries along with the inclusion of simultaneous sound paved the way for a complete revitalization of movies among all socio-economic groups. Popular genres in France and Great Britain were the biopic and the musical. Mainly these movies showed a popular figure in a movie with an uplifting moral message. It was not long before these genres crossed the Atlantic.

During the 1920s movies in the United States followed suit with those of Europe. Movies about Abraham Lincoln along with figures of French and British ancestry ruled the film houses. In the 1930s, however, movies went away from strict biopics regarding famous figures to those depicting events such as World War I or the colonization of foreign lands, such as *All Quiet on the Western Front*, based on a book of the same title that was published in 1929 by a German veteran of World War I (fig. 23).

These movies were extremely

Fig. 23. A popular movie of the time that depicted the First World War was *All Quiet on the Western Front*. This movie was based on a book by the same name written by German veteran Erich Maria Remarque, published in 1929.

## Part Three. 1919–1939: Lull in Fighting or a Continuation?

popular, as they romanticized the nature of the European men on these colonizing missions. Due to this popularity, scenes of far-off lands were depicted in books and paintings during the 1930s.

Another element not seen in films until the thirties was the depiction of woman as sexual figures. This sexualization was primarily seen on United States and French screens, such as in the use of scantily clad women as backdrops to the real theme of the movie. With the acceptance of tighter-fitting clothing with less cloth, directors began to market to one demographic. Even movies that did not have explicit sexual content had posters that enticed viewers, such as the poster for *The Sin of Nora Moran* (fig. 24).

This marketing approach became more important as the film industry grew. The clothing and attitudes in movies influenced written works, and vice versa. This sexualizing of women carried over strongly to World War II and the artwork that was placed on planes.

Another element that assisted in the production of nose art was the thriving art industry during the 1920s and '30s. The younger generations, feeling that older generations' artwork was outdated, began to usher in an era of post–World War I Modernist artwork. Modernism developed between the two world wars in two distinct periods. The first began during World War I and the second starting in 1930. The first generation of Modernism expanded in Europe following the war. Surrealism jumped from the written page into art communities. Beyond Surrealism, there was the expansion of Cubism, Dadaism and other forms of Modernist imagery.

Modernism was at first looked upon negatively, and many places refused to show art in that style. Two well known

Fig. 25. During the Spanish Civil War planes were a common sight. To promote a new generation of pilots and air crews, posters were commonly seen regarding glider clubs. These clubs trained young men and later women to become pilots (courtesy Library of Congress).

Surrealist painters, Salvador Dali and René Magritte, chose two completely separate paths for Surrealism in art. Both were at first shunned for their artistic beliefs, but as the '20s continued, a new fondness for Surrealism grew in Europe. The second generation of Modernism incorporated more Cubism and less color. Dali was very colorful, but modernist paintings of the '30s showed slightly less color and more contrast. The nature of the paintings also changed as signs of war were being seen in Europe. These paintings went from a look at the juxtaposition between the real and imagined to a look at life and death.

Although Surrealism gained acclaim in art communities and assisted in the development of future art eras, it did not transition very well from canvas to metal. In the Spanish Civil War there were little if any Surrealist paintings adorning the side of planes. Most of the artwork was similar to that of World War I. It was not until World War II that a scant offer of surrealist paintings were seen flying high. A possible reason for this was that art on a wall produced a vastly different response than artwork on a plane. Artwork on a wall was static and was created by one or maybe two individuals working together. Artwork on a plane was fluid, and created by entire flight crews. Art on a plane was not going to be placed on a wall to be looked at. It was going to be shot at, damaged, repaired, and otherwise altered during the life of the plane and crews.

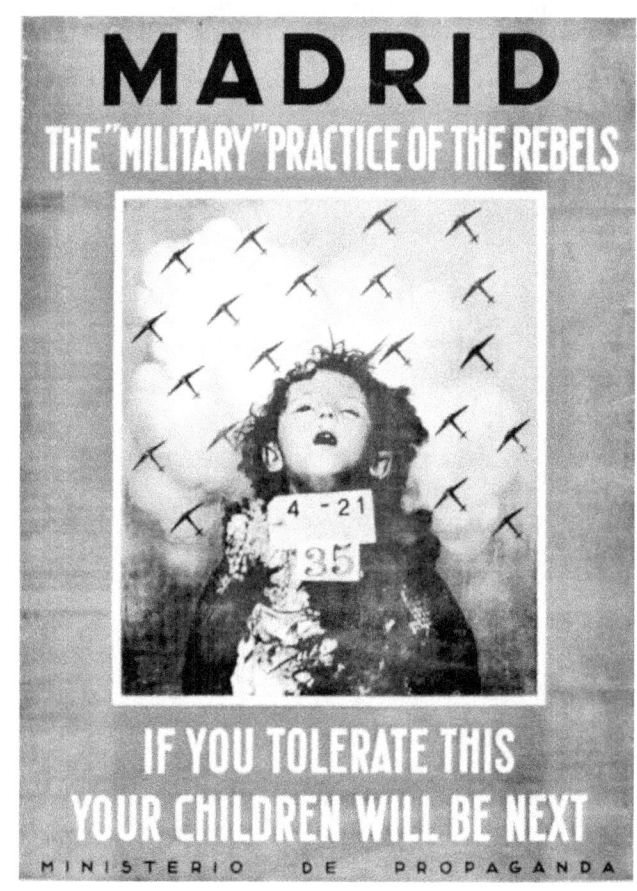

Figure 25 is representative of the art of its time as well as of propaganda during the Spanish Civil War. This image, with its title "Spanish Youth Should Practice Gliding," shows that planes were becoming an important part of conflicts.

Not all propaganda that was published during the Spanish Civil War was artistic or uplifting. There were political cartoons and propaganda that showed the more grim side of the conflict. This was specifically true for the Spanish government in its attempts to

Fig. 26. This is one of the more graphic images that came out of the Spanish Civil War. The Ministry of Propaganda created this image of a deceased young child with a body tag, with small planes in the background. This poster was meant to incite rage and increase enlistment (courtesy Library of Congress).

## Part Three. 1919–1939: Lull in Fighting or a Continuation?

sway public opinion away from the rebels. It also should be noted that the Spanish used images that pushed the boundaries of what was acceptable. Figure 26 shows this practice, as well as how influential planes had become in combat. In fact, many images created during the Spanish Civil War had some form of plane included. The United States commonly used death to prove a point, but never to this extreme. This was not the first and sadly not the last time that countries used horrific imagery to push an agenda. This type of imagery was used to shock individuals into doing something, be it rationing, enlisting, or sending money. The Madrid image was to shock the viewer into supporting the government regardless of what the rebels said.

The three countries were ready to stand on their own feet and declare that the effects of the war were gone. When that time came, however, Germany and Italy were ready with open arms to start the fighting again. This shook some fundamental beliefs about what war stood for and what it meant to fight for good versus evil. Young men upon hearing stories from their fathers were not necessarily inclined to join the military ranks, but when the country called, they answered. The United States was afforded the luxury of sitting back and watching the war build in Europe. It was not long, however, before the United States needed to make a decision regarding draft versus enlistment. Throughout all the disagreements and complaints during the early years of the war, nose art stood steady. World War II exemplified what the heritage of nose art meant and the emotions the paintings invoked.

# 6

# Mickey and the Gang

World War I ended, much to the relief of all affected countries' governments and militaries. Several of the allied countries wanted to believe that this had been the final large conflict of modern society. World War I began to be called the Great War and the War to End All Wars. The French and British militaries returned home to regroup and assess losses and begin to think about what form they should take in the future. As many of the countries did not foresee combat occurring in the near future, military forces were cut and men returned home as civilians. These decisions by France, Great Britain and the United States did not drastically affect military nose art.

Great Britain and France suffered much more than the United States during the war. While the European countries were forced to rebuild after the war, the United States was much less hampered with regards to experimentation and invention. This allowed the United States to explore how advancements in plane technology could benefit it during peacetime. Inventors and the government, however, remained mindful of possible aggressors and still considered wartime applications. Companies that built planes during World War I started to experiment with planes that could fly higher and faster and carry more weight. Both established and new companies started to dabble in civilian aeronautical applications. With a large inventory of World War I planes being sold off cheaply, and lots of pilots who knew how to fly them, commercial and recreational aviation skyrocketed.

Not all aviation invention stopped in Europe following 1918. France's war costs resulted in economic problems that made it hard for the government to justify spending large amounts of money on military aviation. Instead resources were diverted to the civilian sector. Yet it was still important for the French military to maintain an operating combat force for its colonial responsibilities and to thwart foreign aggression. Eventually the process of aeronautical research, development, and invention slowed after World War I.

Great Britain's economic situation fared slightly better following World War I. It had more wealth and therefore was able to continue plane development and production. This allowed for new planes made out of modern materials to be ready for when combat was needed. The main inventors in Great Britain worked on new frame designs and materials and also engine and wing design. Britain also began to train individuals to pilot these new plane models. This gave Britain a fighting force in case another conflict started. This, along with the U.S. advancements, placed France at an aviation disadvantage.

All of this preparation and training was soon utilized with the start of the Spanish

## Part Three. 1919–1939: Lull in Fighting or a Continuation?

Civil War. The Spanish Civil War started in 1936, and many countries of the world began to support the opponents.[1] France, Great Britain, and the United States were just 3 of more than 56 countries that fought for either the Republican or Nationalist parties. France not only actively engaged the enemy in Spain but also imposed embargos against the Nationalist combatants. Countries outside of Spain could not require individuals to fight, but many volunteered from France, Great Britain, and the United States, for both ground and air service. The United States, France, and Great Britain saw many World War I air veterans returning to combat. This was a chance to fly and fight that was unavailable to most in their home countries. These individuals brought their experience of aerial combat to the conflict, and brought nose art on their planes.

Nose art had been evolving since the end of World War I. These changes resulted from both the euphoria following the end of the war and the cultural changes that occurred during and after World War I. During World War I, nose art was primarily nationalistic as well as having elements of personalization. Most of the art was directly connected to the pilot or flight crews. Many paintings naturally showed strong nationalistic characteristics. This nationalistic attitude can be attributed to the unprecedented scale and scope of the

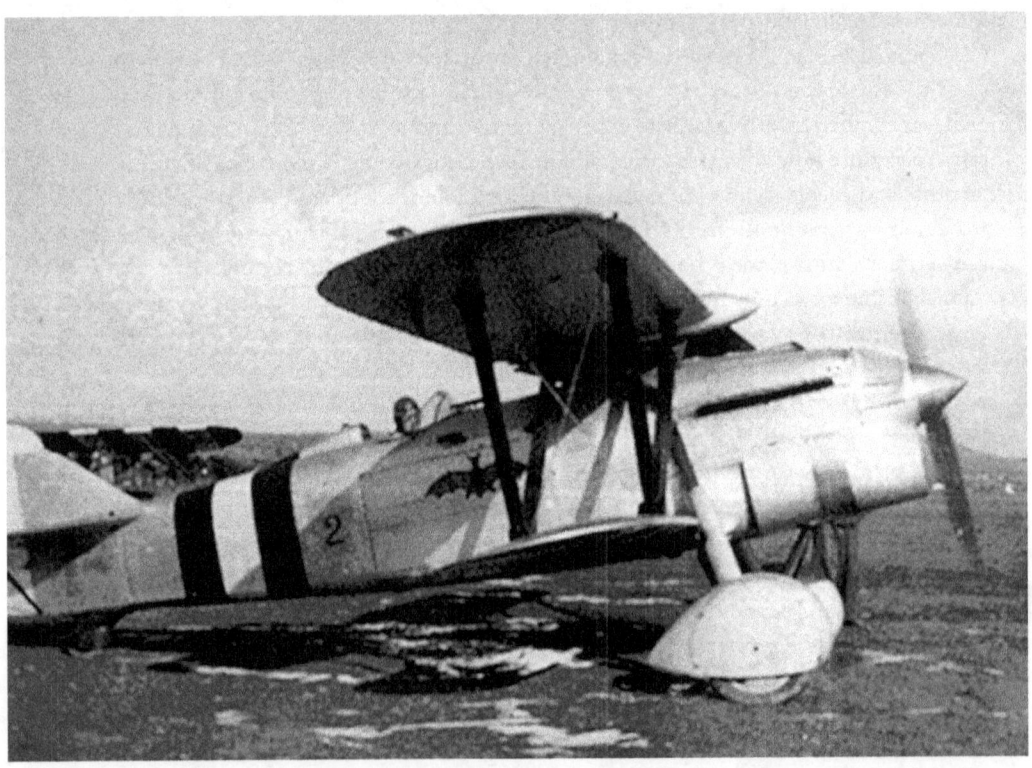

Fig. 27. Common image seen early on were bats and other animals. Bats specifically were thought of as a totem animal and would assist the pilot during flight. Entire squadrons had bat motifs on the side and nose of their planes (Fiat CR 32, Collection T17/33, Air Force History Office).

conflict. Many pilots were volunteers coming from a wide variety of locations in the United States and Europe. With such a wide variety of backgrounds and religions, the only thing many had in common was their country of origin.

A slight change occurred to nose art during the Spanish Civil War, though this change went relatively unnoticed until the start of World War II. During the Spanish Civil War two new themes began to be seen in aerial combat. The first was the increased usage of camouflage. Planes created during World War I were made mostly out of wood and cloth. Initially, weak anti-aircraft defenses and limited air-to-air combat slowed the evolution of camouflage during World War I. During the Spanish Civil War, most planes were camouflaged in one fashion or another. The camouflage usually consisted of a colored pattern that matched the terrain the pilot was assigned to fly in. The patterns were chosen for two reasons: The main application of the airplane was in support of ground combat operations. Planes were also increasingly used for aerial combat missions. While not highly personalized like nose art, camouflage still produced the effect early decorators wanted, a way for fellow pilots to distinguish one plane from another in the air. For that reason not all of the camouflage patterns were the same, and some pilots chose to change their color scheme slightly to enhance the difference.

The second theme that was seen during the Spanish Civil War was a change to the nose art itself. Nose art began to show images that were symbolic as well as personal. The personal paintings were similar to World War I, with names of family members, or personalized nationalistic symbols. The popular paintings of good luck charms carried over nicely from World War I onto new planes. There were instances when the nose art was actually the emblem for a squadron. The Italians used a bat to represent the Majorca (fig. 27).

Decorative paintings also began to appear that did not have any personal significance to the pilot or ground crew. A small number of artists volunteering for military service were hired by ground crews and pilots to create and paint designs. It was at this point that nose art started to move away from being necessary identification to being an artistic expression. This trend of having artists assist in the creation of nose art was minor during the Spanish Civil War. This was due to the Spanish Civil War's being a minor conflict and not total war, as was World War I. In addition to artists being commissioned, a growing number of individuals started to take images from the entertainment fields. This was a way for individuals to stay connected to the civilian world while actively engaged in combat.

One such example of artwork being taken from the movie screen was in the example of a young individual who drove ambulances at the end of World War I.[2] During downtime, he drew cartoon images of animals and fantasy characters. His artwork gained popularity with many soldiers. Many soldiers were able to escape the war when reading or viewing the cartoons. Upon returning to the United States, this individual began to market his creations. While working for art studios, a chance finally came along to create a character that soon became very popular.

In 1928 the cartoon character finally hit the big screen in *Steamboat Willie*.[3] By the start of the Spanish Civil War, Mickey Mouse was one of the most popular cartoon characters in the United States. During the Spanish Civil War, Mickey was seen on planes fight-

Part Three. 1919–1939: Lull in Fighting or a Continuation?

Fig. 28. It wasn't long before Mickey Mouse started to adorn the sides of planes. During the Spanish Civil War, Mickey could be seen on both sides, waving a gun at times. This entire German squadron had Mickey on the side along with a name on the nose (courtesy National Archives).

ing for both sides. Figure 28 shows Mickey sitting on the side of a German Bf-109 D-1 fighter.

It wasn't just Mickey Mouse that got some creative freedom. From the Spanish Civil War continuing through Vietnam, multiple Disney characters were immortalized on the side of a plane. Although Mickey was the frontrunner, Bugs Bunny saw an increase in popularity and therefore fuselage space, such as in this example of Bugs Bunny from World War II's European theatre (fig. 29).

Another element of popular culture that gained popularity as nose art can be seen in the translation of newspaper and magazine photos onto the side of planes. During the interwar period, women played an increasing role in the media and in the entertainment field. Planes started to sport images of women that came from calendars and even playing cards, but it was during World War II that this theme really took off.

While the Spanish Civil War raged, further crises engulfed Europe. Adolf Hitler began to gain power in Germany starting in 1930 and officially became the chancellor in 1933.[4] He and Benito Mussolini of Italy began to discuss retaliation for what they believed were injustices suffered during World War I. Mussolini believed that Italy should have received more for wartime sacrifices during World War I. Hitler on the other hand blamed weak Germans, and especially Jews, for the loss of the war. Hitler and other German nationalists

## 6. Mickey and the Gang

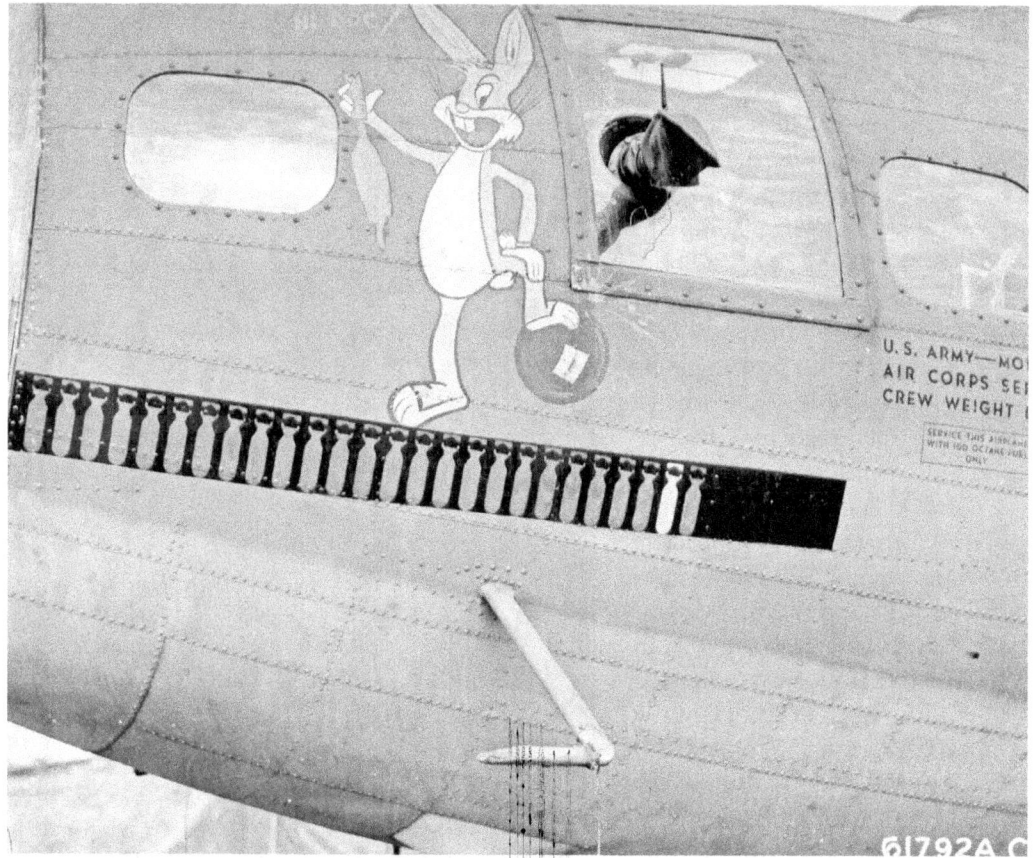

Fig. 29. Mickey Mouse was not the only Disney character that made its way to the nose of planes. Bugs Bunny was also seen fairly regularly on planes, especially during World War II. Usually he was dropping a bomb on Adolf Hitler or acting up as only Bugs could do. In this image from the 303rd Bomb, which was stationed in Europe, Bugs Bunny is seen eating a carrot and waiting to drop a bomb, with his trademark saying "Hi Doc!" (courtesy National Archives).

believe that the "War Guilt Clause" and the concessions that Germany was to pay with the signing of the Treaty of Versailles had to be undone. These two individuals together were determined to transfer the balance of power in Europe.

Benito Mussolini gained power as the leader for the National Fascist Party and was elected to the Chamber of Deputies in 1921. In 1922 Mussolini and his Fascist Party marched on Rome.[5] This march resulted in the prime minister being removed and King Victor Emmanuel III appointing Mussolini as prime minister. Over the next two years Mussolini slowly gained more power. He was now for all intents and purposes the dictator of Italy. For the next decade Italy created an Italian empire and gained power and wealth.

During the Italian expansion campaign, Adolf Hitler strove to overtake Mussolini in many aspects. Hitler soon gained supporters and began at first to slowly dispatch his enemies and those he saw as enemies to the Aryan voice. These people included intellectuals,

the disabled, and specific religious groups. In the years between gaining power and the invasion of Poland in 1939, Hitler convinced many that he was the right person to lead the German people.[6] This conviction led large groups to believe that Hitler and the Nazi Party could fix all that was wrong with Germany. Hitler not only commanded the Germany military to begin rearming, which was against the Treaty of Versailles, but also signed an agreement with fascist Italy in 1936 and again in 1939. Even with that happening, it was not until 1939 and the invasion of Poland that France and Great Britain declared war on Germany. The United States and its allies, and many in Germany itself, feared that Hitler would attempt a power grab for Germany under the Third Reich; figure 30 shows an adamant belief that things were going to end poorly if the Third Reich gained power.

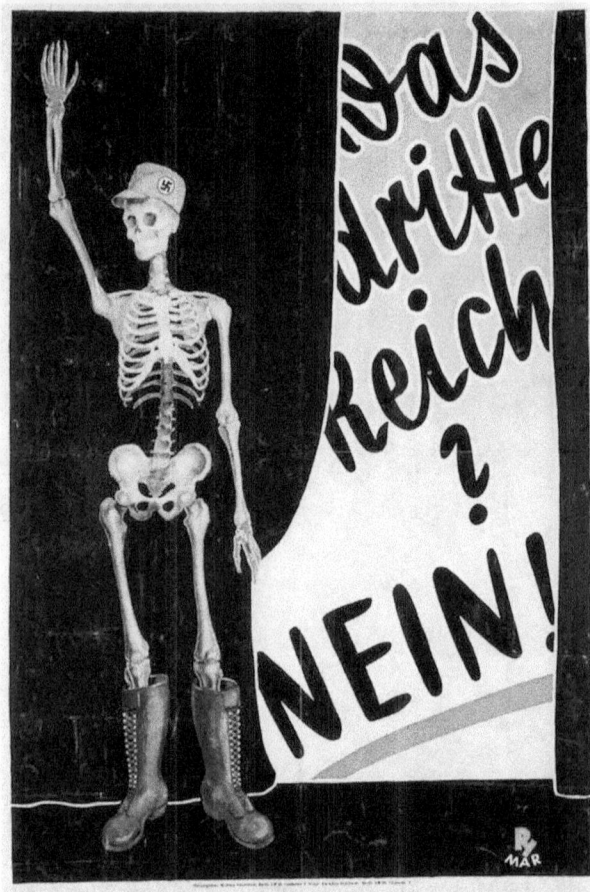

Fig. 30. Prior to Adolf Hitler's gaining power in Germany, many European governments were worried about what would happen if he were to gain a leadership role. In fact, there were individuals in Germany who were worried if Hitler with his Third Reich were to gain any formidable power. This poster implies that if the Third Reich were to gain power, it would result in many more skeletons (courtesy Library of Congress).

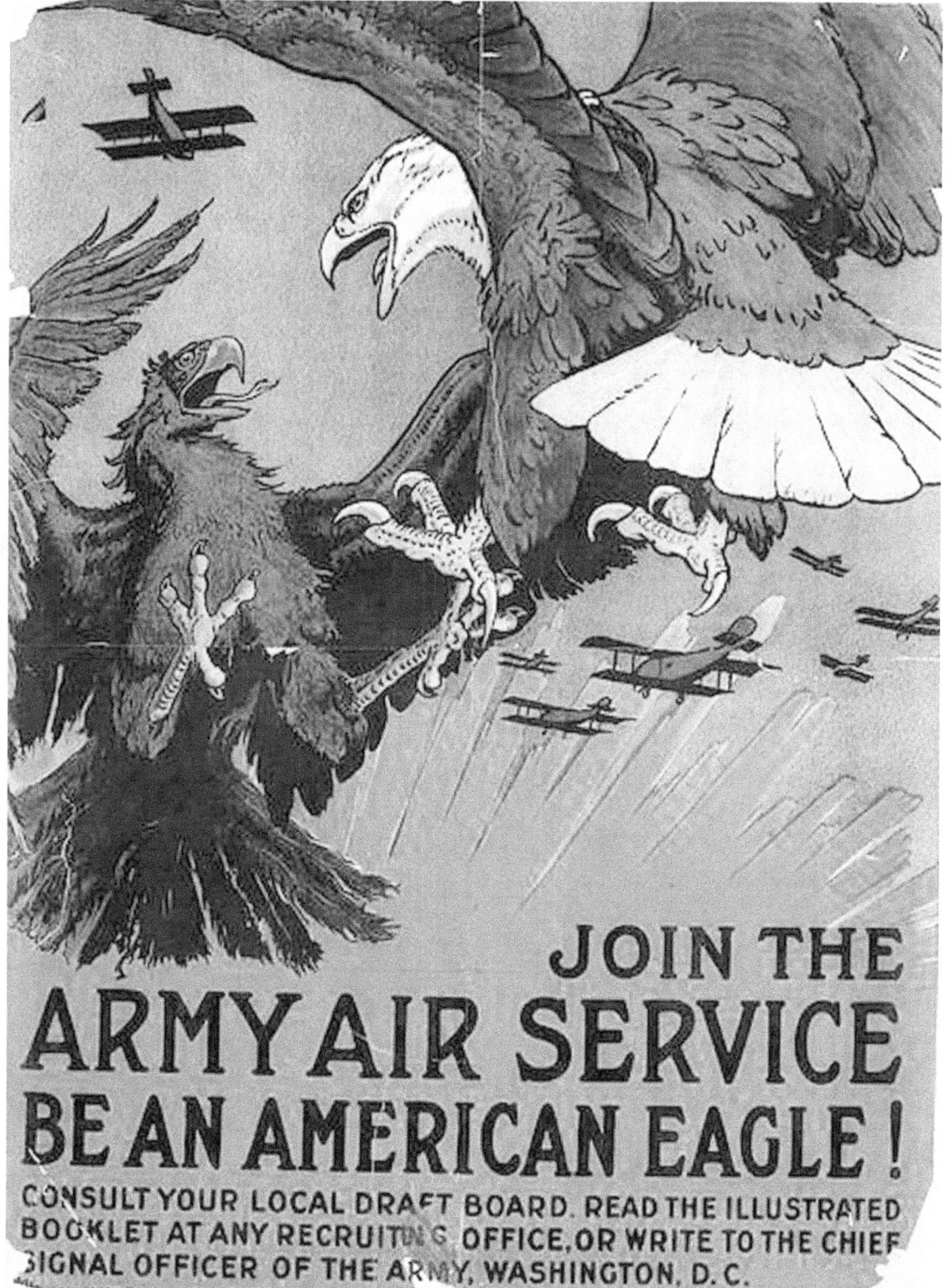

Fig. 14. When the United States finally recognized the power of planes, it began to actively recruit. The army recruiting office used the United States mascot, the bald eagle, to showcase its air power. The bald eagle is seen in an offensive position against a black bird that represents the German military. In the background, bi-planes can be seen (courtesy Library of Congress).

Fig. 24. During the 1930s movies started to appear that were more sexualized. *The Sin of Nora Moran* is one such movie. Not only was she scantily clad in the movie, but the movie poster had a woman wearing a nightgown that explicitly showed her chest. While this movie did not revolutionize Hollywood movies, it is a good example of how a change was occurring (courtesy Imp Awards).

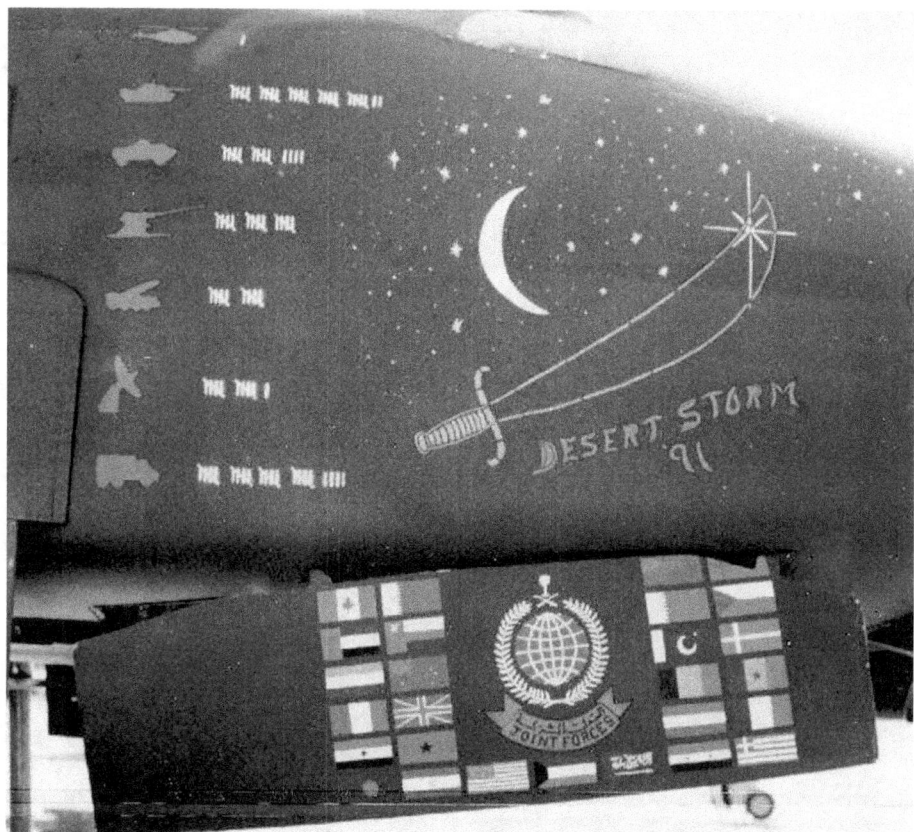

Fig. 66. Even though there was a moratorium on nose art following the Vietnam conflict, when the United States began Desert Storm in 1991, it was present. This image shows the countries that aided the United States as well as a traditional Middle Eastern sword (courtesy 2951st Combat Logistics Support Squadron).

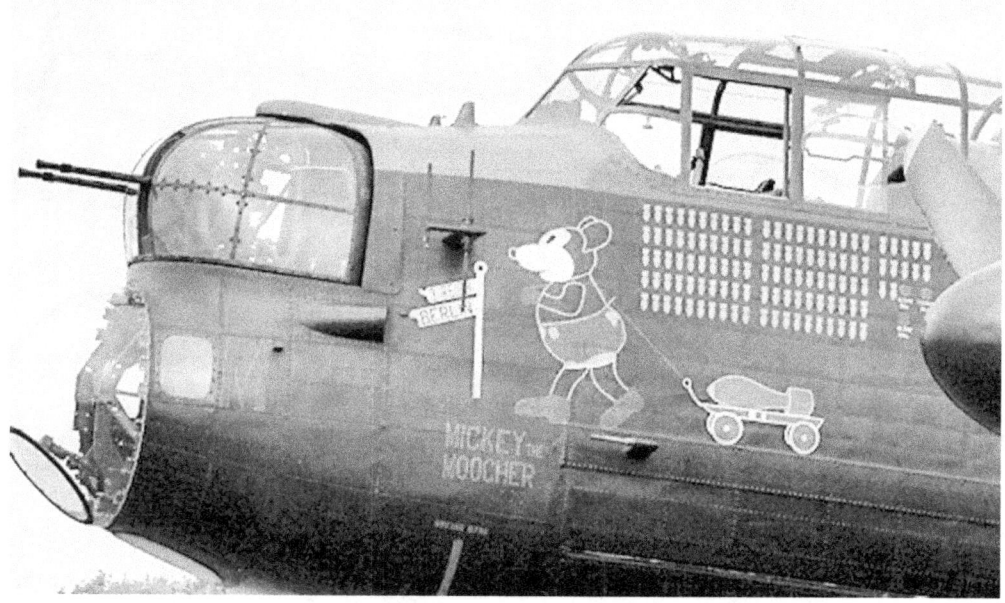

Fig. 31. Here is another image of Mickey Mouse, taken during an air show, this time on the side of a British Avro Lancaster during World War II. Mickey Mouse and fellow Disney characters had gained popularity in civilian culture and they transitioned well to the sides of planes.

Fig. 39. Not every element of war is advertised, and many in the United States did not understand why they were fighting Germany again. To educate as well as push enlistment and negative feelings towards Germany, the United States government frequently created posters that detailed what the Germans were doing. This poster clearly states what the Germans had done to the citizens of Lidice Czechoslovakia, specifically detailing what happened to women and children (courtesy National Archives).

Fig. 40. One element of propaganda that was prevalent especially during World War II was the dehumanization of the enemy. This poster is a great example of how the United States dehumanized the Japanese by representing them as rats. It was not uncommon for the Japanese to be represented as rats or monkeys and the Germans as large primates or monsters (courtesy Library of Congress).

Fig. 41. In addition to using dehumanization of the enemy for enlistment purposes, the United States also used it to drive civilians to assist with production of materials used for the war effort. In this poster both Germany and Japan are represented as monsters to incite fear (courtesy National Archives).

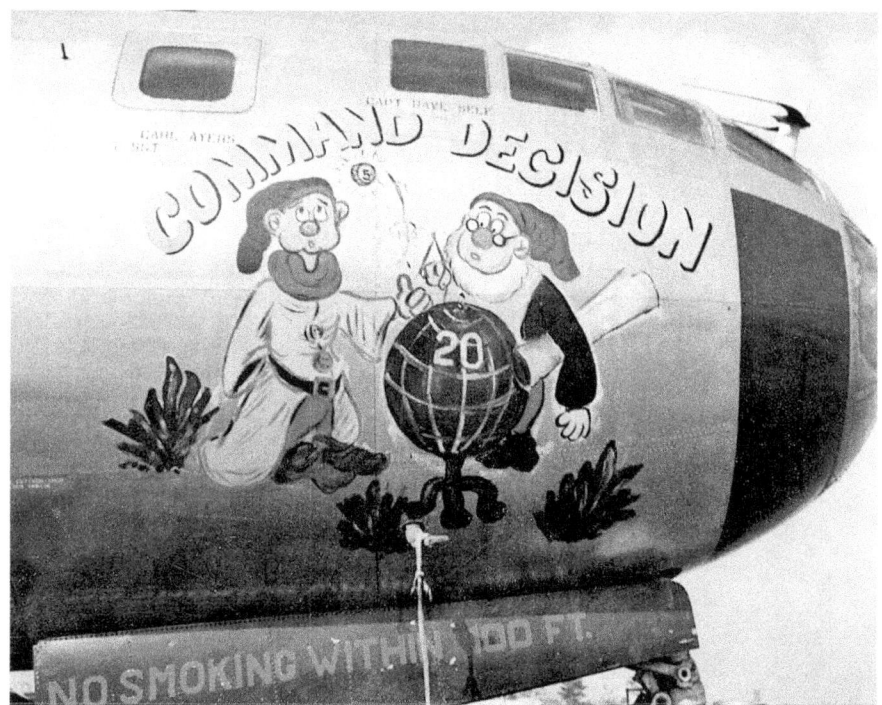

Fig. 55. During the Korean conflict, understanding who the enemy was was not as simple as in World War II. It also became apparent to some that commands did not know what was happening or what the next mission was going to be. For that reason a common image on bombers during the time was "Command Decision," showing two commanders flipping a coin to decide what would occur next (courtesy U.S. Air Force).

Fig. 62. The 1960s and 1970s were drug-heavy decades, specifically drugs that caused psychedelic visions, such as LSD. This effect along with the song "Good Vibrations" easily fit on the side of a helicopter (courtesy 132nd Assault Support Helicopter Company).

Fig. 67. Although the United States frowned upon nose art, the British military allowed it almost without reservation. This image from the 208th Squadron depicted a nude woman along with the brand of a Scotch whiskey, "Tamnavoulin" (courtesy 208th Squadron, RAF).

Part Four

# 1940–1945: Same Adversaries, Same Place

# 7

# Ration and Save

When war in Europe began to expand in 1939, much of the world did not want to become involved. The Great Depression was over and many people were starting to have extra money and freedoms that had not been available a decade earlier. Those in Great Britain and France were unable to distance themselves from combat as the Germans started to move towards the borders. The United States by geographical circumstance was able to continue economic growth while watching the growing conflict. Many in the United States government felt that the conflict could be contained in Europe and there was no need for an extensive United States presence. Later events showed this belief to be naive.

This conflict, along with previous wars, threatened how countries functioned at the base level. Societal change along with global change caused the world to differ in 1945 from what it had been in 1939. In some instances the citizens were forced to choose between family and country. This choice affected how individuals saw themselves, their families, and their home countries. The decisions that individuals made compounded and created a change in town structure, entertainment, and political and economic elements.

Due to the scope and length of the war, the United States and Great Britain could not rely on individuals enlisting to provide the personnel needed. The United States along with Great Britain had used the draft during World War I, but the numbers were not necessarily as high during World War II. The issues concerning the draft during World War I were remedied during the interwar period, and during World War II conscription was used effectively to fill units needing extra men. Although many individuals thought this war was a noble fight of good versus evil, citizens of all three countries felt that the draft was not the answer.

In the United States the draft was officially recognized in 1940 and continued until 1947. All told, more than 10 million men were inducted into military service during World War II. The United States was not without protests from those who believed that the draft was not equal among socio-economic groups. African Americans and those individuals claiming conscientious objector status were the two loudest objecting to the draft. Many individuals who objected to the war were imprisoned and tried as defectors.

Great Britain also saw protests of the draft. When Germany began to remilitarize, Great Britain felt that war was near. A draft was brought into effect prior to the official start of World War II to guarantee that there would be troops if needed. Unlike the United States, Great Britain allowed some professions a deferment. These professions were centered

## Part Four. 1940–1945: Same Adversaries, Same Place

on manufacturing and raw materials. All others between the set ages were sent draft cards by birth year. Due to complaints from men as to why women were not also being drafted, Great Britain began to draft women into non-combat positions. This insured that there were always troops either in training or ready for combat when the conflict started. Although there were millions of individuals called up by their country, the World War II draft did not produce a climate for social change. This could be due to the war being "justified," with an aggressor that not only had been faced before, but also was geographically close.

Cultural change did occur in many other ways during World War II that permanently affected how France, Great Britain, and the United States reacted. Due to the German occupation of France, widespread cultural change was truncated. The Germans ensured that once-prominent aspects of France culture were quelled. The French underground during this time expanded. The cultural changes during this time continued after German occupation was over.

Politics and entertainment were affected to the greatest degree. The German military held a tight reign over the French government. This was to limit any possible widespread anti-military movements along with utilizing the French population to its maximum potential. On the surface it seemed that the entirety of the French population was compliant with the Germans' demands. However, there were groups of French individuals who, while publicly submissive, were privately defiant. It is this group that produced the greatest cultural change in France.

French citizens looked at politics during this time with apathy. When the war broke out and France was quickly taken under the German authority, some started to question what government really meant and how useful the elected officials were. During World War II the leader of the Free French Forces, Charles de Gaulle, moved to Great Britain. Great Britain's leader was attempting to save Britain from France's fate, while the United States president was attempting to stay out of the war. This disparity between how the leaders were reacting to German aggression affected how the citizens felt about the war as a whole.

The majority of British citizens, realizing the need for quick and decisive action, lined up at enlistment and factory lines to assist in the war effort. Women assisted in any way possible. Women lined up to work in traditionally male occupations along with volunteering for organizations that assisted the war effort, such as the Red Cross or military auxiliary units. Although many volunteered, the need was so great that the government and military specifically created propagandistic flyers and posters to incite more dedication. This similarly occurred in the United States following December 7, 1941.

Prior to December 7, 1941, the majority of U.S. citizens believed that the United States should stay out of the European conflict. The small percentage that thought differently were those who volunteered in both Asia and Europe. After the attack on Pearl Harbor, the president believed that this was only the start of bigger things. It was not long before the United States was involved in both Europe and Asia. With the changing thoughts of the government came a change in how the general population felt about conflict. All around the United States, citizens were joining together to enlist and/or organize social groups to assist in acquiring materials needed by the government and military. In those areas that saw

## 7. Ration and Save

minimal pro-military assistance, the government and assisting agencies started to create propagandistic materials to encourage enlistment and/or monetary backing.

During this politically tense time, the family structures in all three countries were affected. Family life in France was disturbed a great deal as the Germans occupied the country. Many men were part of either the Vichy French military or the Free French Forces. To be involved in the Vichy French military required extensive travel to Africa and Eastern Asia for both German and Japanese colonial holdings. This travel separated families for long lengths of time. During this time, many women were forced or chose to join the workforce to support the household. France during the interwar period and World War II saw extended families living together. These extended family households provided protection and economic stability that was not possible with traditional nuclear-family households. The men that remained in France were forced to work in German-controlled factories producing military equipment for the German war machine.

Those who sided with the Vichy French government assisted the Germans in their persecution of those of Jewish heritage. This further separated families, as there were groups who risked their own lives to save Jewish families. France was a two-sided country during World War II: those who disliked what the Germans were doing and assisted the resistance movement any way possible, and those who thrived on the German hatred and power hunger. Distrust was commonplace, and the families struggling to remain in their country of birth were in the middle. This only became worse as the war continued. France created an internal rationing program during the early years of the war in attempts to combat the German invaders. When Germany invaded, rationing either was independently sanctioned, as in Vichy France, or fell under the control of the German rationing system. One reason the Germans introduced the rationing system so early in France was that it allowed for those of Jewish descent or those opposed to the German occupation to be easily discovered. The Germans used this method of rationing as a way to also conscript many into German factories. Rationing in France impacted the familiar structure specifically, if a result was to send male family members to Germany to work.

Great Britain also faced structural changes in family units during World War II. Great Britain, confronting the enemy locally with attacks off the coast of France, was forced to separate families from the soldiers. This caused many households to be run by females or by those too old to fight. These families were not always sure when money might come from the soldier; so many women began to work outside the home to survive. This caused families that might have once been nuclear in structure to branch out and have multiple generations living in the same dwelling. Another element of the war that directly affected the stability and readiness of the British family was rationing. The size of the family and the age of its members directly affected how much food was allowed in any given week. As the war continued, rationing expanded to almost every part of daily life. Customary things such as petrol and meat were rationed soon after the war began, to ensure that the military was receiving what was needed. Soon things such as rice, fruit, and even sweets were rationed as food shortages became commonplace. The scarcity of supplies forced some to turn to the black market. As black market prices were high, the need for employment grew.

## Part Four. 1940–1945: Same Adversaries, Same Place

Women worked not only in offices and companies as secretaries and bookkeepers but also in munitions factories and warehouses to assist in the military effort. Prior to war, a third of all metal and chemical workers in Great Britain were women.[1] Sensing that war was brewing in Germany, the British government in 1938 created the Women's Land Army, which allowed women to learn farming techniques. Another step forward for women's rights as well as equality on the battle field was the British creation of the Auxiliary Territorial Service (ATS). The ATS was originally a support structure for the British Expeditionary Force (BEF). Soon after World War II started, the ATS not only was stationed with the BEF but also was actively engaged in combat activities. Having this many women working created a change that affected every part of British culture following the war.

The proportion of women that were employed and/or volunteering in the war effort was comparable in the United States. As the United States joined in conflict later than Great Britain and France, the proportion of women at the onset was lower. As war whispers were heard, two influential women created a bill that allowed for women to join in the newly formed Women's Army Auxiliary Corps. The corps in the United States was similar to that of Great Britain, as women travelled with their male counterparts to Asia, Europe, and Africa. Along with the WAAC were the WASPs and the WAVES. These sister organizations

Hoping to both decrease depression and reduce the large numbers of individuals sitting around, the U.S. Employment Service created posters for women to get them into the work force. This was a twofold approach. First, it decreased the amount of people sitting at home, and second, with all of the men away at war, many businesses needed additional laborers (courtesy National Archives).

allowed for women to join the military in numbers as never before and to contribute positively to the war effort. Over 100,000 U.S. women wore a military uniform during the Second World War.[2] In addition to their large presence in the military, nationally women were striving for the betterment of the United States. Not only was there a large presence in the military, but women nationally were striving to participate to the betterment of the United States. In fact, the U.S. government produced propaganda in hopes of gaining more female workers.[3] The growing number of women in the workforce and military forced clothing and clothing manufacturers to adapt or face going out of business.

As France was the predominant leader in fashion prior to the start of World War II, it was also hit the hardest when Germany invaded. Paris as the capital was able to still produce clothing lines, although significantly changed following the onset of war. The clothing style of excess and finery was out, and drab and utilitarian forms were in. Since cloth was rationed in France, many women were told to mend the clothing already purchased and create new uniforms out of old pieces. For the fashion-forward Parisians this was unheard of, and the black market in France exponentially expanded. Even nylons were a hard item to find, and some French women resigned to using gravy and painting a black line. In addition to the rationing of cloth, money was not readily available, so clothing was also trimmed down and simplified to use in multiple venues.

The atmosphere of British clothiers was dire compared to Parisians. Many factories previously used in Great Britain for clothing were refitted for munitions and war supplies. A few were able to continue on in their original line as long as a percentage of the clothing being created was suitable for soldiers. This prompted Great Britain to follow the pattern of France and create pseudo-uniform styles for the general population in addition to the uniforms needed by the organizations participating in the war. The wealthy, at the beginning of the war, attempted to maintain a level of comfort and prestige.

In 1942 Great Britain went a step farther and declared that excess buttons, decorative trimmings, and extra stitching were unlawful, as the military manufacturers needed these materials more. In an effort to accommodate the British rules regarding clothing allowances, a group was created to make the most out of what was given. The Incorporated Society of Fashion Designers of London created suit designs specifically intended for women.[4] All of the designs were created out of materials that were not rationed or used rationed items in such a way as to make women look respectable while still conforming to the regulations. This led to fashions that were form-fitting, therefore decreasing the cloth used, and drab in appearance. Bright coloring cost money, and money and materials were not always available. World War II also created an atmosphere in which bright colors were inappropriate. The only bright colors usually seen were pastels used for going out on the town. Men's clothing in Great Britain also lost many extra layers and additions. If a man was not in uniform, the typical outfit was work clothing. For those men who could afford to go out, the normal attire was also made out of rationed materials. Due to the scarcity of cloth, many men chose to wear a sweater-vest or knitted waistcoat, versus a suit jacket. Only for special occasions were ties worn. One aspect of the British underground was the Zoot Suit. Not only was this suit against the British clothing laws, having an oversized

jacket and pants, but the flamboyancy was the opposite of what many people associated with World War II.

Prior to the onset of the war, many United States designers travelled to Paris to attend the Parisian fashion shows and return with the newest fashions. When Germany invaded and later occupied Paris, it was impossible for designers to travel to Paris. For that reason, U.S. fashion began to slowly separate from European fashion. Things such as Zoot Suits and the uniform styles created in Great Britain were seen in large cities in the United States, but the majority of styles were unique. U.S. designers began to create clothing that was more form fitting for women and men, and thus was comprised of less cloth, therefore assisting the war effort. Skirts and dresses became drastically shorter in an attempt to create more outfits with less cloth. Women were asked to "make do and mend" rather than buying new clothing for their families. As money became tighter, outfits made out of tablecloths and curtains were common.

The United States was also known for two other forms of fashion that increased its fashion designers' creditability and overall stance in the world market. These two things were sportswear and the expansion of Levi's jeans. Sportswear prior to World War II was made mainly out of wool or other heavy fabrics. U.S. clothing designers, dedicated to separating themselves from their European counterparts, began to create fabrics both organic and synthetic that were light and breathed better. These inventions allowed for sportswear to be worn more often and the styles to become widespread.

Jeans, or as they were sometimes called, waist overalls, had been popular with working-class men since their invention in 1873. During World War II more than just factory workers were using jeans as a way to stay comfortable and stylish. Men were able to wear jeans not only to work, but also to the store and other places that allowed for casual wear. While it was still inappropriate culturally for women to wear pants outside the home, jeans inside the home became popular for household duties. Women in tight jeans were often displayed in magazines and movies. This prompted many sailors and airmen to paint jeans-clad women on the sides of their planes. These paintings usually consisted of a back or side view of women in only jeans and nothing else.

The swimsuit for both men and women changed drastically during the interwar period. During World War II women began to use magazines as templates for what they should look like, and took pride in a good appearance. When vacation or pool time was available, women chose revealing suits, as did men. Two-piece swimsuits for women garnered more attention than during the '30s.

These changes in what people wore both affected and were affected by the entertainment culture. Music, movies, printed materials, and art all changed due to the war. Prior to the start of World War II, music began to take on a life of its own. Jazz and big bands were still popular during the beginning of the war in both Great Britain and the United States. In addition to these two genres, country music and swing music started to gain popularity. Anything that soldiers and civilians could dance to was popular. Music during this time was used as a distraction from the war and allowed hardworking citizens to have an enjoyable night out.

Great Britain began to experiment with radio as a way to increase the musical audience. Radios were used for sports and newscasts as well. Citizens who were unable or unwilling to go to a music hall or night club were still able to listen to the music that was being played nightly. As a thank you from Great Britain to the United States, many large towns and cities opened dance and music halls specifically for U.S. soldiers on leave. This allowed young women and men to dance and listen to contemporary music. The United States created more dance halls due to the increase in demand.

Culturally, in Great Britain and the United States, dancing was the only way that young men and women could touch and be close to each other without being betrothed or married. Many of the men who frequented the dance halls in the United States were soldiers on leave either looking for a significant other or looking to have a good time while in town. Some of the women met during these periods of leave were later immortalized on the sides of planes in paintings such as "Dance Hall Dolly" and "The Can-Can." Neither one of these paintings was derogatory to the women; rather, each represented a memory of a good experience and was a reminder of what was waiting for the airmen at home. Planes in the Pacific consisted of many dancing women, mostly clad in hula garb.

Radios and dance halls both increased the visibility of already established artists and enabled new artists to break into the field. In addition to new artists came a change in the actual music. Big bands and jazz were just starting to expand during the interwar period in the United States and Great Britain. During the war, both genres exploded on either side of the Atlantic. Due to the large numbers of U.S. soldiers in Great Britain, many previously unknown artists' music was being played in dance halls far from the United States. The mood of the music changed to accommodate the growing sorrow and impatience with the war.

Music started to gain stories of lost love and returning love. Some of the most popular songs both in the United States and Great Britain were about joining and ultimately winning the war. One such song was "So Long, It's Been Good to Know Yuh," written by Woody Guthrie and first played in the United States on November 10, 1942.[5] This song is about the idea that while the war might be hard, enlistment was needed, and ultimately, "It won't be long till all the fascists are gone." In addition to music being created by the general population, some military marches and hymns were created for those on the home front. Lyrics of popular songs at times appeared on mostly European-based planes. This was due to the British radio stations. In the Pacific, the USO provided much of the entertainment. Music, much like movies and printed material, often included elements of propaganda during World War II.

Due to the advances in filmmaking, the usage of film grew, and going to the movie theatre in Great Britain and the United States was a popular pastime. Film also became a way to deliver information in a variety of ways. This was done either directly with nonfiction films or by using actors to portray events. While movies were created and viewed in France, due to the German occupancy many of the early films displayed had strong Axis-power propagandist traits.

Although some German films were popular, France wanted French-created films. In 1940 the Vichy French created the Comite d'Organisation de l'Industrie Cinemator-

graphique to control the production and decimation of films. This organization only allowed those films that supported the Vichy's goals. The Germans in Paris, however, believed that in the spirit of corporation and with an eye towards the future of European filmmaking, French filmmakers should be allowed to make their own films. This allowed production to return in 1941, to the acclaim of many French citizens. With the lack of films coming from the United States due to the occupation, the French film industry flourished in comparison to the prewar era. While the French film industry was having an identity crisis with the German occupation, Great Britain was having an industry revival.

The British film industry waned slightly during the mid and late '30s, as the United States and France commanded the majority of film studios and popular actors. During World War II, however, Great Britain began to make movies out of two main studios. Of the movies created, the most popular and long lasting were documentaries. Great Britain was not able to actively compete with the United States in fictional films. Although there was a studio that did films of popular Shakespearian plays, the majority that were seen both Great Britain and the United States were the documentaries regarding the war, and the effects of the war on the general population. In addition to creating a growing film industry, the war created an outlet for actors to perform. The movies of World War II were able to create a new generation of movie stars.

The cinema industry in the United States at the beginning of World War II was still soaring from the 1930s. With the addition of sound and the popularity of animated cartoons, the United States excelled. In 1939 what has been claimed to be the greatest movie of all time, *Gone with the Wind*, was released. This movie, along with *Citizen Kane* in 1941, pushed the boundaries of what the movie industry could do and increased U.S. predominance in the film industry.

Cartoons also spotlighted the United States. Walt Disney and the creator of Looney Tunes made cartoons for the big screen. In many instances the cartoons were first published in print and then transformed, due to demand, to the big screen. The writers of these cartoons created two-part cartoons. One part was for the enjoyment of the children. Characters such as Bugs Bunny and Mickey Mouse attracted children. The British Avro Lancaster in figure 31 is one of many that were adorned by a cartoon figure created in the United States. The other part the writers included was the stories. At times the stories were mainly for children, but with an increase of printed propaganda came propaganda-themed cartoons.

Cartoons and films created in the United States were not isolated to the United States. Many movies and popular cartoons reached Great Britain during the war. Film industries, along with the military, strove to keep morale up by sending films to foreign-stationed troops. This gave the soldiers and airmen a chance to see the new movies along with the cartoons. The popularity of cartoons both on film and in printed form created an atmosphere that allowed many flight crews to add cartoon images to the aircraft. Bugs Bunny was notorious for dropping bombs on both other cartoon characters and representations of enemy leaders. This is depicted in a 467th Bomb Group painting of Bugs Bunny and a skunk (fig. 32).

Due to the location of many units, the only way that information was transmitted quickly was by printed material. There were many dailies and weeklies that were created

## 7. Ration and Save

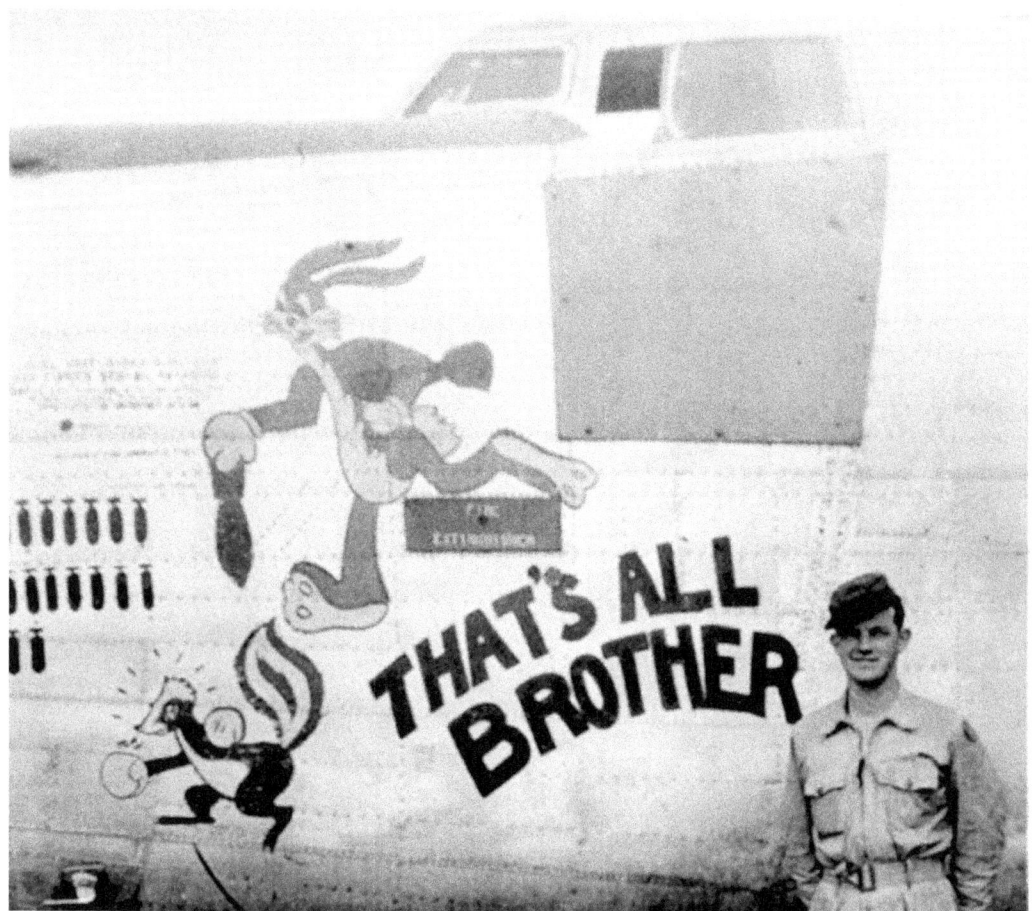

Fig. 32. Bugs Bunny did not let Mickey Mouse get all the spotlight. Bugs Bunny is recreating what he did on the big screen by dropping a bomb on an unsuspecting skunk. This skunk is not an ordinary skunk but one that is representative of the enemy, as detailed by the boxing gloves and the wording "That's All Brother" (courtesy 467th Bomb Group).

specifically for the deployed soldier. These papers, along with the printed material created for the general population, kept them busy during the down times. In one good example of this, an entire set of paintings depicted the "Li'l Abner" cartoon strip (fig. 33). The 56th FG and the 47th FS of the 15th FG's planes were mainly painted with elements of the "Li'l Abner" strip.

Great Britain, France, and the United States all created comic strips. Comic strips easily traveled across the Atlantic, and many U.S. strips were included in British papers. Due to the possibility of wide dissemination, propagandistic single-paned cartoons were widely used. In addition to propaganda and entertainment, advertising and political statements were drawn. Due to each country's involvement in World War II, the comics all differed.

France prior to the occupation created posters such as *"car ton bras.... Sait Porter Lepee"*

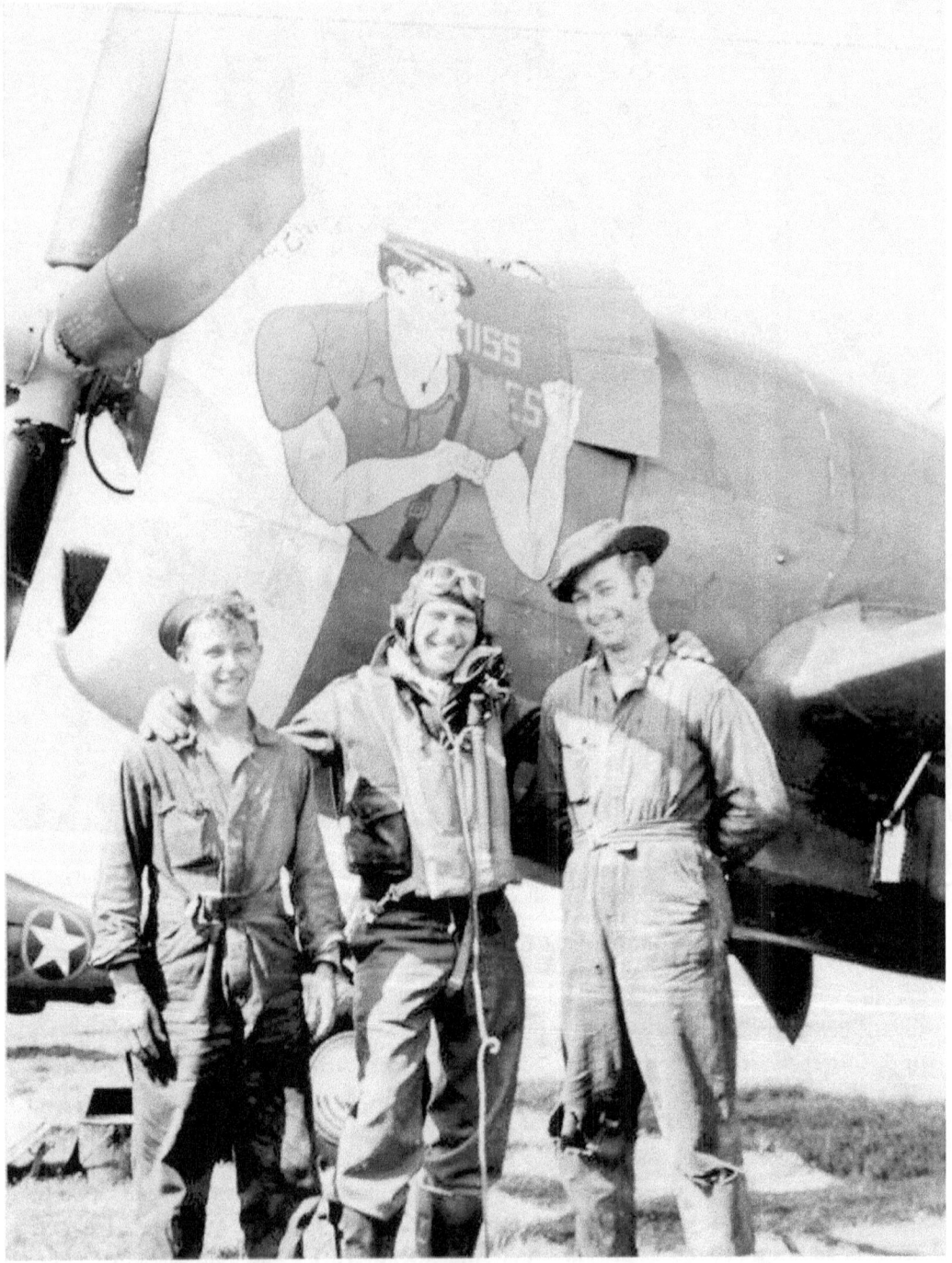

Fig. 33. Comic strips were a common part of civilian culture. Lil' Abner was a popular comic strip that was frequently read by service members overseas (courtesy 56th FG).

in hopes of recruiting French Canadians to the war effort.[6] Although the intended recruitment did not result in enough troops to fend off Germany, the propaganda continued following the occupation. Due to the division in loyalties among the French, both sides created posters and cartoons to persuade the other side. The Free French Liberation used their symbol for many of the posters to assist the population in remembering what that symbol meant. The Free French Liberation created posters similar to figure 34 in hopes of gathering more resources to its cause.

The United States, understanding how important the Free French Liberation was to the overall war effort, created posters similar to the one below in hopes of gathering more resources to its cause. The poster consists of one of the free French military's main themes for gathering support. France prior to the occupation was mainly ambivalent with regards to religion, while Germany was not. The lower section states "one of the four liberties for which the allies are fighting." This poster was created in 1942 by the United States when a strong allied presence became known to the French fighting in neighboring countries. It was written in Spanish to gain supporters for the free French Military.

France's cartoons and posters were minimal compared to those of Great Britain and the United States. While the posters and propaganda from France was mainly trying to enlist citizens on one side or the other, the British posters spanned a much larger range of concerns. St. Andrews in Great Britain has separated British war posters into six main themes and one general category. These themes are as follows: specialist recruiting, industrial production, maintaining morale, security concerns, savings and austerity, and health and safety.

Fig. 34. Although the French were quickly overpowered by the German forces, there were still small groups that fought the German invaders. This poster was created in the United States in support of the Free French Liberation, but in Spanish so that potential supporters of Free French Fighters in Spain would understand the posters. Although France was relatively agnostic, when the Germans began to invade they took a stance that the Germans would strip the freedom of religion from anyone who chose to believe.

## Part Four. 1940–1945: Same Adversaries, Same Place

Due to the large percentage of men serving in the military already, many of the posters for enlistment were directed specifically towards women, both for military service and for civil service. Service-specific enlistment posters were often used. The posters even detailed exactly what the military believed women were doing and how they could help. In addition to recruiting for the military, there was a big push for men and women to increase production of military-grade supplies. Again, the RAF was a popular backdrop for posters.

As a counterpart to increasing the supply of human and material goods, rationing domestically assisted in the governments' goals for food and cloth. Rationing became such an important part of daily life that numerous posters featured it, even more than other genres. This was both to remind people to ration and to explain why rationing was so important.

Some artists went to great lengths to show the dreadful effects if rationing did not occur. One poster, for example, states that to share food and wealth now would be better than anything in the future if Great Britain did not win.[7]

Food was not the only thing rationed. As all of the different materials began to be placed on the ration list, citizen morale began to drop. The government and military both knew that domestic morale was paramount. Artists of comic strips and artwork were asked to complete posters for specific purposes. Posters that incorporated cartoon elements along with a strong morale booster proved specifically successful for the country. One poster was meant to show the citizens that even though the British might have started slow, it was not long before Hitler and the Axis forces were humbled by the roaring lion.[8] Posters depicting Winston Churchill also provided a boost to those feeling the weariness of the war. Winston Churchill was believed to be the

Fig. 36. During any conflict there are individuals that become traitors or relay secrets to the enemy. This poster reminded service members that regardless of to whom one is speaking or where the conversation takes place, there is the potential for the enemy to overhear and use those secrets to gain an advantage (courtesy 6th Airborne Division).

## 7. Ration and Save

only man who (along with the United States) could stop the aggression from the Axis powers.

One thing that even Churchill could not stop was leaking of information to foreign spies directly or indirectly. Great Britain created a campaign for security measures. It was the government's belief that anyone could be a spy; even your girlfriend or wife could be working for the enemy. Posters of both comical and serious content began to appear in open venues. In addition to safety from spy activities, safety of one's person was extremely important for the government. Two main reasons for this increased security were the rolling blackouts and venereal diseases. Due to the number of soldiers away from home, Great Britain feared that without proper education those soldiers could infect women, therefore compromising the work force during the war. Figure 36 shows an example of the methods that Great Britain used to educate the population. With all of the suspected spies, careless talk among service members could adversely affect the overall fighting power of the military.

Great Britain was slightly more accepting of women in the military, and the amount of posters addressed to women showed this. Both countries, however, needed as many citizens as possible for both military and support professions. For this reason, there was an influx of posters surrounding enlistment for women and men into the war effort. Portions of the United States were still very paternally based, but there were organizations that needed women to enlist.

The poster on the overleaf exhibits the need for women to enlist and states that a woman can do the same job as any man. This poster shows a strong, independent woman, but due to the fact that she cannot enlist in the regular military, as stated by the line

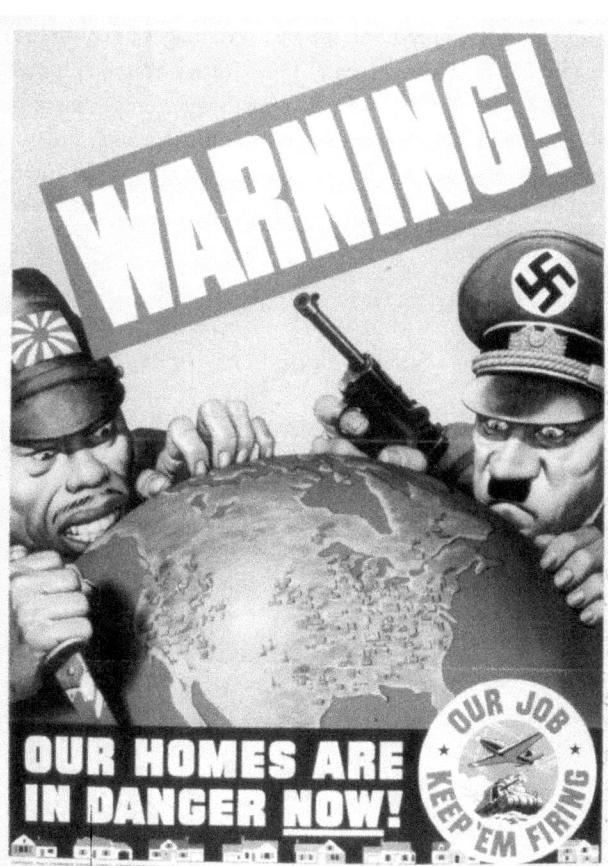

Fig. 37. The United States frequently used scare tactics to engage civilians. This image used close representations of the enemy to show how if they were not stopped on the battlefield, the United States or "home" would be their next target. This was not an enlistment poster per say but more of a call to support, be it rationing, bond purchase, or enlistment (courtesy National Archives).

"for you in you NAVY," she is not quite equal to her male counterparts. This, along with the artists who painted women, assisted the transition to women as the muse for nose art to a greater extent. Although there were similar fears represented on posters, the United States represented certain fears in slightly different ways. The United States was more dramatic and graphic than Great Britain was in their propaganda. The United States used scare tactics to a greater degree. By displaying a graphic view of the enemy, the U.S. hoped to incite the public to do everything asked of them. This specifically occurred for the purpose of increasing enlistment and output. Figures 37 and 38 show the method that the United States used. By threatening an immediate threat by both the Japanese and Germans, the government pushed people to work longer hours in factories and fields in hopes that more production would increase the ability to push them back.

The United States also used images of countries and towns that were directly attacked by Germany and Japan. The United States employed actual and imagined depictions of war-damaged areas. These images were those that stayed with the viewer, causing the desired action. The U.S. government employed both full-time artists and government officials to create the posters for maximum impact. As the European countries were being ravaged by the invading Germans, and a large percentage of United States citizens had European origins, these created the strongest impact.[9] The poster in figure 39 was used mostly on the eastern side of the United States to directly influence European immigrant populations. While there is no evidence that this poster directly affected the enlistment of European immigrants, the imagery likely stayed with the viewers.

During this time, the United States was maintaining a wait-and-see approach. Although asked by Great Britain to assist, the

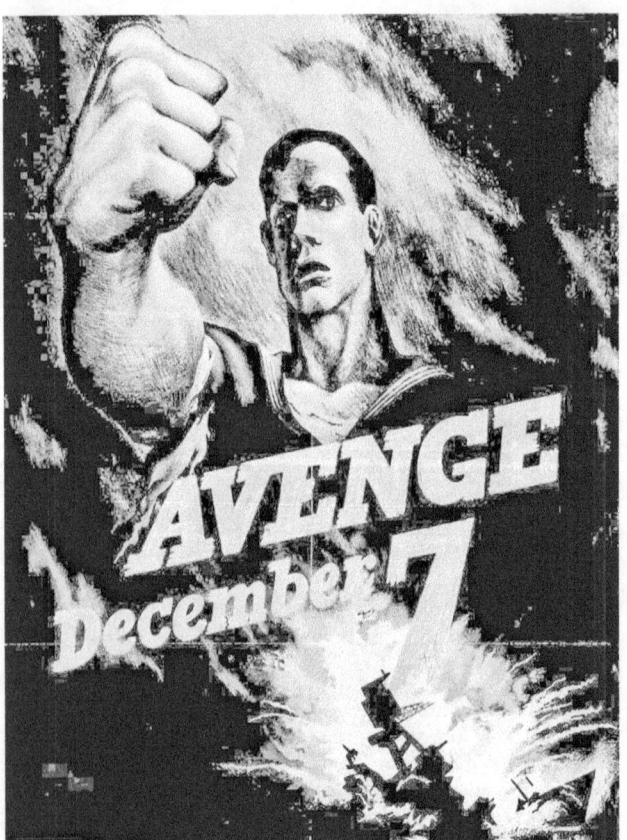

Fig. 38. December 7, 1941, did more for the United States than anything else the enemy could do or that the United States could say. It was the rallying cry for men and women to pick up arms or shovels, or join the work force. Enhancing the poster with an image of the actual attack on the navy just increased its effect (courtesy Library of Congress).

## 7. Ration and Save

United States did not enter the war until Japan attacked Pearl Harbor. This event was used for propaganda to rally not only the troops but also civilians. The U.S. government did not pull any punches when the propaganda began.

Not only were images from Pearl Harbor used extensively but as seen in figure 39, images of what the Germans were capable of. This was prior to knowledge of the full extent of the atrocities that the Germans perpetrated in the concentration and death camps.

Even if people did not understand why the Germans were doing what they did, these posters threw into their faces the depravity that the Germans caused. Posters like this were not used for any specific purpose other than to shock U.S. citizens into realizing that this wasn't like World War I in terms of civilian deaths. While these posters showed the results of enemy action, there was another set of posters that were directly related to the enemy. The United States created racist posters that made the enemy appear less than human, such as the German brute above. This imagery was often used on airplanes while in country. The Germans, depicted as larger than life at the beginning of the war, were slowly made smaller as the war continued.

Interestingly, although there were not that many brutes placed on planes in the European theatre, there were a lot of rats and other depictions of Hitler. The Asian theatre produced a lot more racist and potentially politically harmful images. Throughout the war, the Japanese were considered rats, and a lot of posters and airplanes depicted them as such (fig. 40). The air crews did not stop at portraying them as rats, but often combined the Japanese rat with a trap symbolizing the United States.

This imagery was often seen on planes, usually with either a rat or a roach representing the Japanese. Monkeys were also a popular cartoon figure used to represent the Asian enemy. There were also images that were strictly to install fear, such as the "Stop this monster" image created to increase production (fig. 41).

Although morale and enlistment were important, so was the rationing of food and material goods to assist not only the United States in the war effort but also Great Britain, which had been fighting for longer. The United States, entering the war three years after France and Great Britain, created a level of rationing that rivaled that of Great Britain. The government asked citizens to ration all foodstuffs and to collect metal and rubber scraps to assist in vehicle building. Due to the need for a multitude of different supplies and food, the United States began to employing artists to create cartoon images regarding rationing. These posters ranged from serious to comical such as figure 41. This poster, while created in 1916, was also used during World War II. Rationing decreased the morale of the citizenry. To combat this decline in morale, artists such as Norman Rockwell painted images that depicted daily life as patriotic. These paintings first appeared in newspapers and became popular for their artistic properties. The British Pat Keely and the American Rockwell were not the first or the last artists to adapt to the new format in which art was displayed.

Many of the artistic revolutions that occurred during the '30s expanded during World War II. Both painted and written expressions combined the experiences from the interwar period with the artists' thoughts and feelings regarding the war. As with World War I, when the war continued past the first two years, changes occurred to the beliefs of artists around

## Part Four. 1940–1945: Same Adversaries, Same Place

the world. Artistic expression in Great Britain and the United States was similar during World War II, but the situation in France was different. France due to the occupation did not have the freedoms that Great Britain and the United States had. Many of the great artists of the '30s fled the persecution and oppression of the German regime by coming to the United States. This caused the French artistic community to decrease production and ultimately fall behind that of the United States and Great Britain, even following the war. Great Britain did not see an influx of French artists due to both being in close proximity to France and being directly involved in the war.

Although Great Britain did not gain many new artists from France, it already had a large base prior to the war. Due to the extent of the war effort, much of the art and written material produced during the war was to increase morale, or was used to understand the conflict. The second generation of Modernism, which began in the '30s, continued on until the end of the war. This generation of Modernism consisted of dark images and straight lines in paintings and drawings. Due to the expansion of mass-produced artwork, high-valued artwork diminished in quantity during World War II in Britain. One genre that returned following the interwar years was the art and writings of soldiers deployed. This gave citizenry an inside look at the emotional consequences of war.

The United States' artistic evolution was similar to that of Great Britain. With such a large influx of artists fleeing from France to the United States, the artistic landscape was affected. In the United States, Surrealism, along with a continuation of the Harlem Renaissance, escalated U.S. art to the top of the international scene. Having the French artists only increased the productivity and demand by art enthusiasts. With the war effort in effect, many artists enlisted in the military to assist the United States. What this did was cause many artists to paint on any available canvas, including the sides of planes. The artwork that was published by military or civilian publications was a representation of how the soldiers saw the war. These representations carried over to the written genre.

World War II saw an increase in the demand for knowledge of the war. With this demand, increases in written publications were seen. This extended past dailies and weeklies in the United States to weeklies and monthlies created specifically for deployed service members. These publications allowed artists such as Norman Rockwell, Alberto Vargas, and Gil Elvgren to have their work not only in civilian publications such as the *Washington Post* and *Esquire* but also in military papers. These publications expanded the audience for these artists and contributed to the large number of planes that displayed imagery originally designed by artists. All of these cultural changes during World War II directly affected what was painted on the planes.

# 8

# Cartoons

When war broke out in Europe, the United States attempted again to project an isolationist attitude. As in World War I, many Americans travelled to Europe to volunteer. Americans also began to travel to Asia to assist the Chinese against Japan. World War II was a two-theatre war. With Germany attacking Poland and fellow European countries, and Japan attacking its Asian neighbors, many former soldiers saw a chance to see combat again. China and Europe both saw U.S. volunteers ready to fly and fight to push back the enemy. It was during this time that many volunteers began to see the atrocities that led to specific changes in nose artwork following the United States' official entry into the war.

Volunteers from the United States served with both the Chinese and Great Britain at the beginning of World War II. Prior to U.S. involvement, the Soviet Union provided the Chinese with both fighter planes and bombers. When the Soviet Union left in 1940, the Chinese requested planes and pilots from the United States to assist them against the Japanese as part of a Lend-Lease agreement.[1] The Americans who served in China were allowed to by presidential sanction and commanded by Claire Chennault. During the winter of 1940–1941 Chennault acquired planes and personnel to travel to China. Many of the pilots and ground crew were active-duty military personnel who were released from active duty to be employed by the Central Manufacturing Company (CAMCO), a private contractor.[2] The Chinese Air Corps was in its infancy, and the influx of American personnel allowed for training opportunities. The Flying Tiger program was so popular that Chennault employed roughly 100 pilots and over 200 ground personnel. This number of volunteers resulted in a command of three fighter squadrons and the creation of the 1st American Volunteer Group.[3]

One of the reasons that this program was so popular with active duty and prior service members was the pay. At this time, the U.S. military was paying roughly $200 a month to a pilot. CAMCO, however, was paying $600 for pilots and up to $750 for squadron commanders.[4] With the Great Depression still on many soldier's minds, it was not surprising that many jumped at this opportunity. Aside from the basic pay, there was also a bonus for every enemy plane that was shot down. Many also joined who felt that this was the right thing to do. The indecision regarding military entry by the United States also prompted many former and current soldiers to volunteer.

Not wanting to repeat the actions of the Soviet Union, Chennault also employed army flight instructors to train Chinese pilots on flight maneuvers and procedures. This allowed

## Part Four. 1940–1945: Same Adversaries, Same Place

the Chinese to create the Chinese Air Task Force (CATF) to gain independent air power instead of always relying on foreign assistance. These instructors soon were assimilated into fighter units, and some went on to fly combat missions.[5] The American unit called themselves the Flying Tigers, and all of their P-40s were equipped with sharks' teeth on the nose. The sharks' teeth were a sign of both a fighting spirit and a level of fierceness akin to a shark. Due to the popularity of the 1st AVG, plans for the creation of the 2nd and 3rd AVG were set in motion. However, the attack on Pearl Harbor on December 7, 1941, caused the United States military to recall both the troops and planes from the 2nd and 3rd AVG.

The 1st AVG was not recalled and started to see battle soon after the attack on Pearl Harbor. During the winter and spring of 1942, the 1st AVG was highly regarded for its abilities against Japanese forces. Not only was their nose art formidable, but with combat bonuses paid for almost 300 downed enemy aircraft, the pilots were too. During the early months of the United States' involvement in the Pacific region, the Flying Tigers assisted in dividing the Japanese military's attention. As the United States military moved towards China, the AVG was replaced with the 23rd Fighter Group. The 23rd maintained not only the nickname but also the nose art. The teeth of the AVG were just the beginning of what is now considered the golden years of nose art.

The years of World War II were full of art placed on planes and in printed material for soldiers. With the scope of the war came a massive increase in personnel and aircraft. Some of the pilots and ground crews either had served in World War I or were relatives of former air crew members. This heritage created an atmosphere accepting of nose art. Soon there were thousands of designs on planes. During World War I there were more planes without designs than with. World War II was the polar opposite.

Even though there was artwork on a large percentage of the planes, most artwork can be placed in at least one of six categories. These six categories are in no way exclusive, and many paintings could be placed in two or even three categories. These categories are sentimental, characteristic, female, cartoon, racist, and location. These categories were created by viewing artwork from the time period and noticing a pattern. This pattern has elements of culture associated with what was painted on the plane. In some cases the reason behind the design was more important than the actual design. Each category will be accompanied by artwork that best exemplifies the culture and reasoning.

With an increase in planes came an increase in accidents and deaths. All three countries encountered death and destruction on a daily basis, since in combat or during training, accidents occurred. To counter accidents and injuries many crews aboard combat planes took it upon themselves to promote their own safety. Superstitious nose artwork, while also present during World War I, really took off during World War II. If the frequency of superstitious images represents overall feelings of superstition, then aircrews of World War II were greatly more apt to use good luck charms than those of World War I.

Many crews began to believe that nose art could increase survivability. Some airmen honestly believed that World War II would be lost without painting creations on the sides of planes.[6] One graphic that was widely used was "Superstitious Aloysius" (fig. 42), a good-luck elf, complete with "wishbone, horseshoe, four-leaf clover, tied string (on his nose), and

## 8. Cartoons

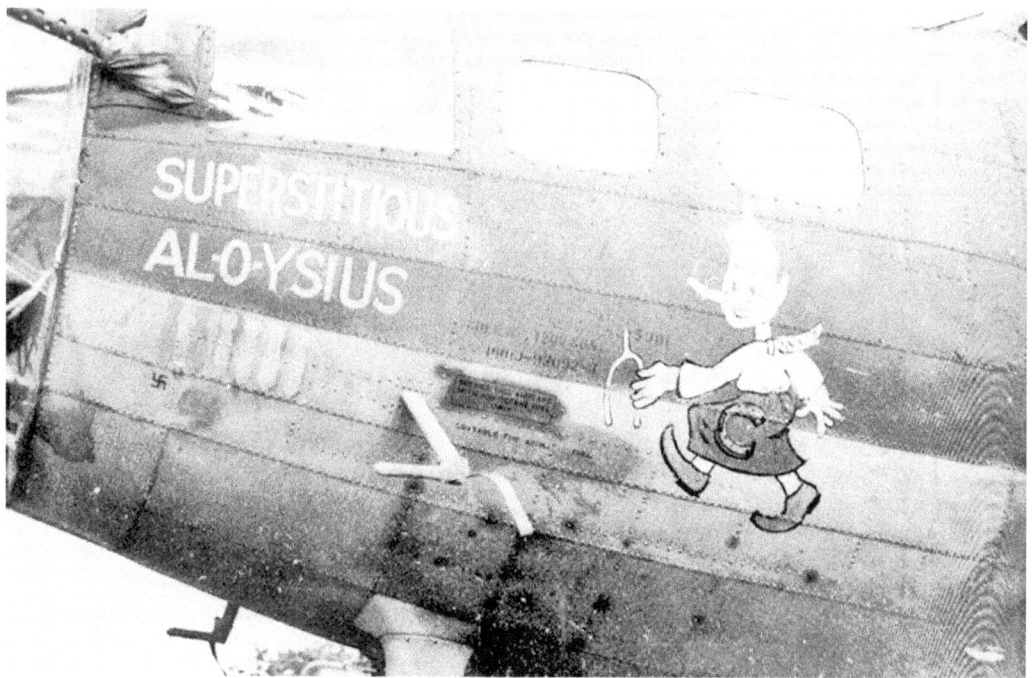

Fig. 42. Every time the pilots took to the air they put their lives on the line. For that reason, many were highly superstitious. From four-leaf clovers to wish bones, a variety of images were painted. If the pilot did not think that one image was enough, "Superstitious Al-O-Ysius" was painted. This image was seen on multiple planes and consisted of an elf with a horseshoe, a four-leaf clover, a rabbit's foot, and a wishbone (courtesy 91st Bomb Group, H).

a rabbit's foot while crossing his fingers."[7] There is no evidence supporting or discrediting the effectiveness of Aloysius, but the sentiment was there. This belief about survivability in some cases, however, was not just local legend, but reflected a true story about how a plane brought her crew home safely, even when she was damaged.

One specific case of this was *Satan's Lady*, an American B-17G that was assigned to the 369th BS, 306th BG crew on October 1943. The name originated from the fact that the pilot's original plane was called *Satan's Mistress* and he found the name fitting for his second plane.[8]

*Lady* was remembered as the ship that brought her crew home. She logged in 112 missions "without a mechanical failure and always came back on four engines. She was shot quite a bit but with a lot of patching up and repairs it was off to another mission." As air crews during this time rotated home following their 25th mission, many requested to be on *Lady* for their last mission. Of all the crews who completed their 25th mission on her, no one was ever injured and no one received the Purple Heart.[9]

Other forms of sentimental nose art are designs that have meaning for the pilot and/or flight crews. The designs' meaning came from a variety of places, such as heritage, important people, or the war the crew was currently engaged in. The naming of planes usually was

Part Four. 1940–1945: Same Adversaries, Same Place

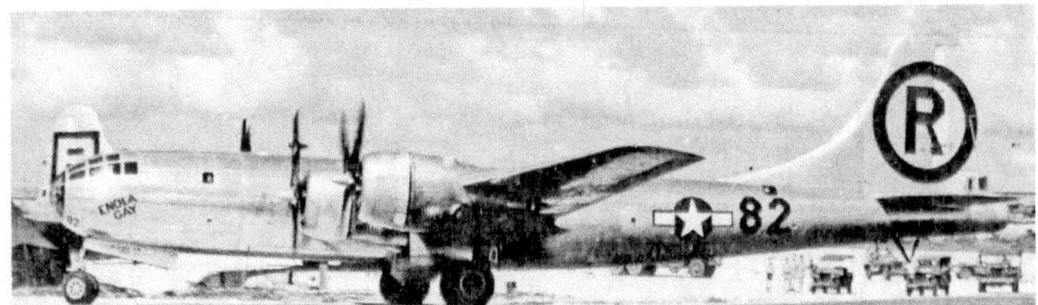

Fig. 43. The *Enola Gay*, a historic B-29 that carried one of the atomic bombs dropped on Japan, was named after Colonel Paul Tibbets' mother (courtesy National Archives).

associated with women who were important to the pilot or crew. One well-known plane, the *Enola Gay* (fig. 43), was named after Col. Tibbets' mother.

Another plane painted specifically for someone was the *Ruby's Raiders*, commemorating a young woman who won the "Most Beautiful WAC in the ETO" competition. It was not long before Ruby Newell was painted on dozens of planes in the European theatre.

Women were not the only sentimental designs painted on planes, however. Other subjects for this type of artwork can be seen on the *Sweetest of Texas* and the *Ish-Tak-Ha-Ba* (fig. 44). The B-24 *Sweetest of Texas* was piloted by a man who was born and raised in

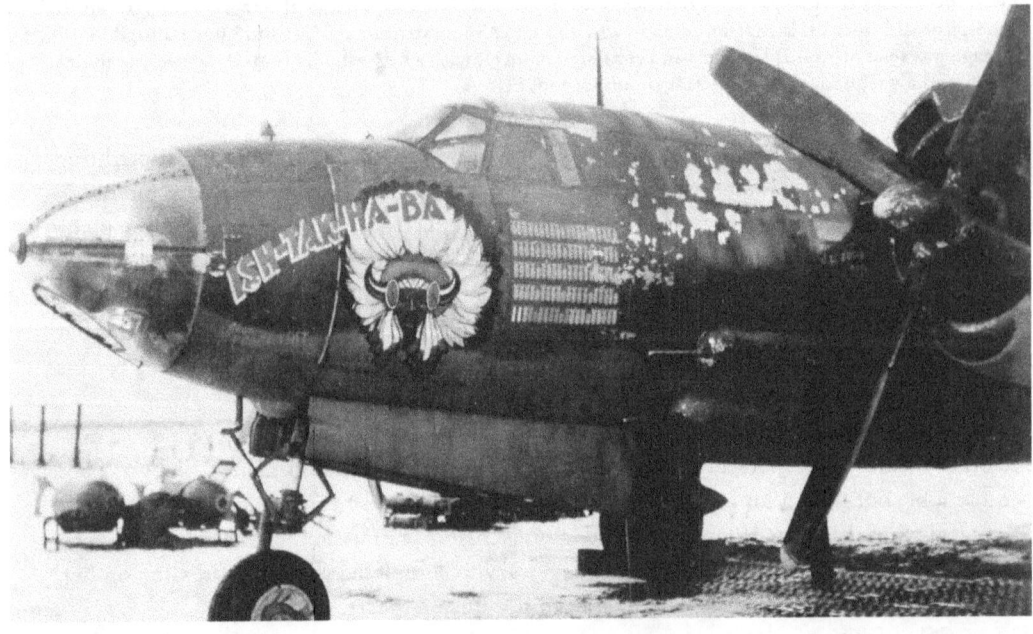

Fig. 44. Planes were at times named for states, or locations that were important to the air crews. Lt. Martin Harter from Sleepy Eye, Minnesota, was the pilot of *Ish-Tak-Ha-Ba*. "Ish-Tak-Ha-Ba" means "Sleepy eye" in a Native American language (courtesy National Archives).

Texas.[10] *Ish-Tak-Ha-Ba*, a B-26, was piloted by Lt. Martin Harter from Sleepy Eye, Minnesota. "Ish-Tak-Ha-Ba" means "sleepy eye" in a Native American language.

These, along with many other planes, brought a piece of home with them on the long flights and difficult missions.

Characteristic markings and artwork were usually chosen by the crews who flew and worked on the planes. Planes that were created for a specific purpose usually were aptly named. *Klondike Kodak*, an F-15, was named after its sole job during World War II, which was to take pictures. The plane's armament bays were filled with camera equipment instead of munitions.[11] The *Kodak* was originally placed with a night fighter, and these two planes could cover vast distances over large amounts of time. This tandem, however, was not fully utilized during World War II due to needs elsewhere. Two other examples of mission-specific naming were *Chow Hound Junior* and *Somewhere I'll Find You*. *Chow Hound Junior* was a B-25D whose main mission was to carry provisions from May to July 1945. As this was a stripped-down model specifically created to carry supplies, a group of fighters accom-

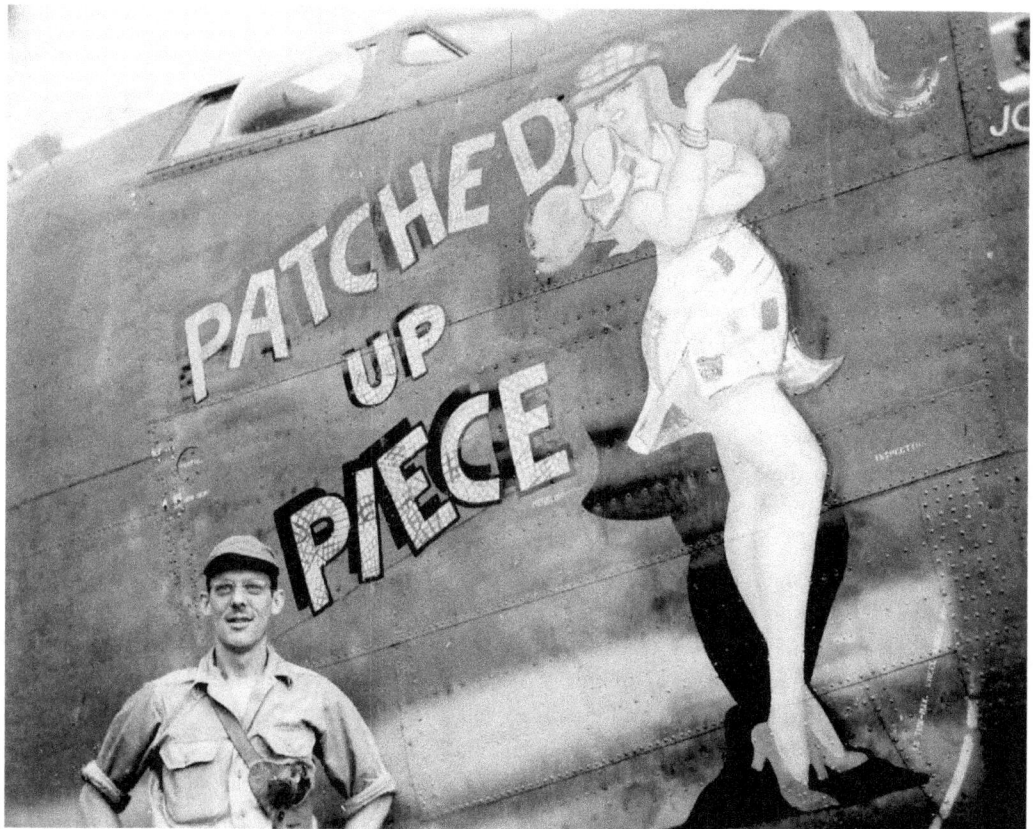

Fig. 45. Descriptive paintings were very popular, as in the case of *Patched up Piece*. This plane was aptly named due to the numerous pieces and parts that came from other planes to make it flyable (courtesy National Archives).

Part Four. 1940–1945: Same Adversaries, Same Place

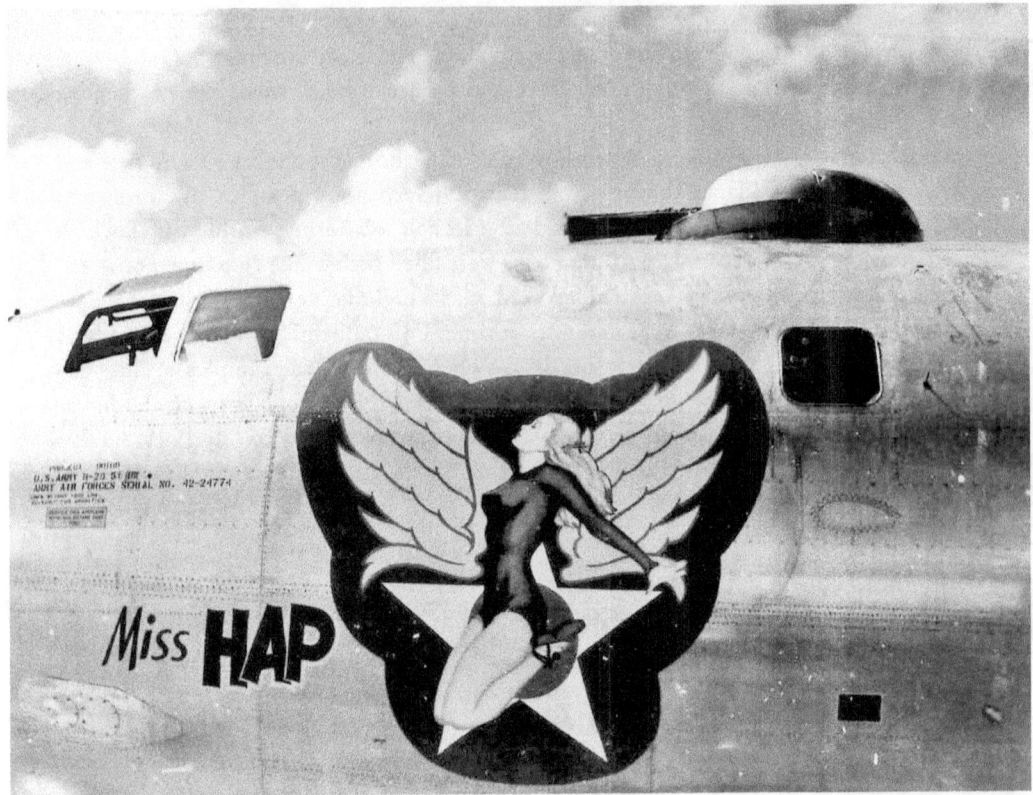

Fig. 46. Another plane that named itself was *Miss Hap*. Although the story is unclear, it appears that this plane had many accidents during its careers.

panied *Chow Hound* on all its missions. The design was that of an orange dog proudly carrying a picnic basket laden with oranges and eggs. This painting was one of the larger paintings, taking up the entire nose.[12] A somewhat more sentimental naming occurred with *Somewhere I'll Find You*.

*Somewhere I'll Find You* was a plane created by the United States for rescue missions in the China/Burma/India combat area. Due to both weather and geographical conditions, many planes were lost over this area. This plane was a cherished yellow C-47 whose sole purpose was to find those who might otherwise have been lost forever.[13] As this plane saved not only Americans but allies as well, it was cherished by all who saw her. The name came from a popular American song and movie as well as the mission.[14]

Characteristic names also came from the planes' personalities.

Two planes that were named after maintenance issues or general plane quirks were *Patched Up Piece* and *Willit Run? Patched Up Piece* (fig. 45) was a B-24 so named because every time the crew flew this plane, something went wrong and needed to be repaired. It was not long before the plane was a mixture of multiple planes' parts. The name was not officially decided until a routine flight from Australia to New Guinea. During this route,

8. *Cartoons*

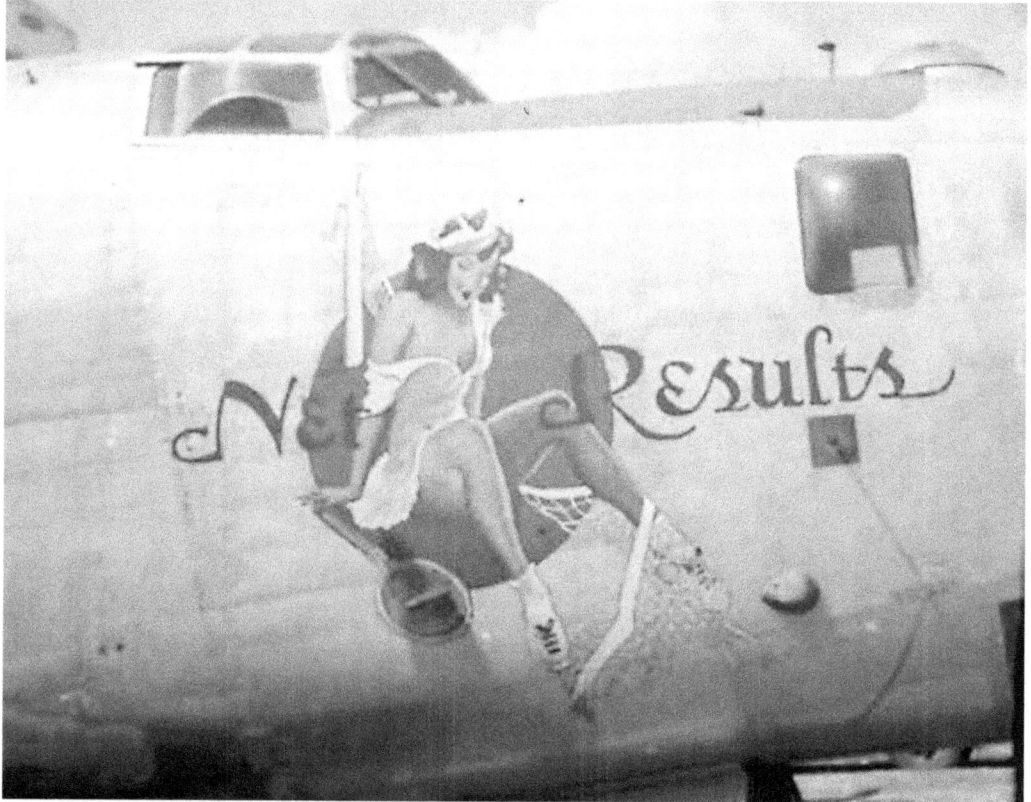

Fig. 47. Gil Elvgren, a very popular artist during World War II, created images using semi-clad women. These images were frequently used on publications that reached the troops. *Net Results* was a direct reproduction of his image (courtesy National Archives).

the crew ran into rough air and realized that without new parts, the trip might not end well. It was at this point that the crew realized this plane consisted of so many different planes that she was truly a patched-up piece.

Every morning when the crew of the P-51 *Willit Run?* went to start the engine, there was a chance that the plane might not start.[15] Even with a pristine maintenance record and routine check-ups, this plane chose when and for whom it would start. The plane's decision to not start may have saved its crew on a couple occasions. Missions that the plane and her crew were supposed to be on, but due to mechanical issues were unable to perform, resulted in lost aircraft. Whether the trouble in starting came from cold weather or a sense of foreboding, the crew aptly named her and continued to fly.

One more plane that I found interesting is *Miss Hap* (fig. 46). I am unsure of the history other than that it served in the Pacific and was a B-29.

Many of the sentimentally named planes and those reflecting the planes' personalities included women as part of their artwork; woman-inspired artwork, though, constituted less than half of all nose art during World War II.

Part Four. 1940–1945: Same Adversaries, Same Place

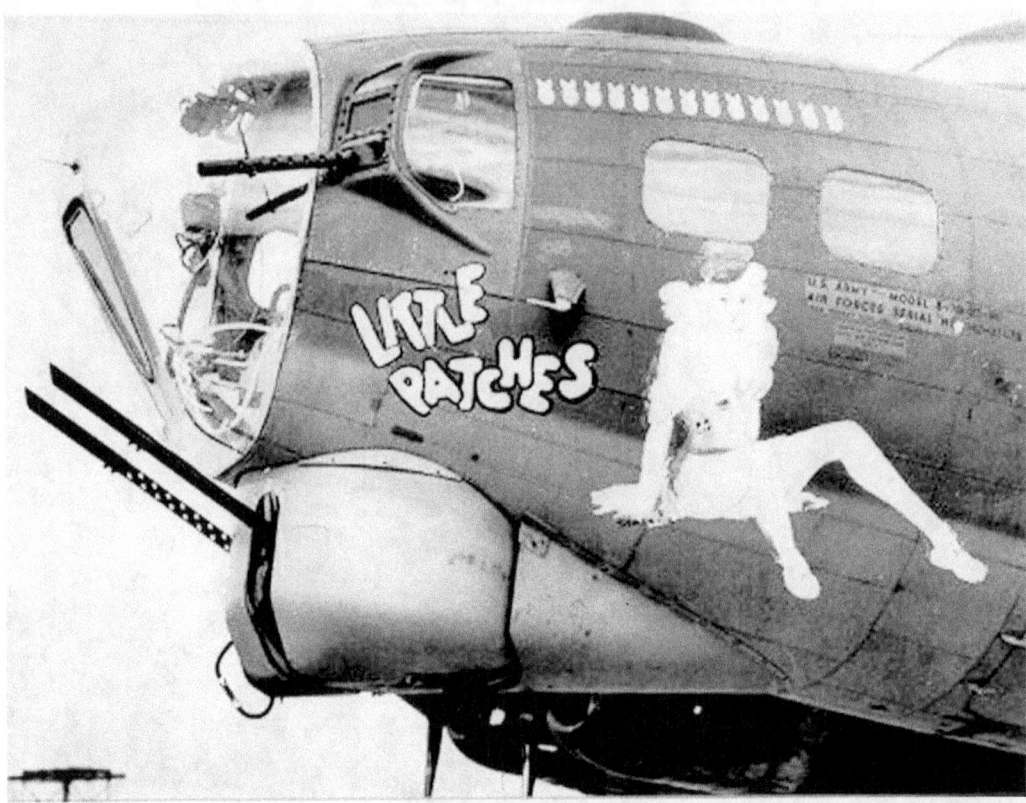

Fig. 48. *Little Patches*, with another reproduction of Gil Elvgren's tennis girl, used only the girl and omitted the net and tennis racket (courtesy National Archives).

In the 1940s many artists such as George Petty, Alberto Vargas, and Gil Elvgren began to create pinups of women for magazines and matchbooks. These became the inspiration for many of the crews looking for proper symbols for their planes. While all three of these men actually used wives and female family members for their muses, the designs were mostly produced in their imaginations. These men created the motifs for not only single soldiers' dreams while overseas, but also out of a new respect for the female body and its usages in artwork. Vargas' artwork became the staple if one wanted a nose art design to be reproduced from professional artwork. While many crews sought out articles and advertisements for ideas, there were also plenty of drawings that were unique to the artist. One popular Elvgren painting was of a woman wearing a white dress that is falling off one shoulder. Her pleated skirt is riding up as she is sitting on a tennis court net. To complete the picture there are a racket and ball. This pose was recreated on at least two planes: *Net Results* (fig. 47) a B-24 that directly copied the artwork, and *Little Patches* (fig. 48), a B-17 with just the woman from Elvgren's imagery.

Knowing the desire of deployed soldiers and seamen to have pinups, the United States created comic books whose back was a full-page painting of a woman. With so many young,

unmarried men deployed on flight crews, it is not surprising that women were portrayed on the planes' noses. Although these men sometimes transferred their desires to the noses of planes, many times the images were left to the inside of planes and barrack rooms. One of the popular methods of viewing women was in magazines that contained not only photos of women but also stories for and by soldiers in the field.

This type of magazine consisted of a front cover with a storyboard regarding the picture. The painting *Naval Maneuvers* was of a woman dressed in Hawaiian garb with a naval officer's hat on. The front cover showed a woman performing the hula in front of admiring navy fans.[16] This drawing was replicated on both the B-29 *This Is It* and the B-25 *Incendiary Blonde*. The clothing and nationality of the model on the B-25 was different than in the original painting, yet the pose was the same.

The first three categories were created by plane characteristics and crew. The following two categories were created by circumstances of military assignment and outside influences.

Mickey Mouse and his cartoon counterparts maintained their popularity at the beginning of World War II. Cartoons were directed towards civilian populations and the military during the early years of World War II. This caused an increased level of popularity, as service members were able to read cartoons and comic books even out in the field, in military

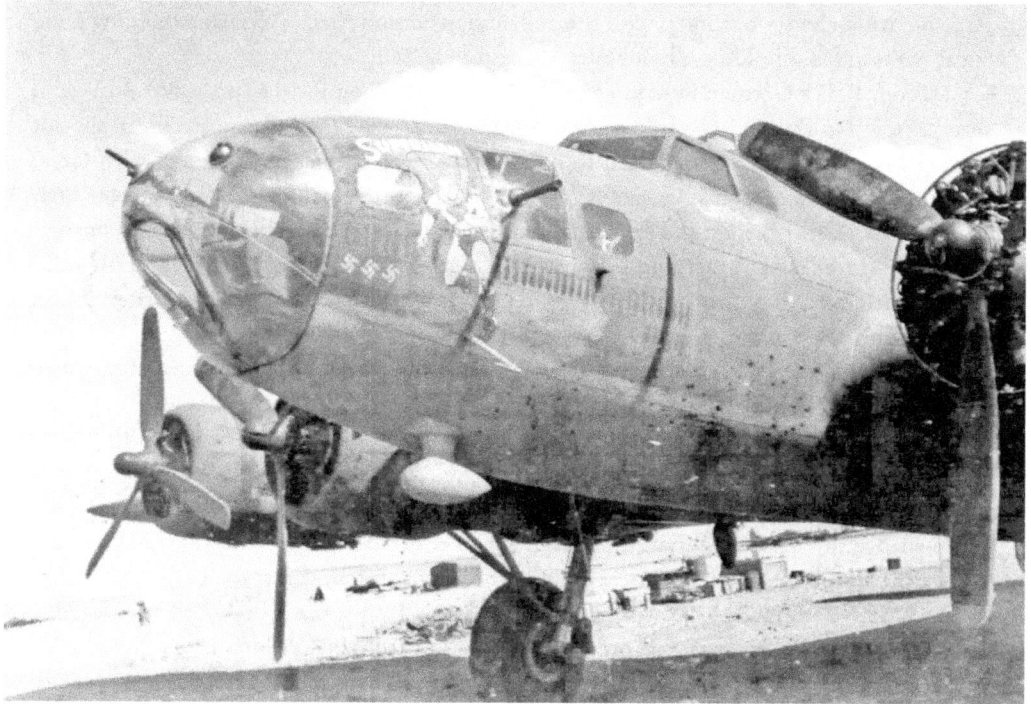

Fig. 49. Many airmen began reading comic books in the mid to late 1930s. During World War II, comic books helped to fill a gap that service members were feeling due to being away. Superman, one of the most popular comic book characters during World War II, easily transitioned to the nose of planes (courtesy National Archives).

## Part Four. 1940–1945: Same Adversaries, Same Place

magazines. Due to this popularity many planes were equipped with cartoonish figures. Superman, a DC comic superhero, is seen in figure 49 on a B-17 stationed in North Africa that had over 17 different engines as well as over 300 flak and bullet holes. Apparently the aptly named plane was in fact only susceptible to kryptonite.

The cartoon category is by far the most diverse, with everything from Disney to storybook personalities and zodiac figures. Pilots were able to identify with some Disney characters. Many planes had Mickey Mouse or Donald Duck. *Big (Ball) Buster* was a B-29 that had Bugs Bunny with a carrot in a pocket and Bugs giving a thumbs-up to dropping the large bomb that he is carrying.[17]

At times the artists created entire sets of paintings for a group of planes that were associated with each other. The 343rd Bombing Squad 98th Bombing Group 9th Air Force was painted with the story of *Snow White and the Seven Dwarfs*.[18] Each plane was painted with a different dwarf. Prince Charming and the witch were also included with this set.

Sometimes it was not the crew that decided on a specific cartoon figure. If the crews were unsure what they wanted, they hired artists to paint something on the nose. One such artist was Philip Brinkman. He was not only an active duty member of the 486th Bomb Group, but also a popular artist. His Zodiac creations were individual paintings that were part of a larger set. These paintings were well liked and in great demand. An example is his *Gemini*, which has two women with the zodiac sign behind them.[19] They are holding identical twins and are holding a bomb, preparing to release it.

From 1939's German invasion to the Japanese attack on Pearl Harbor, World War II was centered in Europe. This allowed European countries to focus their attacks on specific regions. British planes soon started to fly against the Germans. France along with Great Britain declared war against Germany in 1939. During the remainder of 1939 and the early part of 1940, Great Britain and France fought Germany in occupied France. The supposedly superior air forces of France and Great Britain were decimated by the German Luftwaffe. France surrendered to Germany in 1940, and for the rest of the war France engaged in almost no air combat.

Following the Battle of France, Germany wanted to destroy the French military as it had during World War I. Not all the planes were destroyed. The planes that were not damaged by the Germans were transferred to Oran in northern Africa. Great Britain feared that France's military assets would be used by the Germans as an extra asset. In an attempt to take French navy vessels out of combat, Great Britain requested the French navy admiral Marcell-Bruno Gensoul to move the navy fleet to either British or U.S. waters. When the French admiral refused, the British admiral ordered an attack against the French navy. The Vichy navy was attacked by Great Britain in an attempt to persuade France to change sides. According to some historical records more than 2,000 French sailors were killed during the British attacks. In response to the British attacks, Vichy France retaliated. It was at this point that all Vichy airplanes were given specific markings to distinguish them from other European planes. The Vichy planes did not have nose art per se but did initially have bright yellow tails, which later were given red and yellow stripes. The French roundel, which was popular during World War I, was still present. From 1940 through late 1942, Allied forces

## 8. Cartoons

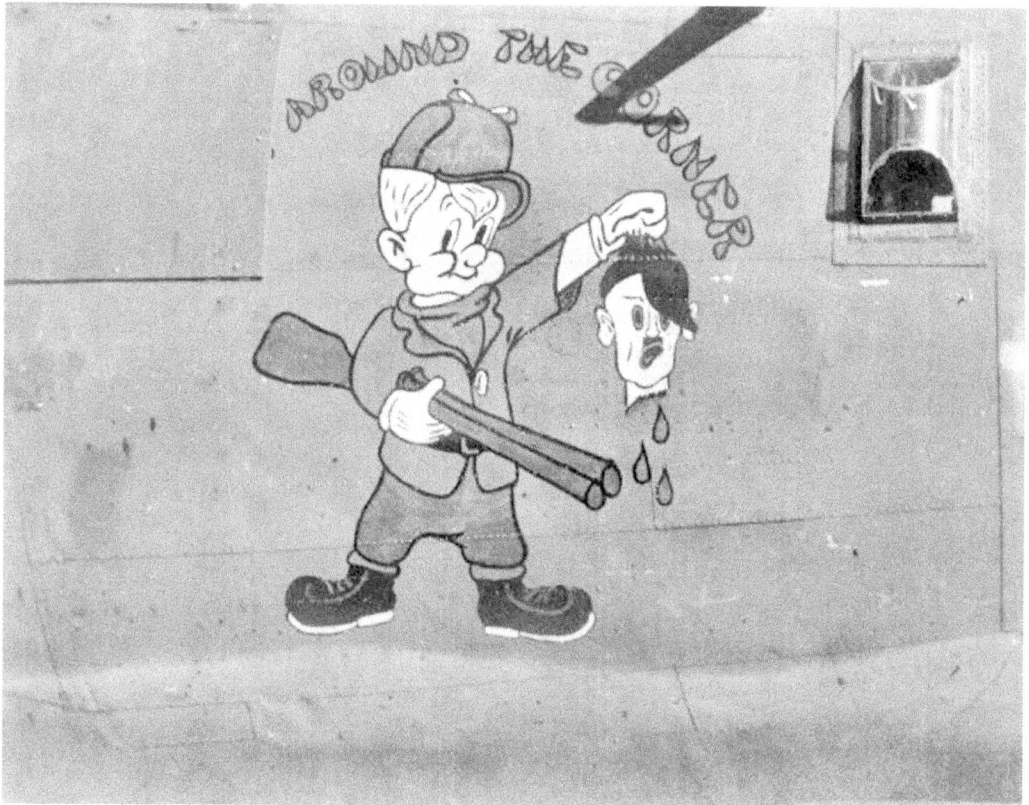

Fig. 50. There were times that the images painted were too risky even for the military. This image of Elmer Fudd was considered dangerous in the event the plane went down in German territory. The crew was asked to redesign the image (courtesy 458th Bombing Group).

were in combat against not only the Axis powers but also the Vichy French in northern Africa. It was during this time that another group of French pilots were fighting on the side of the Allies.

The Free French Air Force also served in northern Africa during the years of 1940–1942. In attempts to not be attacked by Allied pilots, the Free French pilots took on another symbol, the Cross of Lorraine. They even went so far as to create a French flag with the cross in the center of the white stripe. In 1943 the Vichy French and the Free French air forces combined to create the French Air Force. The symbol that the French Air Force used was a combination of the Vichy roundels and the coloring of the Free French flag.

The French Air Force mainly fought in Africa, and so location-specific nose art was not as prominent with France as with the United States. The main types of nose art seen on French planes (other than the traditional roundels and the Free French cross) were sentimental images and cartoons. Many of the cartoons were political cartoons from French and American papers and American cartoons. These cartoons included Mickey and friends along with Popeye and other popular characters. There were times that cartoon characters

Part Four. 1940–1945: Same Adversaries, Same Place

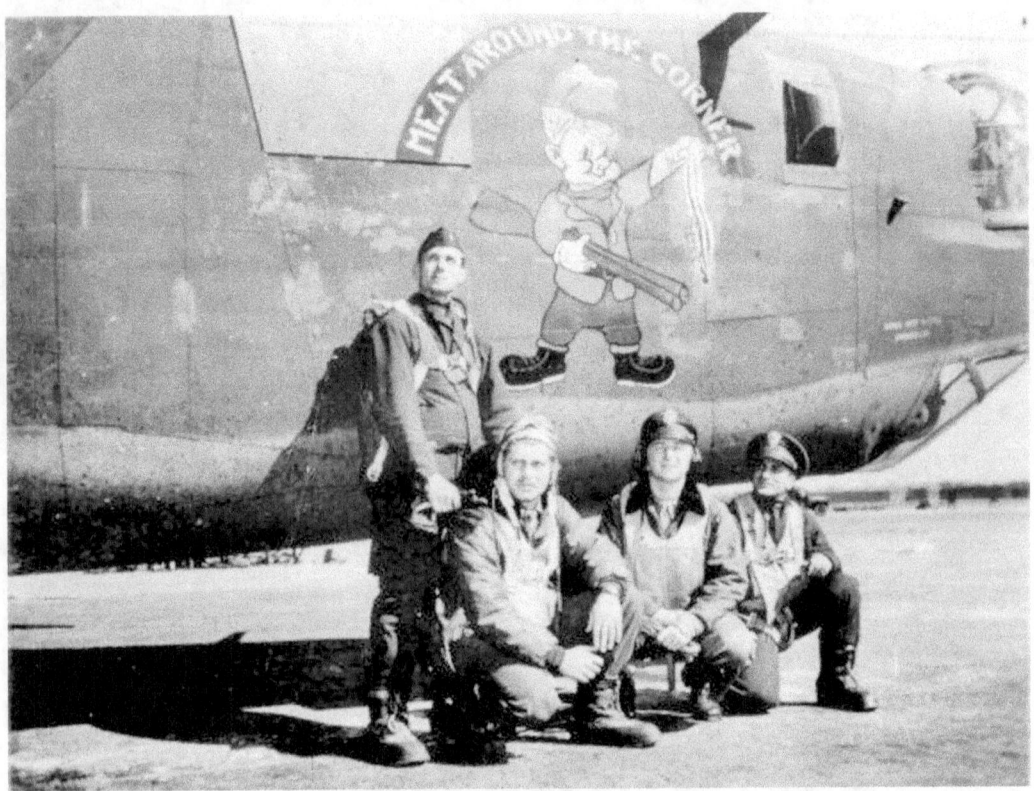

Fig. 51. "Meat around the corner" is the redesigned image, with Elmer Fudd holding a piece of bacon instead of Adolf Hitler's head (courtesy 458th Bombing Group).

were deemed "too hazardous to the crew's health" and were asked to change it. Elmer Fudd was changed from "Around the Corner" to "Meat Around the Corner" (figs. 50 and 51).

When the United States entered the war, the combat soon took on a two-theatre aspect instead of being centered on Europe. Great Britain, not having the strong desire or need to travel to Asia, maintained a strong force against Germany in the English Channel. This split of American forces affected the nose art that was placed on planes. Planes in Europe showed a drastic difference in location-specific artwork from those stationed in the Pacific theatre.

Planes that were flown in the Pacific had many references to Pacific Rim culture. Planes such as *Pacific Passion* and *Yellow Fever* were specific to fighting on the western coast of the United States. *Pacific Passion*, decorating the side of a B-24, was an image of a woman who resembled a Hawaiian Hula dancer.[20] While topless, she had a lei around her neck and smaller leis on her ankles and forehead. It was apparent that this plane was stationed either at a Hawaiian airfield or in another Pacific Island country. This assumption is based on the fact that the Hula dance is primarily a Pacific Islands dance and the name on the plane is *Pacific Passion*. *Yellow Fever* is more location-specific, to Japan. In another drawing, a woman

8. Cartoons

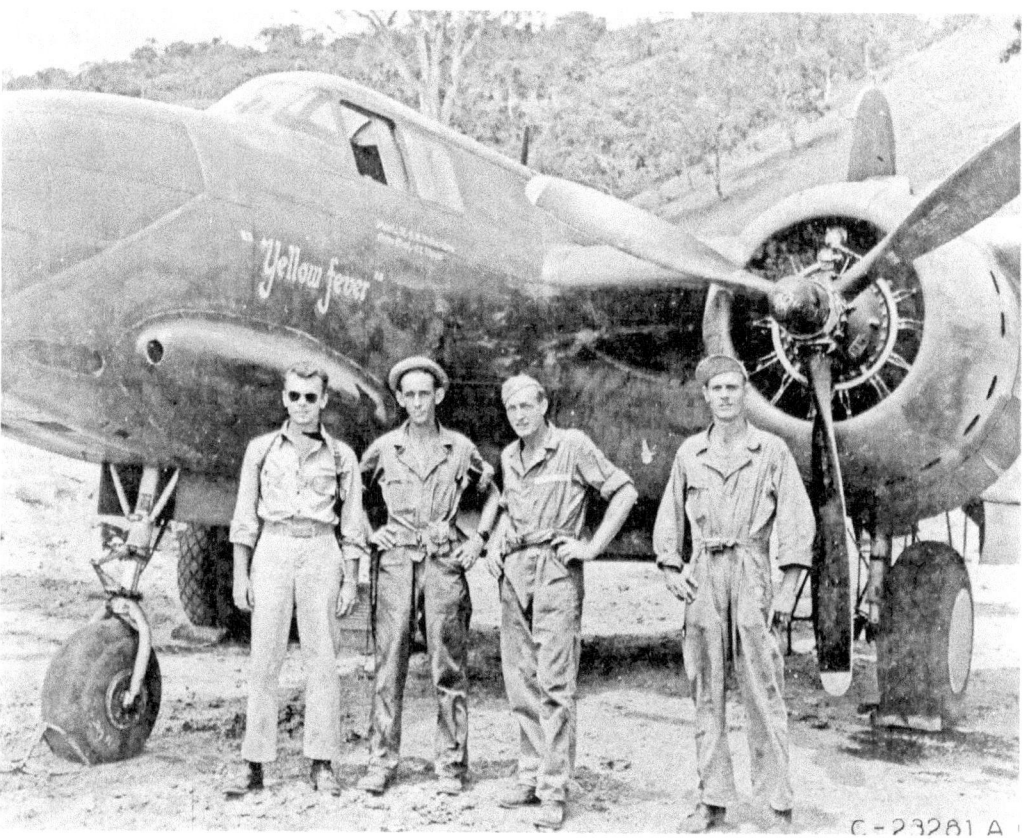

Fig. 52. It was not only Germany that the United States portrayed negatively on the side of planes. *Yellow Fever* was a direct comment on how the Japanese had yellow skin (courtesy National Archives).

is wearing a top but no pants and is obviously of an Asian heritage, by the slant of her eyes and the hair style. The shirt that she is wearing is of Japanese creation.[21] *Yellow Fever* was seen on multiple planes in the same geographical area (fig. 52).

European planes were less tactful with regards to who they were fighting. Planes that sported location nose art in the European conflict had some representations of what the United States and its allies felt about Germany. *Can Do* was a B-17 that had on her nose a coat of arms including a swastika breaking up under the pressure of a wing-guided hand carrying a bomb.[22] It is quite obvious what the purpose was of *Can Do*. The most visually accurate depiction was on *Desperate Journey*, another B-17. *Journey*'s nose art was of a bald eagle that held Adolf Hitler in its claws.[23] A character that was a common starting point for nose art was Hitler, such as on the *E-Rat-Icator*, which showed him as a rat (fig. 53). This plane was also a B-17 located in Europe with the 452nd Group.

Great Britain also saw nose art work that was location-specific. Great Britain did not experience the revitalization of nose art that the United States did. It is not entirely clear why the artwork did not come back to the same extent that it did in the United States. The

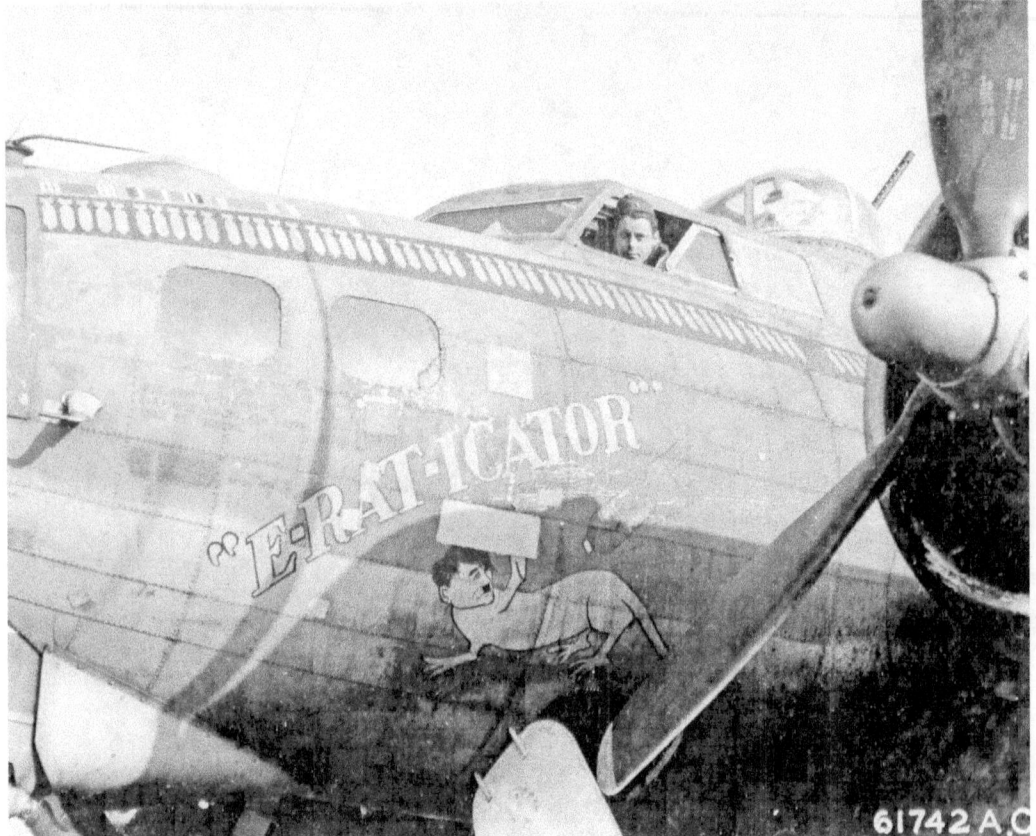

Fig. 53. Adolf Hitler was commonly a figure of ridicule on the side of planes. In this image Hitler was represented as a rat with a bomb coming towards him with "Rat Poison" written on it (courtesy National Archives).

art work on British planes was subdued compared to U.S. planes. Unit badges along with serial numbers were widely seen on British planes. Women, cartoons, and location-specific nose art were still present but in smaller amounts than in the United States.

*Lady Orchid* and *Red Headed Woman* were two planes that were painted with semi-clad women in sensual poses. Due to the proximity of many planes to British cities, not many planes were able to have images that might have proved offensive. The farther the planes were based from their home countries, the more artwork was found. This may be one reason why most of the British planes did not have large designs, while U.S. planes did. Planes that were stationed away from home countries also had less women involved with the planes than those stationed in the United States or Great Britain.

Many nose art designs were created by men or for men. However, two designs that were specifically created by women and for women lighted up the skies during the later years of World War II. *Pistol Packing Mama* was the name of planes flown by both the United States and Canada that were crewed by women. These planes never saw combat,

but they were used during training. Additional planes may have been named the same, but the originals were created by female flight crews. This was not the last time that women were involved in the creation or application of nose art.

At the beginning of the war many women started the push to join the military in similar fashion to World War I. The difference between World War I and World War II was that many countries' thoughts regarding what women should do for professions had changed during the interwar years. Women gained independence during the interwar years and started to fly in private organizations. World War II saw many new organizations and agencies that accepted women for assistance during the war. The military acknowledged that women who served during World War I as nurses and clerical staff were successful in their assigned fields. These women and a whole new generation saw this as another war with a place for women to serve. Women used the interwar period to learn to fly. This training gave women the experience needed to assist the United States and Great Britain's military forces. The United States military realized that with a two-theatre war, women were needed to subsidize the loss of male soldiers. At first the United States military only used women for nursing and clerical staff, as in World War I. Women were willing and able to do more than these two professions, and the military reluctantly allowed them.

The military, handling a two-theatre war and a high operation tempo, needed more service members. With women attempting to enlist in other fields than nursing, the army saw a wealth of personnel previously unused. Some of the senior leaders did not want to integrate women into the services. December 7, 1941, was the event that finally pushed army officials into allowing women to join fields other than nursing. Women arrived in droves at enlistment offices. The first unit that was created by the United States military was the Women's Army Auxiliary Corps (WAAC). When women started to train at the first WAAC training center at Fort Des Moines, Iowa, other branches of the military began to contemplate allowing women to join the ranks. With a slight nudge from First Lady Roosevelt, the navy authorized an all-woman navy and marine reserve. The navy called their unit the Women Accepted for Volunteer Emergency Service (WAVES). The coast guard, not wanting to be the only branch that rejected women, created the SPARS, which came from the coast guard motto *Semper Paratus*. Following the coast guard's creation of the SPARS, President Roosevelt signed a law that the WAAC was to be the Women's Army Corps. This resulted in women being part of the military and not an auxiliary unit.

This increase in women serving in the military led to women serving not only in the United States and Great Britain but also in combat areas. Many WACs served in Europe and north Africa. Women were used not only for nursing staff but also in clerical fields. This meant that where the American combat units travelled, so did women. When the war heated up in the Pacific theatre, the military began to move many female service members to Asia to assist already-established units and bases. The increase of women in combat areas created an atmosphere that affected nose artwork. The involvement of women with nose art were not as expected. Women did not object to nose art, and in fact in a few instances they assisted the male crew members in the design and naming of the planes. Some think that the reason women created female paintings was to somehow be accepted

by their male counterparts. However, in multiple sources there is a theory that women knew what art did for the morale of the troops, and in the few cases that the artwork was considered too obscene, the flight crews usually adjusted the paintings to reflect the objections made by female crewmembers.

When the war ended, many of the planes previously adorned with nose art were scrapped and flight crews returned home. At this time, many believed that World War II would be the last war they would see. The military created regulations regarding the usage of nose art. It was not long before France, however, was embroiled in conflict, soon followed by Great Britain and the United States. The following conflicts were fought almost consecutively. Military culture did not have time to drastically change between World War II and the conflicts of the 1950s.

PART FIVE

1945–1953:
The Start of the Cold War

# 9

# Rock a Billy

During the Korean War individuals were wary of enlisting in the military. World War II had been over for less than five years, and many soldiers and civilians alike were unsure about jumping into another conflict. The United States, afraid of losing the majority of soldiers and sailors that served during World War II, continued to employ the draft. The draft was used in both World War I and II with positive results. World War I and World War II had nationalistic connections that the Korean Conflict did not have. When the Korean Conflict began, the United States did not have enough soldiers in the regular army and used the draft to supplement those who enlisted. Great Britain did not enlist using the same methods as the United States. Great Britain used colonial residents as draftees by promising full British citizenship to combatants.[1] France was not active in many conflicts and therefore was able to use both the French Foreign Legion along with French units to ensure that enough troops were available if needed. These differing methods of recruitment and drafting affected how each country felt about the military and any conflicts that arose. These militaristic attitudes went beyond the military and affected how civilian culture evolved.

Following World War I many attempted to return life to prewar standards. This was also attempted after World War II, but life had changed more in the years of World War II than previously. The cultural trends that were just beginning during World War II expanded during the Korean Conflict. Every part of culture was affected, even though the Korean Conflict was not as geographically broad or economically draining as World War II. As before, advancements in culture changed how people saw life and what was painted on airplanes. Clothing was the first element of culture that was affected by the end of the war and also showed some of the most drastic changes in a short amount of time.

The war created a change in how clothing was viewed. Women expressed themselves with what was available. Couture clothing was seen as lavish and in Great Britain was actually illegal to buy or sell. One fundamental change in clothing and all of culture was the creation of a teenage consumer population. The generation began to directly influence how culture was seen and developed following World War II. Following the war and the loosening of rationing in France, the designers bounced back.

In an effort to visually display that the war was over, the French designers created lavish garments with excess cloth. Dior created a drastic change from the uniform outfits of the 1940s to feminine, long skirts of the 1950s.[2] Jackets with wide shoulders and tight waists became popular. Not all the French critics liked Dior's designs, and Chanel jumped

on the chance to create outfits without the boned bodices that Dior was fond of designing. Prior to and during World War II, female teenagers dressed and acted like their mothers. During the years following World War II, these same teenagers began to change their appearance in an attempt to look their age or younger. Chanel saw this change and designed clothing for both adults and teenagers. This allowed teenagers to begin to develop their own personality in culture.

Great Britain during the war was able to maintain a level of clothing designs that France was not. Following the war Great Britain maintained a high level of rationing that upset many of the citizenry. This was especially true with cloth. Great Britain in an attempt to gain economic stability continued rationing certain types of cloth and only exporting it. Citizens saw French designers jumping back from the war with many new fashion designs. The British government even seemed to flaunt their exportation status by having the Festival of Britain exhibition in 1951. The festival showed over 6,000 new designs in fabrics that many British citizens had not seen before. The visitors at the festival saw this as both depressing and wonderful. The depressing fact was that almost all of the clothing was labeled "for export only." However, due to the advancements in synthetic cloth and colors unseen before, many saw this as a first step in British excellence in fashion. The British historically had competed with France as the fashion leader of the world. Following World War II, however, Great Britain began to compete against the United States for fashion predominance.

The United States during World War II started to create designs centered on sportswear and not the glamor that Europe was previously known for. Following World War II the United States began to create not only the sportswear that made the designers a force to be reckoned with during World War II but also glamorous clothing. These glamorous designs created a flurry of activity in Europe as fears grew that the United States was going to be the fashion capital of the world. The United States gained an upper hand following World War II with an expansion of two important clothing lines: jeans wear and sporting wear. While not solely made in the United States, these two clothing lines gave the United States a large advantage over its European counterparts.

Clothing overall changed from a polished, refined look for women to a slightly more informal and comfortable style. This style change was not as pronounced for men as it was for women. About the same time this change in clothing occurred, a change in music began to become apparent. This change affected all three countries during the years following World War II.

France, attempting to rebuild economically and militarily following the removal of German forces, did not spend much time or energy on music. However, there was a small group of musicians that used the turmoil to produce popular music. Three such musicians used their experiences during World War II to create music enjoyed by many. Georges Brassens, Leo Ferre, and Charles Aznavour expanded on national and international concerns to both empathize with and increase awareness of political and economic events. All three of these artists were known for the musical style of *chanson francaise*. *Chanson francaise* simply means "French song"; the style was unrelated to any of the musical movements that were evolving in Great Britain or the United States.

Georges Brassens, having survived a German work camp, wrote many of his songs while living in the work camps. Many of these songs did not survive long enough to be recorded. The songs recorded were derived from personal experiences and his own anarchist beliefs. Some of his songs gained such popularity that they were included in soundtracks for French movies. Leo Ferre, also an anarchist, created new styles of music by combining monologues with prose set to music. Ferre also added music to poems created by fellow French poets. While Brassens and Ferre gained prestige primarily in France, Charles Aznavour was known outside France for his music. Aznavour was known for his music, which spoke of romance and pain.

France's music scene developed at a slower pace than that of Great Britain or the United States. Following the end of the war, music in Great Britain mostly stayed the same, with the addition of a new genre of music. This new music was formed by a shift in musical thinking and as a result of the continued rationing program. Musicians who saw a decrease in classical music's popularity started to acquire common household items to create music. In this musical style, known as "Skiffle," musicians used pots, pans, and other ordinary items to create music. It is believed that this may have been the precursor of British rock and roll, which evolved separately from U.S. rock and roll.[3]

Music in the United States following World War II began to change due to a movement of ethnic populations in addition to an increase in younger populations. Country music was once considered a genre mainly located in isolated regions around the United States. During the early 1950s, country music began to gain a wider appeal. The Grand Ole Opry was a destination for many country music enthusiasts. This travel allowed for many to gain a deeper appreciation of the history and evolution of country music. Country music did not stagnate, but was ever changing due to external conditions.

A combination of Southern, African American and country styles with a growing exodus of Anglo and Celtic populations coming from remote regions created new genres of country music. Banjos were used mainly in the South to create the bluegrass genre. Northern country music was created by using guitars. Musicians began to combine the two instruments to create a new genre. Some of the top country songs of the time gave titles or complete lines to nose art during the Korean Conflict. One example was Hank Williams' "Your Cheatin' Heart," recorded in 1952. This song quickly was transposed to the side of a plane. The design was a woman along with the words "Your Cheatin' Heart."

Men were not the only ones that benefited in an expanding audience. The expansion of country music allowed for women to break into the industry and start to vocally fight the sexism that was inherent in the profession. One design seen that attested to this influx of women was modeled after the top female performer of the time, Kitty Wells. Wells was the first woman to have a number-one song on the billboard 100. "It Wasn't God Who Made Honky Tonk Angels" was seen on planes both agreeing with and ridiculing her song.[4] With country music's appeal growing, it was not long before genres closely related to country began. During the early 1950s folk music, which spoke to a more liberal audience than country, started in remote and country regions. This music, while related to country music, was more about politics and life than country, which was based on religion and relationships.

With an increase in these two genres came a decrease in Big Band music. The artists of Big Band music began to branch out to other genres to maintain popularity. For this reason, blues and jazz gained new artists.

One type of music that originated before World War II began to overshadow previously popular musical genres. Rockabilly, a combination of country and rock and roll, started in the 1930s and 1940s, but it was not until the 1950s that the audiences grew.[5] Rockabilly started as a combination of country music with jazz. During the early 1950s, in addition to jazz themes, rockabilly began to incorporate rock and roll into songs. Rockabilly was mainly if not entirely composed by white musicians who took from ethnic styles to create a new sound. Due to the civil and political tensions, rockabilly evolved differently in the northern United States and the southern United States. During the Korean conflict, rockabilly was just starting to gain speed, while rock and roll was just emerging on the music scene.

Rock and roll used multiple popular genres to create this variety that quickly exploded both in popularity and in number of artists. Country, blues, and gospel were all combined and modified to create rock and roll. Music was defined as rock and roll by what the lead instrument was, and by how the artist defined their music. In one case, the wording and meaning of nose artwork actually contributed to the title of a famous song. "All Shook Up"

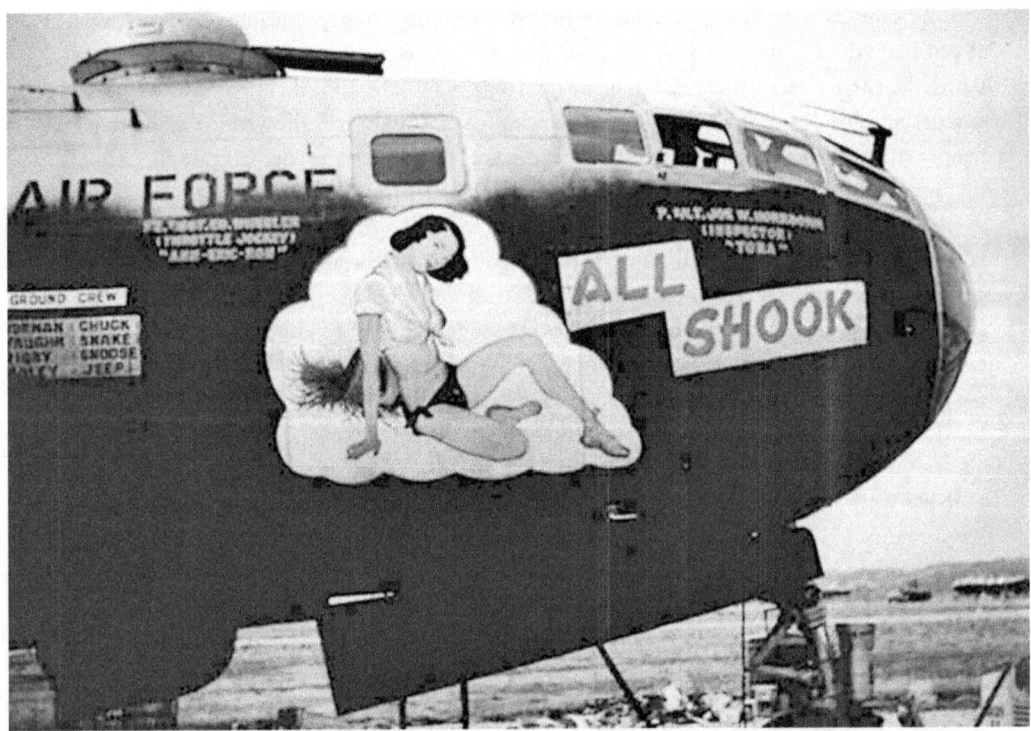

Fig. 54. Some images and their titles contributed to famous songs. "All Shook Up" was named after a popular slang phrase at the time meaning "affecting [me] deeply." It was later used as the title of an Elvis Presley song. For some reason, the pilot chose to not use the entire phrase (photograph by Tom Long).

was slang for "affecting [me] deeply"; part of the phrase was used as the name of a B-29 that flew in Korea. Elvis Presley would later perform a popular song by the same name. Due to the relative newness of rock and roll it was only starting to be heard by soldiers by the end of the war, due to a lack of radio stations overseas. Those songs that were played on overseas military radio stations were popular with soldiers.

Although the Korean conflict did not last long, more than just music was affected during this time. During World War II the film industry in Great Britain and the United States was able to maintain production of films for the general population as well as create films for the fighting forces. France, however, was split between the Vichy regions and the German-occupied regions with regards to what could be produced and shown.[6] Due to the blockade that Great Britain and the United States placed on France following the German invasion, foreign films were not available for distribution. This lack of outside films caused an isolation of French-made films that affected how the French film industry reacted at the end of the war.

In 1945 when the Germans left France, the film industry was struggling to produce films and to maintain equipment and personnel. Due to the censorship and persecution by the Germans, many well-known and innovative members of the French film industry fled to Great Britain and the United States. At the end of the war this caused a crisis for France. Members were gone, equipment was used by the Germans or was outdated, and there were still two conflicting beliefs regarding films in France. To better regulate and shape the future of French filmmaking, the new government took from the Vichy government examples of how to liberate the film industry. Two steps that the government put into place were the creation of the Committee for the Liberation of Cinema and journals regarding the film business.

The Committee for the Liberation of Cinema was created by using tax revenue created by the production and viewing of films. The main objectives were to regulate and support the growing industry. This committee along with the Blum-Byrnes agreement pushed French producers and filmmakers to create likeable films.[7] The Blum-Byrnes agreement, signed in 1946, stated that a certain amount of time each year must be solely devoted to the showing of French films in all French theatres. It was also during this time that France signed an agreement with Italy to co-create movies. This was done in the hopes of adding new faces and abilities to the shaky industry. With all of these agreements and arrangements put into place soon after the end of the war, the French film economy became healthy again.

Many in the business felt that the cinema was not only rigid but also forbade the creation of many films. The French government kept a close eye on the films being created and threatened complete censorship for movies dealing with a variety of subjects. These subjects were about not only what was occurring after the war, but also what happened during the war. Due to the conflicts that France was engaged in during the early fifties, any movies that sought to understand or depict current events were subject to censorship. It was not only the rigidity of what could be created that upset many, but also the restrictions on who could perform in or produce movies.

Due to the agreement with Italy, a period of time known as the Tradition of Quality

began. This created movies that much of the younger populations believed to be of prewar quality and therefore were not suitable for this new world. It kept new methods and genres of movies from being produced, and it placed long-time producers in the front running for new projects over those new to the field. One thing that came out of this time period was a term that assisted France in finding a cultural standpoint for the cinema. The term *cinephile* means one who is not just a fan of movies, but of everything movie related, including the history of movies. Even with the increase in *cinephiles* in France, the copying of the old works proved detrimental to movies being produced in Great Britain and the United States.

Great Britain, hoping for increased visibility, started to make movies to compete with the United States. To achieve this, two major companies began to enlist popular directors to create epic movies. Due to a decrease in attendance, however, there was not enough money to make a lot of films. This caused the film business to come up with new ways to compete with Hollywood. In addition to creating long, expensive movies, Great Britain created less expensive, shorter movies to increase attendance by having a double or triple feature. The genres of movies consisted of comedies, dramas, and documentaries. Comedies, while not as lucrative as documentaries, did something that many other films of the time could or did not do: they pointed fingers and poked fun at organizations and places that were well known.

Although not as popular in the first years following World War II, as time went on, the population was ready for relaxed forms of entertainment. Comedies such as *Whisky Galore* and *Kind Hearts and Coronets* were popular not only in Great Britain but also in the United States. This was the beginning of a British comeback in the United States.[8]

The manager of Ealing Studios, Michael Balcon, hoped that these movies might gain popularity in the United States and show what being British was about. When Balcon stopped producing popular comedies and attempted to create dramas that he felt might provide this unique sense of what it meant to be British in the United States, the British film industry started to falter. While not overly popular, dramas were present during the war and gained importance during the years directly following the war.

Great Britain also used the war as the background for many postwar movies. Motion pictures during this time surrounded the current events that were occurring in colonial holdings. The nose art "Command Decision" was designed after a popular 1948 movie by the same name. The movie was full of A-list movie stars and depicted the difficult decisions that were made during World War II in Europe.

Documentaries and dramas were popular during this time with British citizens. Audiences wanted to know what was occurring in the world, which gave the film companies many plots and themes. Those concerned with the future of the British film industry were not particularly worried about French films, but having been second to the United States during World War II greatly concerned British film companies.

The United States film business during the Second World War was able to continue to produce films with minimal issues. Due to this, many of the films that were popular around the world following World War II were made by the United States. Following World War II the United States maintained its advantage over its European counterparts. Due to

## 9. Rock a Billy

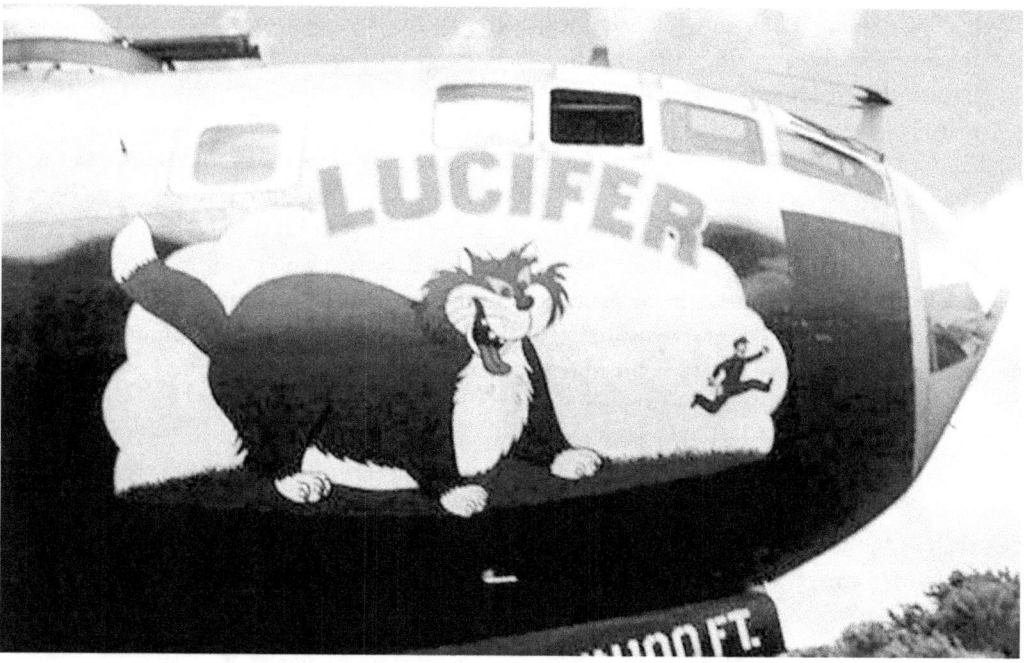

Fig. 56. *Cinderella*, a Disney movie, had a cat named Lucifer who was frequently causing trouble. The air crew of *Lucifer* brought American movie culture to the side of their plane during the Korean Conflict (photograph by SSgt. George Amthor).

the growing population of young adults and teenagers, producers realized that the popular movies of World War II were not going to have mass appeal in the 1950s.

During this time the younger generations moved away from their parents' movies and wanted to see rebellious and fearless actors. Following World War II, movies with an anti-hero began to appear. In addition to anti-heroes and heroines were popular comedies and dramas that showcased new actors such as Marlon Brando and James Dean. These actors along with the right movie scripts created a transition in movies being made in the United States. This transition was not limited to the movie screen but was also seen in the new artistic medium known as television.

Not all nose art was from traditionally "adult" films; this image of Lucifer was used on a B-29 bomber typically used for bombing sites such as the Yalu Bridges.

While Great Britain and France both utilized television, it was really the United States that took this new medium and expanded to a new level. The early 1950s saw more televisions brought into households than at any time before. In addition to more televisions being in homes, young generations were watching television shows in greater numbers and for longer periods of time.[9] Television started as a novelty but soon became more than that. People began to take what they saw as normal and accepted. While the shows were in a black-and-white format, this did not detract from TV's popularity. Certain shows began to stand out among the rest in ratings and overall success. One show specifically gave the

audience an inner look into historical world events. *You Are There* was the first of its kind to allow audiences this experience. One side effect of television was that the growing film industry started to suffer, with more families staying at home rather than going out. Printed material also began to suffer in all three countries due to the increase of television shows.

The end of World War II caused turbulence in France, and literature reflected this change. The country was economically stable but politically and culturally in turmoil. Both theatrical and novel writers refused to continue with the traditional themes, characters, and plots. Due to this change, most of the newly published written works took a new direction. Books were not only answering questions about the past but also addressing current events. Younger generations were starting to break out from their predecessors' beliefs and wanted books to reflect these new thoughts. French literature during the early 1950s, however, did not affect the artwork that was being placed on French planes.

France was not the only country to show a change in literature. Great Britain saw an increase in science fiction and fantasy writing during the late thirties, and these genres continued to have mass appeal following World War II. Following the end of the war writers such as Ian Fleming and Gerald Gardener used spy novels and the rebirth of a historical religion to answer questions regarding the world and society. In 1952 Ian Fleming created *007*, which was the story of a spy tackling issues that mirrored those of the current political atmosphere without being overtly political.[10] Gerald Gardner, instead of using drama, revitalized the historical religion of Wicca to answer some of the current issues of society. This was the time that British dramas and adventure stories got their start. By explaining current and historical events in a fictional setting, writers were able to give readers new understanding.

The United States was just coming out of World War II and was attempting to adjust to the new culture and life. Soon, however, the United States went to war against North Korea. This again affected how citizens related to the government and to each other. Newspapers and magazines became a method for many writers to spread nonfiction and fiction nationally. This allowed for a greater dissemination of information than before. A side effect of this was an increased knowledge of and concern over national events. Writers used this concern in attempts to answer some questions regarding the status of United States society and one's individual self.

During World War II it was expected that everyone conform for the better good, but writers during the Korean conflict wrote about choosing and controlling your life and fate. This led to a group that specifically wrote anti-establishment works that set the stage for society in the mid–1950s. In addition to anti-government and anti-establishment works came an influx of science fiction and fantasy. These genres were used to take individuals out of their daily lives. This was also a way to discuss current events and struggles in an abstract way.

Literature did not create an immediate change in nose artwork, but other forms of artistic expression did. World War II was a time for nationalistic artwork in both Great Britain and the United States. In France, however, there was a split due to the German occupation and the Vichy leadership. It was not until after the war that France began to

## 9. Rock a Billy

connect as a cohesive unit. Artwork in France during the late 1940s and early 1950s began to show nationalistic tendencies.

In addition to the nationalistic paintings that coordinated with nationalistic nose art was the creation of *art informel*.

Many artists believed that past methods were rigid and cold in the years following World War II. *Art informel* was more spontaneous and authentic. These artists thought old thoughts and instruments of painting were obsolete. This new style allowed artists to draw what they saw and felt without modifying it. In addition to *art informel*, a form of abstraction began to appear on the art scene. Lyrical Abstraction was very similar to *art informel* in spontaneity and in its use of free form. Where it differed was that Abstraction used geometric lines and an element of intellect, while *art informel* was emotionally based.

While fine art was adapting to a new generation of artists, French propaganda continued to sway the general population one way or another. Directly following World War II, the French communist party began to flood French streets with visual propaganda in hopes of gaining increased support. In an attempt to counter this, the Paix et Liberte was created. This organization's main goal was to wage a poster campaign against the communist party. Instead of using scare tactics or informational posters, the majority of the posters used comical representations.

Aptly titled "*La Vie Exemplaire du Petit Jacques Duclos*,"[11] this poster depicts the communist party as being manipulated by a more refined and older enemy. The Paix et Liberte creator, Jean Paul David, then the Radical Socialist party deputy mayor of Manet-la-Jolie, did not stop at ridiculing the French communist party, but also used Stalin, Lenin, and the Peace Dove created by Pablo Picasso to decrease its favor among French citizens. David also used pamphlets and other written material in addition to posters to ensure that all socio-economic groups understood the dangers of the communist party.

A continuation of propaganda was not limited to France. When able, soldiers returned home and continued their artistic professions. There were also soldiers who used the war as a starting point for their artistic goals and wished to continue upon return home. With an influx of artists returning back to Great Britain, new schools opened and new methods of creating art were developed. These methods mainly used art for satirical and political reasons. The early 1950s saw an increase in the number of political cartoons published in dailies and weeklies.

It was via this format that much of the uneducated population found out that Great Britain was sending military forces to Korea after North Korea invaded. In hopes of not increasing fear, the British government attempted to use posters that were humorous to gain support. With rationing still occurring in Great Britain, the general population started to get frustrated. Artists attempted to lighten the mood with cartoons such as one from the *Daily Mirror* that depicts the British assembly line going from passenger cars to tanks without skipping a beat.[12] These panels allowed many a better understanding of what was occurring both nationally and internationally.

The United States experienced a slight decrease in political cartoons and propaganda directly following the end of the war, but this was short lived. With a North Korean invasion

imminent, many artists in the United States saw a reason to increase cartoon publication. Artists expressed disagreement and affirmation of all facets of government and military actions though newspapers and magazines. This increase in artists competing for space opened up new venues for their artwork. A relatively new medium appeared: comic books were a great outlet for many artists who did not want to conform to newspaper regulations or gallery standards. Comic books were a medium that was easily used for propaganda, as seen with *T-Man,* a U.S. comic book that ran from 1952 to 1953.[13] *T-Man* was the story of a young Treasury agent who somehow became directly involved in Iran. Cold War undercurrents ran strongly through this and other comic books from this time period. Comic books found an audience across age, gender, and socio-economic boundaries.

A new magazine created specifically for younger men entered the media stream. *Playboy* combined photography of women with articles and political cartoons. This was an outlet not only for photographers but also for political cartoonists. *Playboy* played on the cultural change in the United States that saw women as sexual beings, and used it. Although the first publication came at the end of the Korean Conflict, soldiers in Korea received *Playboy*. This general sexualization of women contributed to sexualized artwork on planes.

This was not the only change that occurred on planes during the late 1940s and early 1950s. The years 1946–1953 showed a general change in all three countries. This change was really initiated and transformed by younger generations wanting to leave their mark on the world. From clothing to entertainment, the three countries saw change that affected how individuals looked at the world and specifically their governments. These generations not only contributed to change in the civilian world; those old enough to serve affected how the military acted and how it reacted to events. They had a direct impact on what artwork was painted and what the cultural meaning behind it was. The soldiers who had been too young to fight in World War II contributed to the change in all aspects of civilian culture. This change extended beyond the confines of national boundaries and affected the cultures of both other countries and those fighting in foreign countries.

The changes to culture that occurred during the Korean Conflict were fast paced and brought drastic differences from the culture of World War II. Young adults were starting to separate themselves from their parents and older generations with clothing and music. Those that were old enough to serve in the military brought that change to the services. These changes ranged from rock and roll to a highly sexualized outlook. With *Playboy* and a lower level of inhibition, culture began to become more sexualized, which transitioned over to the war zone.

# 10

# Transition

Following World War II, conflict began to increase in French and British colonies. Many of these countries realized that the time was right to heighten their fight for freedom. Not wanting to allow economically benefitting countries to become independent, France and Great Britain began to battle revolutionary armies. The United States, with no colonies, hoped that conflict was behind them and relaxed militarily to rebuild the economy following the previous war. The period of time from 1945 to 1949 saw advances in plane type with a decline in nose art. The absence of war allowed for inventions that were not funded during combat.

Korea during World War II was controlled by Japan. Following the defeat of Japan in 1945, Korea was divided into two parts, the South being governed by the United States and the North by the Soviet Union. It was the original plan to hold country-wide elections in 1948 to create a government, after which the United States and the Soviet Union then could leave. The election did not occur and the tensions along the 38th Parallel grew larger. Small skirmishes occurred along the border between the North and South. The conflict escalated from small battles to a full war when North Korea invaded South Korea in June 1950. The UN and the United States were quick to assist the South Koreans against the North Koreans. Initially North Korea succeeded in defeating South Korea in small battles. These battles rallied the UN and the United States to push against North Korea. This alliance was able to push the North back all the way to the Yulu River. With North Korea being pushed back, the People's Republic of China (PRC) unofficially joined the war to assist the North Koreans.[1] This addition drastically changed the dynamics of the war. The possibility of nuclear war grew as the Soviet Union supplied weapons and money to both the North Koreans and the PRC.

This escalation of conflict led to a corresponding increase in activity by the UN and the United States. The UN contingent in South Korea consisted of 15 countries other than South Korea, the United States and Great Britain. With all of these supporting countries assisting, the United States combined tactics from both World War I and World War II to achieve victory. The U.S. government did not consider the Korean War a war. This was partially due to the UN's referring to it as an official police action. The issues leading to war were different than in previous conflicts. Both Great Britain and France were involved in other conflicts. It was not long after the end of World War II that the allied countries were again called up to conflict. Greece was on the verge of civil war prior to the armistice

in 1945. After liberation in 1944 the two main opposing governments began to increase the tension. The United States and Great Britain both supported the previously exiled Greek government. The Democratic Army of Greece, which was run by the Greek Communist Party, attempted to influence Greek citizens. The first battle that was fought was between Great Britain and the National Liberation Front (EAM) in December 1944.[2] The historical reason for the EAM to confront the British has been argued, but the result has not. The British easily beat the smaller, less armed EAM forces.

Great Britain along with the United States mainly supplied funds and supplies, rather than soldiers. This allowed the Greek government to prevail and, following three years of civil war, finally gain complete power over Greece. The Soviet Union came out of World War II in a better position than before the war started. For this reason they were able to provide supplies to the Democratic Army of Greece. While this conflict did not tax either the United States or Great Britain monetarily or militarily, it did start the growing tensions between the Soviet Union and the United States. The Greek civil war was only the beginning for both the United States and Great Britain in mid-century conflict.

Soon after Great Britain left Greece, the Malayan emergency began. This conflict coincided with the Korean Conflict, which actually proved somewhat advantageous for Great Britain. Due to the short distance between Korea and Malaysia, Great Britain was able to use the same planes and individuals on a rotating schedule to increase the soldiers on the ground and planes in the air. The Malayan emergency was another government-versus-communist-party conflict. This time the Malayan National Liberation Army attempted to take control of Malaysia from the Commonwealth. Malaysia during World War II was ruled by Japan; following Japan's defeat the Malaysian government and economy began to fall to ruins. Great Britain interceded in attempts not only to repair the Malaysian economy but also to use the natural resources for British economic growth. Due to the possible outcome if Britain was not able to make enough money in the tin and rubber industry, anyone who protested against British rule was dealt with severely. Rather than give up the protestors began to become militant, eventually killing three plantation owners. These deaths provoked Great Britain into taking emergency actions to prevent further escalation.

Great Britain was still attempting to regain military strength, so the forces originally in Malaysia only consisted of 13 infantry battalions. It was not long before more British forces were shipped in. With the Korean conflict starting to become tense, the British started to bring in Royal Marines and African soldiers to quell the violence. When ground troops proved effective but not overpowering, Great Britain re-formed the Special Air Force, which had been dismantled following the end of the war. The belief was that air power was not as needed, specifically a set of planes used specifically for secret and counter-intelligence gathering missions. During the Malayan Emergency the air force was used for a variety of things, including supply drops and transport.

From 1948 until the communist leaders spoke to the British government in 1955, fighting continued, slowly increasing in intensity. Great Britain at first treated this war as it had World War II, with regard to tactics. It was soon realized that this was a guerrilla war and that different tactics were needed to subdue the communists. Many times during these

## 10. Transition

seven years, the Malaysian, Singapore and British governments tried to reason with the National Liberation Army. During the Baling talks of 1955 the communist leaders attempted to resolve the conflict by agreeing on a ceasefire only when certain demands were met.

The Malaysian government, having gained strength during this conflict, refused the leaders' demands and retracted the declaration of amnesty previously provided. Due to this the communist fighters ramped up their attacks and Great Britain requested assistance from Australia. During this time the nose art became apparent. British soldiers had been stationed in Malaysia or Korea for going on five years. Things were tense, and the soldiers used nose art as a way to reconnect with home and family. The nose art that was used was cheerful and colorful. Cartoons, paintings depicting music and movies, and sentimental paintings were the most common. It was another five years of conflict before Britain began to withdraw from Malaysia.

Starting in 1952 soldiers were also needed in Kenya. Following World War II, another one of Britain's colonies started to push for independence. Kenya began to inundate Great Britain with demands. In 1951, the British colonial secretary arrived in Kenya to announce that the demands put forth to give Kenyans more say in government were to be ignored. This caused many Kenyans to fully realize that Great Britain was not going to assist in creating a fair government. Soon after that declaration Kenyans began to revolt. Great Britain referred to this conflict as the Mau Mau Emergency. The term "emergency" was used primarily due to insurance agencies not paying claims if a war or conflict occurred.

By October 1952 Britain was deep in conflict in Korea and Malaysia. With the uprising turning serious in Kenya, Britain had no other choice than to declare an emergency and send troops to secure British citizens. In hopes of quelling this uprising quickly, British forces started to arrive soon after the declaration was made. Due to the other conflicts raging, Britain was more worried about Malaysia and Korea than about Kenya, and so it only sent three battalions along with a portion of the Royal Air Force. Pilots that were stationed in Kenya and not moving on to the other conflicts chose geographically specific nose art for their planes. Many designs with remarks regarding colonial rule were present.

War in Kenya was not easily won, and Britain had to rely on short supplies and manpower until 1953. Following the end of the Korean Conflict, Britain was able to move more troops and supplies to Kenya to assist the soldiers already there. The next seven years proved extremely difficult for Britain and all Kenyans. War took on a sense of barbarism that was seen in the nose art. Rapes, torture, and other forms of population control purportedly took place. Whether this actually occurred, the nose art does show a change from geographical depictions to paintings regarding the pressures the military personnel were feeling after staying in Kenya for so long. With the Korean War winding down and the Mau Mau Emergency remaining steady, another location that was historically important to British economic and military strategy began to experience conflict.

When the United States entered the Korean Conflict, France was not involved in another conflict. Due to France's not having a direct stake in the Korean peninsula, only when the United Nations requested support did France become involved. For this reason France was only briefly active in the Korean Conflict. The planes that were created by the

## Part Five. 1945–1953: The Start of the Cold War

French during the years of 1945 to 1953 were used primarily for training and exercises in France. The nose art that the French training planes sported were the commonplace French roundel and pilot-inspired personal artwork. The personalized planes of the French air force displayed primarily cartoon and politically themed art. With the French culture and women serving in the military, few women adorned the sides of French planes. The cartoons that were popular during this time were both French- and American-inspired. This artwork corresponded with the positions that France was taking towards the rest of the world and how the pilots felt being stationed near home bases while fighting was occurring in distant countries. France along with the United States and Great Britain felt very strongly regarding both the motivation for and strength of fighting in World War II. The Korean Conflict strained those notions.

World War I was instigated by the desire for land and conquest. World War II was based on revenge and conquest. Korea differed from both of these wars in multiple aspects. The Korean Conflict was not based on conquest or revenge but on a difference in opinion on what type of government should rule the peninsula. South Korea, having learned from the Americans and Great Britain, wanted a republic, while North Korea, being close to China and relying on the Soviet Union following the Second World War, wanted communism.

In previous wars there had been a physical enemy, be it Hitler and the Germans or Mussolini and the Italians. Rarely had the same country been fighting itself aside from in civil conflict. This is exactly what was occurring in Korea. Few people understood why the two halves were fighting. Both sides needed and requested assistance against the other. What might have stayed a simple civil conflict almost brought about a nuclear conflict between the United States and the Soviet Union. This confusion did not just stop on the borders of Korea. Many Americans were unsure why the United States was involved. Having just started to economically rebound from World War II, many American politicians were unsure about jumping into another conflict. What did assist in the rebuilding of the military was that many World War II veterans returned to assist in this new conflict. The short time period between World War II and Korea also assisted the military in other ways.

Because so many of the soldiers were returning from World War II, there was not the need for the training that had occurred following Pearl Harbor. Many pilots, not being able to find reliable, well paying work in the civilian world, also returned to fly for the United States. This gave the United States the advantage of not having to train a whole new set of pilots and flight crews. Of course there were newly commissioned and enlisted personnel that needed to be trained prior to combat, but the numbers were not staggering as before. This percentage of returning personnel created a carryover of nose art that might not have occurred if this war had been twenty or thirty years after World War II. Even with the large amount of returning servicemembers there was still a need for enlistment posters, especially to get more women into the ranks. By showing the latest in clothing along with the possibility of travelling the world, the United States really set their aim at getting women to enlist. The poster in figure 57, created by the United States government, is a prime example of how enlistment propaganda was designed.

The amount of nose art decreased in Korea, but the main themes continued. Another

theme that arose during the Korean conflict was the usage of political statements and cartoons to show how flight crews felt. This avenue allowed the crews to voice their opinions in a medium they knew well. Few surviving planes still carry the political artwork, but photos show the attitudes clearly. World War II nose art was mostly tasteful towards women. While women were nude at times, it was not in perverse positions. For this reason women, while topless, always had a skirt or something covering the lower half of the body. This was due as much to the military's guidelines as it was to the crews' own moral code. The respectfulness towards women did not carry over to the Korean Conflict, however.

In the United States during the Korean War, magazines such as *Playboy* were becoming popular. *Playboy*, founded in 1953, shortly became the highest selling men's magazine in the United States. There is a correlation between the graphic nature of planes' nose art and the graphic photos available in *Playboy* and similar magazines. During the Korean Conflict, *Playboy* and similar magazines were not popular in Great Britain or France. This partially explains the difference in clothing and position of women on planes. The women depicted on planes during the Korean Conflict were bold and blatantly sexualized.[3] This attitude relates to U.S. cultural attitudes regarding women. The 1940s still retained some of the Victorian-era attitudes towards modesty and composure. With the increase in magazines and other avenues for the sexualization of women in the United States, this trend carried over to the planes. A few of those pilots that had flown with women adorned on their planes during World War II carried over the Vargas and Evglan paintings of the 1940s. Nothing was left to the imagination when viewing a Korean-era painting of a woman that had transitioned from what World War II ideals were. This was not due to just the nature of how men felt about women, but how culture portrayed women in a largely male profession.

Fig. 57. Attempting to gain higher enlistment numbers of women, the United States Army Corps created a poster that shows the places one could go while wearing the uniform (courtesy National Archives).

## Part Five. 1945–1953: The Start of the Cold War

The Korean War was the first purely politically based conflict, and with that came more political nose art. Nations during World War II wanted to be protected or wanted to fight. Korea showed an increase in apathetic or downright hostile "allies."[4] The artwork of this time showed a decrease in both personalized portraits of female family members and the happy cartoons that were proudly displayed in World War II. A combination of increased political awareness and confusion over the Korean Conflict created an increase in the amount of political cartoons that were available. The leading newspapers in France, Great Britain and the United States at times ran the same cartoons. Political cartoons have a snowball effect in that the more people see the cartoons, the more cartoons are made, which then creates a wider audience. There were some, although not many, instances of French planes adorned with paintings of a political nature. This can be attributed to France's not being involved in the Korean Conflict. Great Britain and the United States, however, displayed political thoughts about the continued fighting in Korea.

The cartoons that were displayed ran the full scope of current political thought. There were those who believed that the Korean Conflict was not worth the money and time that were being spent. One such cartoon that addressed what many thought of as a foolhardy campaign was "Command Decision."[5] This plane's crew felt that governments were flipping

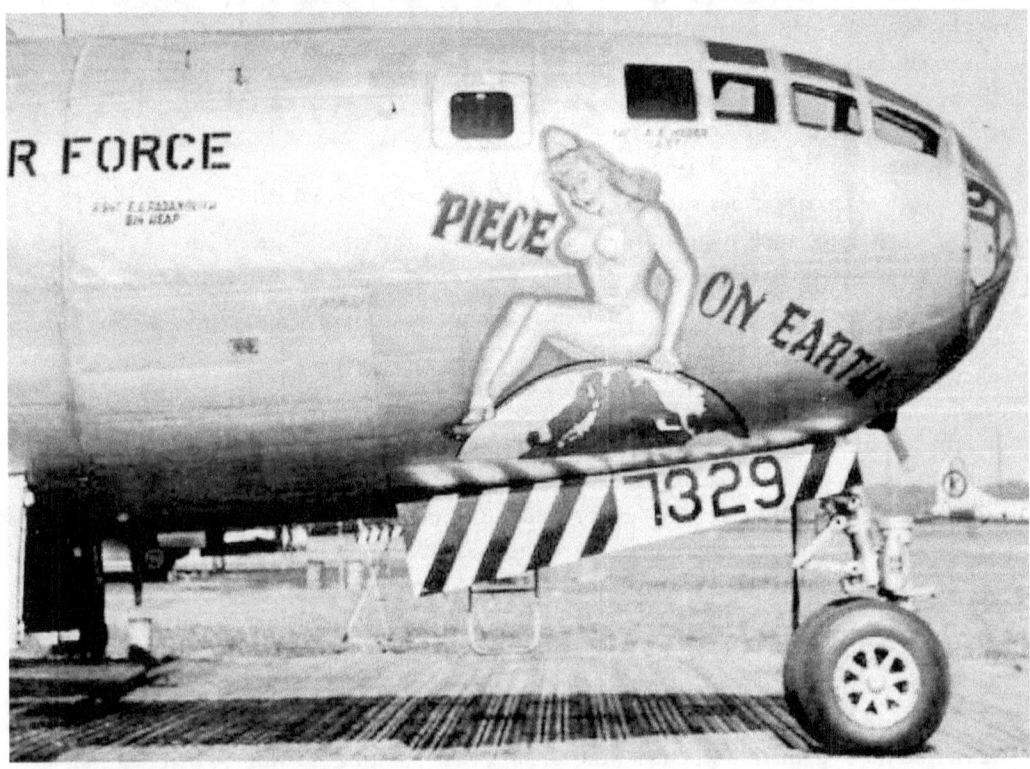

Fig. 58. All anyone wanted was peace on earth. This flight crew took that tongue in cheek and created "Piece on Earth," an image of a naked woman sitting on the earth (photograph by Edward Fitz-Patrick).

## 10. Transition

coins to decide the fate of soldiers and sailors. The British at times felt even stronger about having a presence in Korea. The painting "Diplomatic Service" really was a jab at what crews felt they should be doing. This particular design was located on a plane that dropped bombs over North Korea.

There were those who felt that this conflict was beneficial and worthwhile. One design that was painted on both British and United States planes was the "Piece on Earth." This was a classic play on the word "peace." Although it seems that "Piece on Earth" was against the war, the crew of the American B-24 stated they felt the war "was important for world peace."

These men were on the front lines of a war that was not entirely understood or desired. That does not mean that those men did not believe what they did was important, maybe not to the United States but to the South Koreans.

Racial paintings were primarily absent as artwork. During World War II American planes were often designed with paintings that were negative towards the Japanese or Germans. American soldiers and sailors vilified the enemy by portraying the enemy as animals. Germans were painted as rats, while the Japanese were monkeys. The Korean Conflict did not have this visible racially negative attitude. There were one or two paintings created regarding the Chinese and Soviets when fighting brought the United States in contact with these countries, but even those paintings were tame compared to the ones from World War II. This change did not come strictly from the militaries' view of including other ethnicities. African Americans were present in both World War I and World War II. The proportion was larger in the Korean Conflict than previously. This inclusion of other ethnicities forced the military to accept that these men and women were as capable as white units. The other contributing factor was that the culture of the United States was slightly more accepting of other ethnicities than before. France and Great Britain did not show any racially driven artwork during the Korean Conflict. One reason, beyond a greater understanding of different ethnicities, was that North Koreans and South Koreans primarily looked the same in facial features and overall build. To paint a derogatory painting of the North Koreans was to also portray your allies in the South in a negative light. The military mostly have turned a collective blind eye towards most nose art. With societal pressures and with the location of battle, many racially negative paintings that shone a bad light on the airmen or on the military were forbidden. If any paintings were created, which surely there were, they were destroyed soon after creation and no photos are known.

National Guard units also were used during the Korean Conflict. The California Air National Guard painted up their F-86As to display the quirks each plane possessed. *Puddles*, no matter how much preventative maintenance was performed, still leaked hydraulic fluid. Other planes in this unit were *Miassam Dragon*, the slowest plane in the unit, and *Un-Glued*, which also suffered minor breakdowns. *Spooky* and *End of The Trail* were named, respectively, for the feeling that crews left the plane with and the fact that at the end of the trail, she was so tired that she barely landed safely.[6] *Un-Decided* combined a woman and a personal protest into one piece of beautiful artwork: the woman was completely nude and positioned so her entire body was visible, and the name shows the conflicted nature of the Korean War.

## Part Five. 1945–1953: The Start of the Cold War

Great Britain, although not as ostentatious as the United States with regards to nose art, contributed its fair share. Along with the ever-faithful Union Jack were paintings of women, superstitious beings and the occasional protest or question regarding the war. When comparing the women painted on the sides of British planes to the United States planes, one thing stands out immediately. The women on the British planes were at least partially clothed. This may have been due to the large number of pilots returning from World War II. Another possible reason was that British society was more respectful with regards to female body. Whatever the reason, more U.S. planes than British planes showed women unclothed.

Great Britain showed more patriotic themes on planes than the United States. The Union Jack was included on almost all planes, not just those with additional artwork on the nose. Women wore the Union Jack in some paintings. The United States did not include the U.S. flag alongside nose art. All planes included the standard United States Air Force or United States Navy standard. The only painting found with a visible U.S. flag was one of a donkey using the flag as a cape. There is no practical reason, other than that the British possessed more pride and patriotism than the soldiers from the United States. A possible but unlikely reason the United States did not have flags on all the planes was that a red, white, and blue flag contrasted with the camouflage coloring.

Starting in 1951 following a year of heavy fighting, a stalemate occurred. This stalemate lasted two years and resulted in little forward movement for either side. In an attempt to gain ground, North Korea began to heighten its psychological techniques in hopes of breaking the UN blockade. The UN continued to fight both on the ground and in the air. It was also at this time that negotiations started to occur between the North Koreans and South Koreans. It was not until the election of a new U.S. president and neighboring countries became involved that an armistice was reached. The United States, along with allies and belligerents, ceased fire on July 27, 1953, with little fanfare for the soldiers and airmen participating. Soon the UN command along with the United States, North Korean People's Army and the Chinese People's Volunteers signed into history the Armistice agreement. The current ROK president refused to sign, which meant North Korea was still at war with the United States and South Korea following the return of U.S. troops.

During this entire time France was fighting in Indochina. France following World War II was shocked when in 1946 Indochina started to fight for independence. France had occupied the Indochina region beginning in 1858. At first many welcomed the Western influence. Due to the aggressive nature of Japan during World War II, French Indochina was taken from the Vichy French by the Japanese. Following the settlement of reparations, Japan was forced to give Indochina back to France.

In 1946 the Viet Minh, Chinese, French, and British finally confronted each other on the battlefield. Due to other colonial troubles, Great Britain mainly provided moral support and was only able to provide one air unit and two ground units. With the number of French colonists and citizens that were fighting, the lack of British manpower was not greatly felt. The United States did not actively fight in the first French-Indochina conflict, but during the Korean Conflict, the United States did support the French Union along with Cambodia,

## 10. Transition

Laos, and the South Vietnamese. This support was mainly in the form of weapons and supplies needed to continue the fighting. The first Indochina conflict raged on from 1946 until 1954. The battle ebbed and flowed for both sides as public opinion began to grow hostile in France. In an attempt to cease some of the fighting, France officially recognized the State of Vietnam as independent and as an associated state of France. This was not enough for the Viet Minh, who continued to attack French outposts. Most of this combat consisted of ground activities, but there were some planes that were used, especially in the battle at Dien Bien Phu. It was this battle that finally tipped public and political opinion.

The artwork that was on the French planes during this time showed the dislike of and pity for the people they were fighting. Pictures such as a mother scolding a child or a woman with a pet animal were seen on the side of supply planes. Characteristic artwork was also popular as the war dragged on and the planes were growing tired with lack of proper repair and maintenance. What was not seen were flagrant signs of patriotism. In comparison to the planes flying in Korea during the same time period, there was a noticeable lack of flag or other country designation. This French military did not primarily use citizens, like the United States did. Nor did they use colonists for distant conflicts, like the British. The French military was composed of citizens as well as colonists who fought in all locations. France prided itself on having a diverse and large military stationed at many places in the French empire. Great Britain, also having diversity in the military, displayed the British flag proudly on planes, while the French did not.

In April 1954, France and the Viet Minh met in Geneva for negotiation talks. These talks led to a cessation of conflict and the 17th parallel being marked as the Provisional Military Demarcation line. This line was what divided communist North Vietnam from the pro-Western South Vietnam. A part of the negotiations was over the idea that by 1956 an election that was meant to unite North and South Vietnam was to take place. In light of North Vietnam's lack of determination to leave communism and the new presence of the United States in South Vietnam, the elections did not take place. The emperor of South Vietnam appointed a prime minister. This prime minster, supported by the United States, quickly dethroned the emperor and proclaimed himself president of the Republic of Vietnam.

Due to the lack of elections and the strong United States presence, a growing number of communist cadres reactivated and, by using guerrilla tactics, began to fight the government. It was not long before North Vietnam jumped to the assistance of the cadres and invaded South Vietnam, along with Laos, to aid the supply routes. The United States attempted to remain neutral until the North Vietnamese were seen as a direct threat to the government and legitimacy of South Vietnam. When this occurred the United States, along with fellow anti-communist countries, went to war against North Vietnam.

The Korean Conflict was just one of many small skirmishes that were fought following World War II. For many countries, these were attempts to finally free themselves from what they believed to be oppressing powers. The United States, not having colonial powers, felt that it was its responsibility to assist previous allies as well as those countries that the United States deemed as being oppressed by communism or other anti-democratic powers. Combined with a new type of warfare came new culture that affected nose art.

PART SIX

1954–1973:
The Political War

# 11

# Swinging

Although the United States sent soldiers to Vietnam in the early 1950s, it was not until conflict escalated in 1965 that citizens became aware of the events. It was during the time between the end of the Korean Conflict and the beginning of mass troop movements to Vietnam that culture changed a great deal. With this change, the start of the Vietnam War drew large protests and affected not only how the general population felt, but also how the troops involved in the Vietnam War reacted to the conflict.

Every aspect of life was affected during the early 1950s. When official word was released that the United States was involved in Vietnam, it sent many into action. The backlash in France and Great Britain occurred earlier than in the United States due to the varying conflicts that those two countries were part of. As with all of the previous periods of time that culture changed, the younger generations were responsible for the majority of adaptations to what was occurring. This generation changed how families and individuals reacted to external stimuli. Individuals born during the Baby Boom following World War II had a varying outlook on what life and the family structure should be. Starting soon after the Korean Conflict ended, a transition for men and women took place in how they wanted to live their lives. A rebellion began against many basic tenets of early 1950s living. This rebellion pervaded all aspects of cultural expression, particularly interpersonal relationships, political awareness and music. The changes in these three aspects created ripple effects.

Those of the Baby Boom generation were graduating high school and beginning to attend college. Women began to push for increased freedoms. More women were going to college and integrating into the professional world. This increase strained gender relations both in the workplace and at home. Women more than ever felt that it was not their place to stay at home with the kids, and the feminist movement really took form. This occurred not only in the United States but also in lesser degrees around the world. Due to the equality that women in France and Great Britain already felt, this movement was less about professional rights and more about artistic rights. The United States although having a history of oppressing women, saw radical changes; women started to push for higher pay and positions of power. Women began to be editors and anchorpersons on news stations and in the radio industry. Women entered government and professional fields as well. This caused a dramatic shift in how families were structured, with children being left in the care of nannies or daycare centers. It was mainly unheard of prior to the Vietnam War era to see such a large percentage of families having dual incomes. This gave women the freedom they wanted,

along with more money for the family. Other changes occurred to the family structure that were shocking for older generations.

In the late 1950s and early 1960s the idea of unstructured families began to emerge. Women started to wait for marriage and to date multiple individuals prior to having a serious relationship. It was previously uncommon for women to publicly look for partners, while it was culturally acceptable for men to. Women feeling in control of their lives, in addition to the invention of birth control, allowed women control of their bodies as well. During this time there also was a decrease in planes with artwork dedicated to one woman as had been popular during World War II. In addition to an increase in female liberation there were other elements that changed the preconceived notion of what a family structure was. The late 1950s through early 1970s saw a marked decreased in the stigma surrounding divorce and cohabitation prior to marriage. In the United States and Great Britain there was a decrease in public religiosity, which also decreased the overall stigma of single-parent families. France, already more open with regards to sexuality and atheism, began to push the proverbial envelope concerning what was talked and written about.

As one of many rebellious acts, the generation of change during the 1960s started to experiment with drugs and alcohol to a degree not seen before. One reason for the experimentation was to separate themselves from their parents and older generations. Many also believed that the drug lifestyle was not necessarily harmful and was just a way to increase overall enjoyment of daily life. There were no studies regarding the ramifications of being under the influence at this time. This altered lifestyle affected how people related to each other and how perceptions were formed regarding the war and the artwork that was on the planes. Personal perceptions and relationships were just two of the highly fluid elements during the Vietnam War.

Political awareness began to increase during World War II but really expanded during and directly following the Korean War. This increased awareness occurred in all three countries in varying degrees. With the wars against colonial holdings continuing and an increased awareness of current events, it was not surprising that protesting began against governmental decisions regarding the countries' military, economic, and political futures.

France under the rule of de Gaulle branched out economically and militarily following 1953. De Gaulle felt that France had a chance to become a European superpower, since Great Britain was occupied with the Korean Conflict. To ensure that the military were still earning a wage when not in a colony, the French military began to develop nuclear weapons. It was also at this time that the French government signed an agreement with Germany to place a greater buffer between the Soviet Union and the United States. The military was not the only facet of French culture that was affected. Following the Korean War, France began to increase production and the number of available jobs. This proved to be highly successful, and France outpaced Great Britain in economic output during the early 1960s. This gave France an upper hand in Europe, and France took advantage of this both economically and politically. This advantage affected how France related to neighboring countries, specifically Great Britain and the United States. However, in May 1968 an event occurred that changed international experts' views on socio-economic groups and collaboration. Students in local

universities started to protest France's military activities, and this sparked other protests. Workers in both governmental and private industries began to strike for more wages and benefits. The protesting and strikes that began in 1968 increased to such a level that the military had to defuse the situation. What was significant about these strikes and protests was that all economic and age groups participated.

Great Britain also experienced social upheaval during the years following the Korean War. Prior to 1968 many anti-war sentiments along with other politically important issues were limited to posters and editorials. The year 1968 was known as the war of revolt, for obvious reasons. This was the year when many countries saw protesting and riots. In 1968 workers and students alike began to protest not just the United States' involvement in the Vietnam War, but also numerous societal issues. Anti-war protesters combined with feminist and general anti-establishment groups to create larger protests. As protesting started in the United States and France during the first months of 1968, the British were tense, knowing that revolt might soon arrive in Britain. On March 17, 1968, an anti-war protest brought hundreds of people to Grosvenor Square in London. It was not long before students on college campuses began to find their voice, and in late March students not only protested but physically attacked key members of the British government. It was not just anti-war sentiment that pushed people to frenzy; in April a British activist protested against immigration, and this led to England-wide protests both for and against illegal immigration. It was appearing as if national rioting and protesting was the norm for the rest of the Vietnam War.

The United States saw more protesting than both Britain and France. The United States was directly involved in the war and therefore was drafting U.S. citizens. In addition there was more social movement with regards to race and gender than in the other two countries.[1] The protests that occurred in the United States were usually focused on a particular element of society that the group felt strongly about. The topics for protests ranged from anti-war to civil rights to homosexuality.

During the years of the Vietnam War there were many protests against the war and against the draft. These protests, while mainly peaceful, were frightening to school administration and government officials, who in many instances used excessive force to quell the gatherings. Due to the political climate, the use of police and National Guard created more problems than it solved. With a police presence, more people reacted negatively, and in certain cases death occurred, such as at Kent State in 1970.[2] Students were protesting the continued involvement of the United States in Vietnam and specifically in Cambodia when the National Guard was called to disperse the crowds. The soldiers fired, and students were killed and wounded. The aftermath of this relatively small protest was millions of college students striking against universities as well as peaceful and violent demonstrations at hundreds of campuses around the United States. In many instances, anti-war groups protested against companies that were directly involved in the production of weapons used in Vietnam.

Anti-war feelings may have caused the majority of demonstrations during this time, but there was an additional social concern that caused disturbances. The African American civil rights movement became highly visible in 1954, starting with the fundamentally important ruling of *Brown v. Board of Education*. Although the court sided with African Americans,

schools were slow in implementing the necessary changes. Because of this, along with the general belief that the legal system was working too slowly towards desegregation, many took to the streets with acts of nonviolent civil disobedience. Actions such as sit-ins, boycotts and marches were used successfully where legal action might not have proved successful. One of the first cases of civil disobedience was Rosa Parks' refusing to give up her bus seat to a white passenger. While she was arrested and convicted of breaking city ordinances, the ramifications of her actions resulted in an outpouring of volunteers ready to march and boycott. Over the next decade civil rights movements gained public support and marches were larger.

In 1964 President Johnson signed the Civil Rights Act, which essentially gave African Americans the same rights and responsibilities that everyone else in the United States had. It also outlawed discrimination. While a huge step forward for the civil rights movement, there was more the civil right leaders wanted accomplished. Boycotts and marches continued and were mostly peaceful. This was until Martin Luther King, Jr., was killed following a speech given in Memphis. Following his death, violent riots broke out in over 100 cities around the United States, destroying businesses and lives.[3] The civil rights movement affected nose artwork both in a direct and an indirect way. With a decrease in segregation in the military, more African Americans were in racially mixed units than in previous conflicts. In addition to being a part of mixed units, more African Americans were working on planes as well as flying them. This allowed for more African American influence on what was painted. Instead of depictions of mostly Caucasian or Asian women and cartoons, African Americans began to be painted.

With a new generation of individuals who grew up after World War II starting to have purchasing power, many materialistic elements of culture were affected. While the mid–1950s saw little change to the overall market, the 1960s and early 1970s saw a drastic change in what was being bought and what was popular. Elements of culture that had been popular in the 1940s were thought of as outdated and something a parent might want. One element of culture that in 1972 did not resemble that of 1954 was clothing. The start of the Vietnam War era for fashion was very similar to that of the early 1950s. By 1972, however, clothing and how people related to fashion had changed a great deal. When many think of clothing during this time they automatically think about the changes that occurred in the United States, but Great Britain and France also experienced fashion change that was affected by general cultural changes. While the changes to fashion did not specifically translate to changes in nose art, the overall atmosphere that affected clothing also affected nose artwork.

French fashion was still couture in the mid–1950s, and the leaders of the fashion industry began by creating outfits similar to those of the late 1940s and early 1950s. It soon became apparent that those with money wanted to dress in fresh styles, and waists were dropped and hemlines were knee-length or shorter in some instances. Outside of glamorous couture fashion, France was going though the same fashion transition that both Great Britain and the United States were. This was the start of a teenager consumer generation that caused many designers to rethink how they approached fashion. Teenagers in France during the early 1950s took cues on fashion from parents and older siblings. Starting in

the mid–1950s, however, they began to take cues from musicians and movies. The widespread popularity of U.S. and British Rock and Roll caused many teenagers to dress like those they looked up to. While some suits still were worn, it was mainly separates that were bought by teenage men. Due to cultural sensitivities regarding modesty, skirts in France did not shorten overnight. A general length change occurred from longer skirts to shorter "mini" skirts during the late 1950s and early 1960s. Although not as popular in France as in the other two countries, jeans were worn by both men and women.

Sensing a general shift in what young adults desired in fashion, French designers in the mid- to late 1960s started to create fashions that were made of new fabrics as well as in new styles. The invention and widespread implementation of blends and fiber modifications led to whole new methods of creating fashion. Individuals became more concerned with fabric make up during the late 1960s, and many manufactures started to lean more towards organic fibers for some fashions while keeping prices down by using synthetic fibers for other fashions. During the 1960s long dresses with little to no waist were gaining popularity among young adults who felt that wearing non-binding clothing was a sign of freedom. This corresponded with the anti-war political movement as well as the naturalistic movement in literature and art that was at times referred to as Flower Power.[4]

In addition to long dresses for women, men started to wear T-shirts or buttoned shirts with the top buttons undone. Men also began to wear cardigans and jeans. Hair styles were evolving as well. Men and women both began to grow their hair long, and men stopped being clean shaven. This was all a form of rebellion against older generations as well as what they considered the establishment.

Fashion in Great Britain developed differently than French fashion. During the 1960s the British had two main fashion groups to mirror their clothing after: the "Mods" and the "Rockers." Both groups were heavily involved in the music scene and used this music to promote their clothing. While one was attempting to move forward, the other group was steadfastly trying to stay in the past. The "Mods," short for Modernists, wanted to move away from the past and into the future. They tended towards jazz music and tailored clothing. Men were the primary audience for this style, with bands such as the Who and the Kinks showcasing the Mod fashions. Women who wanted to be part of the subculture were forced to wear men's clothing, and most cut their hair short. Their clothing was close fitting and reminiscent of the Italian and French designers. The Rockers loved everything about the 1950s rock scene and wanted to promote that lifestyle. Leather, greased hair, and motorcycles were the stereotypical elements of the Rockers' fashion. During the mid- to late 1960s this group started to grow their hair out longer and find their political voice. It was a subsection of this Rocker fashion group that protested the Vietnam War.

In the United States, British equaled fashionable. Women and men strove to dress like their favorite bands or celebrities. Although there were fashion-forward individuals such as Jackie Kennedy, many of the top models and designers were still based in Europe. When the hippie style started in Europe, designers in the United States were quick to throw themselves into this new fashion. It was not long before free-flowing dresses and polyester suits were seen everywhere in the United States.

## Part Six. 1954–1973: The Political War

France saw a change in literature. *Nouveau roman* began during the mid–1950s. This term encapsulates the novelists that strove to differentiate themselves from classical genres. Another aspect of the *nouveau roman* was the method that many used to entrance the reader. While previous novels were lengthy and left nothing to the imagination, *nouveau* writers wrote less and wanted the reader to join in instead of just reading. The styles of the *nouveau roman* were different than those of classical works, while the topics remained similar. Starting in 1960 a new movement created by Raymond Queneau along with fellow authors began to inspire readers by using mathematics. *Ouvoir de literature potentielle* (Oulipo) was a small gathering of writers who wanted to move even further away from classical thought. By using constrictive techniques these writers created an entirely new set of readings. In addition to the Oulipo slight changes occurred to French literature until 1968. The rise of structuralism in French literature was brought upon by the relative economic stability that was present during the early 1960s. The movement towards free expression and decreased inhibitions was also seen in French writing during this time. Writers wrote about what they saw or how they felt in this changing cultural time. In these types of writing, it was up to the reader to be an active participant, and many times the reader was confronted with a written mirror that forced the reader to perform self reflection.

The student riots of 1968 not only changed the government's view of political and cultural events but also affected how writers saw the country and themselves. It was during this time that more writers produced politically charged novels and articles attempting to gain a better understanding of international events. When it was apparent that the United States was not going to leave Vietnam, many writers started to write in protest of the continued actions by the United States. This written protest fueled physical protest which in turn created more written protest. With all of the protesting, arguments, and satire that was being published in the late 1960s and early 1970s, women broke into the field in greater numbers. While the Mouvement de Liberation des Femmes existed prior to 1968, this revolt allowed for a greater expansion and visibility than before. Many French female writers of this era pushed for equal literary presence and attempted to change social institutions they felt were not gender-equal. Feminism expanded on the page and many women wrote from a feminist prospective: open, inclusive and joyful.

This was an era for French women to expand their literary strength as well as for a loosening of what was written in the form of protest. Two aspects not yet addressed were the use of political cartoons and the decrease of female exploitation in French writings. French papers did not have the quantity of political cartoons that British and U.S. newspapers did. However, French cartoons were used on the sides of planes. Along with political cartoons, there was a general shift away from depicting women on the planes. Due to all of the political strife that was occurring, artists chose not to include women as before and instead focused on satirizing the conflict. Although not many French airplanes were used following their defeat in 1954, there were some used in other locales that displayed approval or protest of the United States' involvement in Indochina.

During this era British literature also saw a slight shift in popular genres and the emergence of a group of men known as the "angry young men," who wrote during the 1950s and

1960s. These men attacked social values that they felt were outdated and reminiscent of pre–World War II notions. Female writers continued to gain a fan base and popularity. An increase of women as main characters in male-written books was also seen during this time. This inclusion of more women writing and appearing in books allowed for social issues concerning women to be brought to the forefront. It was also during this time that there was a decrease in women painted as nose art.

While the genres of comedy, clandestine activities, and drama continued to be a staple of popular reading, two types of novels quickly outpaced the others. Those two were teenage violence and exploring the depth of human evil. These books, such as *A Clockwork Orange* by Anthony Burgess and William Golding's *Lord of the Flies*, allowed audiences to explore the depth of deranged or otherwise troubled people. It was also during this time that many psychologists began to write fictional accounts in their field for the general population.

In addition to psychologists writing fiction, many other professionals began to write about current political and social events. Historians, political scientists, and sociologists chimed in about what was occurring during the late 1960s in Great Britain and the rest of the world. It was a time of revolution, and professionals wanted to be an active part of it. Some went to the newspapers to protest, while others protested in the streets with students and workers. This increase in political writings caused an increase in politically motivated nose artwork on British planes.

Although the United States was the main ally of the South Vietnamese, other countries assisted as well. Some of these countries were very closely connected historically and politically with Great Britain. Although Great Britain was not in Vietnam, there was a connection to Great Britain through Australia's actions. With this connection, there were protests against Australia's fighting in Vietnam. In addition, Great Britain was actively engaged in at least eight conflicts around the world. The planes that were flying during this time carried artwork that showed both protest and a desire to be home. These protests along with general anger over the continued fighting created a receptive atmosphere for political cartoonists. The British press was generally more accepting of political cartoonists than France was. This is seen by a larger amount of political cartoons published in newspapers in Great Britain than in France. Political cartoons in British papers were written and drawn by both professional artists and members of the political community. Due to the caliber of artists participating, the cartoons that were published were at times well drawn and insightful with regards to what was occurring in the world.

*The Daily Sketch* was a tabloid magazine that began in 1909. The submitters were usually aligned with the Conservative Party, and so most of the articles were politically slanted. Although not as popular as mainstream political publications, the *Daily Sketch* had a small following and produced political cartoons that were astute commentaries on national and international events. Many other British papers used cartoons to increase the visibility of events that might otherwise be pushed aside during heavy news days. Political cartoonists in Britain were similar to those in France and United States in that not only was the Vietnam War drawn about but so were political and social issues of the time. *The Manchester Guardian* was another paper that published many political cartoonists.

## Part Six. 1954–1973: The Political War

Political cartoons were of course not confined to Great Britain. There were some very talented and introspective American cartoonists. Two such individuals were Herbert Lawrence Block and Bill Mauldin. Herbert Block began creating cartoons in 1929 and was very prolific during the 1950s. His artwork provided a liberal slant focused on the government and what was occurring during specific periods of time. Bill Mauldin, who was previously discussed due to his artwork during World War II, took a break and returned to cartooning in 1956. One cartoon that spoke to the continuing anti–United States sentiment was one titled "Two more about to blow."[5] In this image there are hats that are also volcanoes, with Central and South American countries that were against U.S. involvement.

In the beginning of the Vietnam era, many in the Western World felt that negotiators were not strong enough against the communist leaders. There is an illustration that was published in *Manchester Guardian* that shows this well. The image has the United States, France, and Great Britain being sheep while communist China and fellow countries are portrayed as a dragon. It also appears the dragon is inquiring if it can eat the sheep.[6] This image shows elements that are important in understanding the Vietnam Conflict. One element is how Western countries reacted to communist posturing. It also shows a view of where the war was headed. This cartoon speaks to both the United States' continued involvement in Asia and France's experience during the battle for Dien Bien Phu.

Dien Bien Phu was the battle that cemented France's abandonment of Indochina. This single battle claimed 2,000 French soldiers in a relatively short time, not counting POWs that later succumbed to illness.[7] Soon after France's retreat, the United States sent in political and military advisors, which eventually led to military units being deployed to Vietnam. There is a very apt cartoon that shows how little the United States reviewed history prior to engaging in conflict in Vietnam. The United States did not look at past events to have a better understanding of what the future would hold.[8] While not exactly a protest against the war, it was a push to slow down and not throw everything into Vietnam without proper research.

British literature adapted to how the population felt about events. Literature was used to heighten certain emotions and in some cases to sway individuals to believe other things. This was particularly true when political cartoons were involved. These showed how the creator felt at the time, and many were used to persuade the reader to believe one thing or to feel a certain emotion. This specifically proved true with cartoons published after the 1968 protests at colleges and squares around the country.

The literature and cartoons that followed the protests cemented how the general population felt about the government and the events involving the United States military. With every photo that was being published in newspapers and magazines, more people were realizing that innocent people were dying, and they directly and indirectly blamed the United States. Cartoons started to be published that showed U.S. soldiers performing acts that were ungentlemanly. When events occurred that were reactionary by the North Vietnamese, opponents of the United States believed they were deserved. Literature in the United States saw changes that included British and French attributes as well as unique schemes. This new generation of writers in the mid–1950s and early 1960s broke away from conservative

and traditional methods to create new thoughts and techniques. Collectively, these individuals were known as the Beat Generation. This term was originally coined in 1948 but did not take on its full meaning until the mid–1950s with the publication of *Why Am I So Beat?* by Nolan Miller in 1954. This generation focused on the underground slang of beat, meaning criminal activity, and those who participated in it. Drugs, partying, and an overall violent life were themes of many of the writings produced in this genre.

This group of writers also produced articles, poems, and cartoons. These cartoons, along with other comic books coming out at the time, showed a general transition from the previous literary culture to a new one based on personalization and anti-materialism. While not as well-known as their U.S. counterparts, there were a small group of Beatniks who lived and wrote in England during the late 1950s and early 1960s. These individuals were not just trying a method of writing; they believed that one must know and understand oneself. As these individuals became more than just writers and affected culture as a whole, it is not surprising that characters resembling Beatniks were found in other forms of literature including comic books.

Comic books during this time were popular with both soldiers and the general public in the United States. New story lines were being produced, and elements of life were included. One story line of *Justice League of America* featured an individual who portrayed a Beatnik with long hair and a general attitude towards wanting to personally better himself. The mid–1950s saw the start of the silver age of comic books. Large comic book publishers continued with a superhero theme and did not dramatically change the characters in long-standing title runs. One new addition to the comic book lineup was the Fantastic Four.[9] This comic book line consisted of four individuals with superhuman powers who also had feelings and emotions similar to that of non-superhuman individuals. This title resonated with individuals who believed that emotions and living one's life were more important than what others said.

In addition to the mainstream comic book publishers, smaller underground publishers started to print comics that specifically addressed the countercultural events of the time. These were extremely popular with soldiers and college students because they showed what they believed to be the true side of culture. While some titles were so popular that large publishers bought the rights, many had only small cult followings. Comic books were not just used as a time killer; characters from both small and large publishers were painted on planes flying in Vietnam.

One cartoon figure that was seen everywhere during Vietnam was Little Annie Fannie, a character seen in *Playboy*. The iconic playboy bunny was also seen, sitting in Hawaii in figure 59.

Due to the year that *Playboy* was first published, soldiers in Korea only briefly read it while in theatre. As *Playboy* gained popularity during the mid–1950s, when soldiers traveled to Vietnam in large groups, *Playboy* travelled with them. While many were attracted to *Playboy* for the centerfolds, not only the women were painted as nose art; the cartoon characters were as well. This shows that culture during this war was shifting away from reproducing lifelike images of women to images of counterculture and cartoon elements of life.

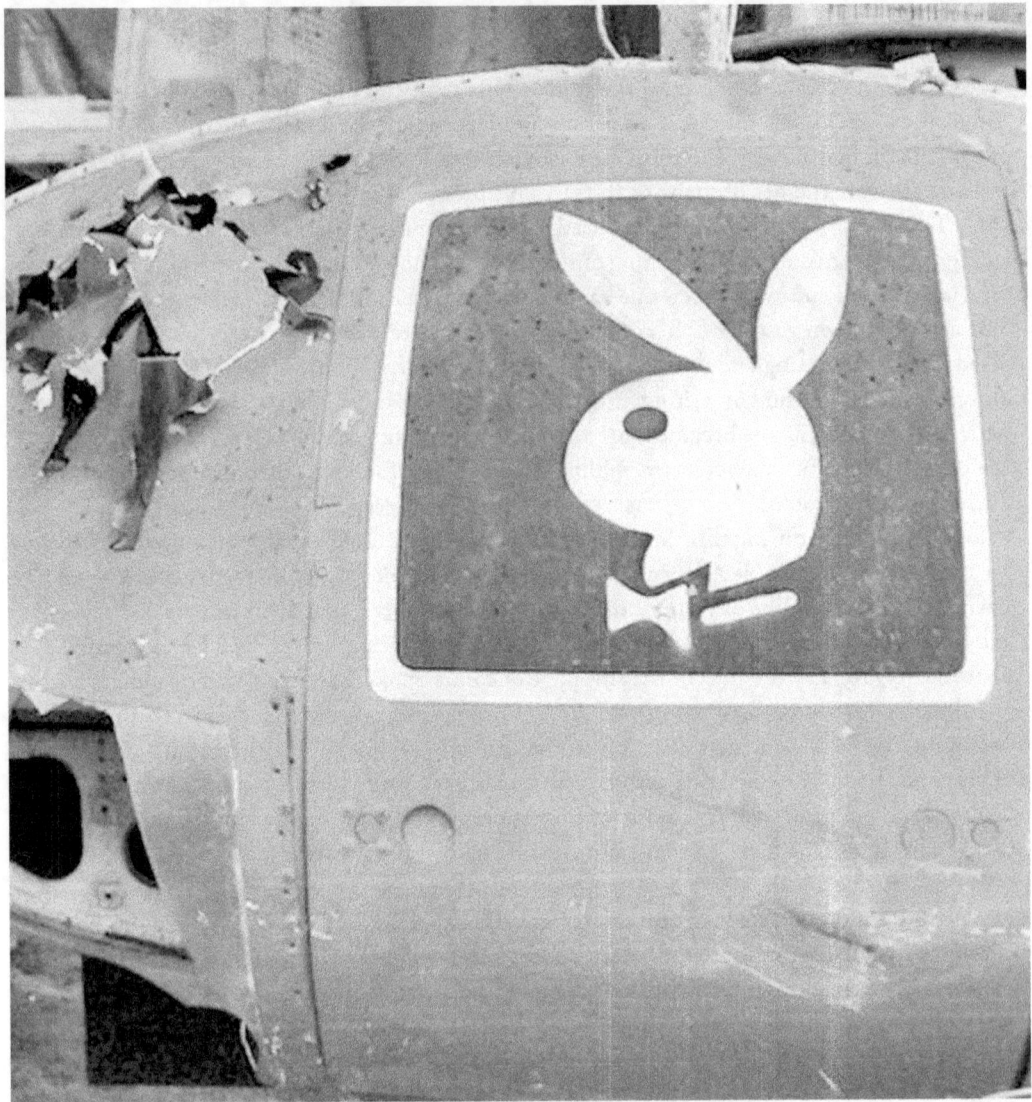

Fig. 59. The Playboy Bunny, the trademark for the *Playboy* magazine, was often seen on the nose of planes. *Playboy* was a very popular magazine that featured nude women.

Political cartoons also were seen in greater numbers. Many large newspapers included political cartoons on a daily basis. This increased during times of political or national strife. Political cartoons were drawn for certain events such as the civil rights movement, Kent State riots, Stonewall riots, and the continuation of forces in Vietnam. The civil rights movement produced political art that expressed the displeasure over events occurring in the United States. The cartoon in figure 60 shows that due to racism in the United States, there was no possibility of fighting the organized enemy. During this time there was so

Fig. 60. Political cartoons were very popular during the Vietnam conflict, as many Americans were against U.S. involvement. Even though it was not true, many United States citizens held to the fact that the United States was superior; but as this cartoon shows, there were many nationalities that were not Anglo-Saxon.

much racism inside the military that in the beginning, all African American units were segregated from white units in attempts to decrease internal violence.

Towards the end of the war most units were desegregated without issue. It was not long after entering the war that soldiers in the field realized that the conflict was not going to be short or pleasant. As early as 1965 cartoons regarding the situation in Vietnam started to be published. These cartoons were published nationally by soldiers returning from Vietnam as well as by other individuals aware of the situation. People started to ask questions, which ultimately led to many of the protests that occurred later in the war.

Although soldiers understood that this was not the same type of war as World War II and Korea, they were under obligation to fight due to the draft or prior enlistments. Due to the reaction that many soldiers received from civilians during leave in the United States, it is not surprising that political cartoons such as the one in figure 60 were popular both in the United States and abroad. Soldiers were unsure of the reason they were there, and some tried to answer questions with cartoons on the sides of planes. Even those fighting were unsure as to the real reason.[10]

## Part Six. 1954–1973: The Political War

Every element of culture was affected during this war, and because of that the soldiers travelling carried the protest and attitude with them. Nose art saw this change of culture in the transition from lighthearted designs to more skulls and protesting. Others knew exactly why they were there, and whether agreeing or disagreeing with the decision showed their emotions on the planes. Specifically, towards the end of the war when new troops were highly swayed by the sentiments of the general population, nose art was highly controversial and even argumentative at times.

France increased the number of dance halls that existed in the early 1950s. This gave French-born musicians a change to gain notoriety outside of the country. There was a time directly following the return of troops from Korea that French music was popular in the United States. This was particularly true in the South, where Cajun music was created. Cajun music used not only French words but French melodies. With a new wave of musicians both in the United States and Great Britain, France's music lost listeners. Although over the next two decades certain songs saw an Anglo fan base, the majority of French music was not extremely popular outside of France and French colonies.

Although France's music lost listeners in the United States and Britain, it was the opposite for British and United States music. During the Vietnam War era, Rock and Roll was listened to in France even with the language difference. Music calling for protest or activism hit the right nerve, and British and U.S. musicians played in French cities during the late 1960s. Although not popular outside of France, region-specific Rock and Roll did gain domestic success as it rode the coattails of highly popular English-language music. In the 1950s Great Britain imported much of its music from the United States, and many of the indigenous musical groups and genres were pushed aside. Local bands, understanding that to be successful they had to sound like the U.S. bands, staged a comeback. Although mostly out of the spotlight, British bands started to play in dance halls and pubs. This offered visibility to rising British Rock and Folk musicians.

In 1964 most of the popularity that the United States bands felt in Great Britain vanished with the televising of the Beatles on U.S. television. The Beatles were a rising power, but no one expected them to push aside a decade of U.S. musical superiority. But that is exactly what the Beatles and the Rolling Stones did in the mid- to late 1960s. It was called the "British Invasion," and everything British was popular in the United States. All parts of U.S. culture began to mirror that of British culture. The Beatles and Rolling Stones opened up doorways for lesser-known bands to make their mark in the United States. Local bands still maintained some popularity, but it was nothing compared to what the Beatles were seeing at concerts.

During this time that Rock and Roll was everywhere, three genres had to adapt to maintain a fan base. Smaller folk bands adapted to create music that the younger generation wanted to listen to. The late 1960s and early 1970s saw an increase in folk musicians singing about current political and cultural concerns. The other genre that really took off during the late 1960s was British psychedelic music. This music drew from Eastern sources such as Indian music in attempts to recreate how it feels to be on psychedelic drugs. Even bands that did not create specifically psychedelic music dabbled in it to gain more fans and to

branch out artistically. The British Blues scene, borrowing from U.S. Blues musicians, created a large fan base and mainstream popularity in the late 1960s with musicians such as Eric Clapton and Fleetwood Mac.

The U.S. music scene consisted of many of the same genres as Great Britain's, but the climb to success was at different times. The United States had very successful Rock and Roll, along with Folk music, in the mid– to late–1950s. Music was being exported along with musicians to Great Britain and other English-speaking countries. The Big Band music of Nat King Cole and Frank Sinatra were still being listened to on radios and in dance halls. Folk music was used to create Rock and Roll while still trying to maintain fans, even though much of what made Folk music good was transformed into Rock and Roll for younger generations.

Among the fight for civil rights and feminism came a music label that changed how many felt about music. In 1959 Berry Gordy, previously an employee at a car manufacturer, founded Motown. During the next four years Gordy recruited singers, songwriters and producers to create a highly successful record company. The majority of Gordy's ensembles were African American men and women who combined Rock and Roll with traditional soulful music.[11] Two well-known groups from this time were the Temptations and Diana Ross and the Supremes. The popularity of Motown assisted the civil rights movement as well as translating to nose art on planes.

While smaller genres began to produce music such as heavy metal and feminist music, one influential genre paved the way for cultural change not only in the United States but also in Great Britain and France to some extent. This was the revival of Classic Rock. Although Rock was not a long established form of music, the changes that had occurred since its inception in the late 1940s were monumental. Classic Rock was more about the music and less about the stage show. This style of Rock was about the music and what the music said to the individual listener. Musicians such as Jimi Hendrix and Janis Joplin were part of this movement. This type of music was popular due to the culture of drugs of the mid- to late 1960s. Not only was this music popular with those individuals, but the musicians themselves fed off this, and both Hendrix and Joplin died of drug overdoses.

The music during this time had a message, and many times the message was about drugs or anti-war sentiment. Those who listened to this music were the same individuals who were drafted to fight in Vietnam. The soldiers carried these messages from the music with them and painted images that reminded them of the music and the culture they left behind. Due to war, and this war specifically, not many elements of culture travelled with the soldiers. Music travelled well and influenced what designs appeared on the planes or helicopters. This was shown here by a whole set of helicopters illustrated with Iron Butterfly, a rock band popular at the time.[12]

During previously discussed time spans, artistic expression changed due to outside influences on artists and what was available in their surroundings. With enhanced technology and a greater cultural awareness, the products of creative thinkers changed at an increased rate. As previously mentioned, clothing and artwork during the mid–1950s to mid–1970s were closely connected. This connection can be seen by looking at all three

countries' artwork during the 19 years that this encompasses. During the Vietnam War era, artwork changed more than at any other time period. In those years over 20 new forms of art emerged between France, Great Britain, and the United States. In many instances a genre simultaneously came forward in multiple areas. Because of international travel along with international conventions and publications, new ideas were able to be shared globally. This communication allowed for genres to gain popularity in multiple areas at similar times. While many new forms of art were created during this time, there were only a few in each country that gained enough success to affect other elements of culture.

Two methods of art that easily migrated to other elements of culture were optical art (op art) and psychedelic art. Optical art was originally created in Germany. This method, once it arrived in Great Britain and the United States, exploded. Op art used lines and colors to create optical illusions. Some elements of optical art were found on airplanes during this time, due to the fascination that it created in people looking at it. Due to the drug use of the 1960s and 1970s, psychedelic art gained popularity. Many psychedelic artists believed that taking drugs to induce an altered sense of reality was a version of artistic inspiration. This method became very popular and was commonly seen on album covers, concert posters, and comic books.

Both op art and psychedelic art were used to take the viewer away from reality, while *nouveau realisme* attempted to show viewers a shock of reality. *Nouveau realisme* is a method of painting that originated in France during the early 1960s. This method of painting is similar in some aspects to the pop art of Great Britain and the United States. Artists wanted to be unique and not use established techniques of creating art. For this reason many French *nouveau realisme* painters used external elements to create collages that portrayed their meaning in new ways. Ever wanting to be different, these artists also used *decollage* to give the viewer a stark look at reality. *Decollage* is the opposite of collage, meaning that instead of building up an image using different sources, the artist cuts, tears, or otherwise removes pieces of an existing image to create a new one.

Great Britain and the United States were also interested in giving viewers a look at reality. Both of these countries experienced the emergence of pop art in the mid–1950s in Great Britain and the late 1950s in the United States. Pop art strained what people thought of as fine art by using common aspects of life to create a new look. Artists used imagery from advertisements located in comic books, magazines, and newspapers. While similar in nature, the origins of pop art in Great Britain and the United States differed. Great Britain used U.S. imagery as a tool to show how manipulative companies were and to look at the issues from afar. One example of this is Sir Peter Blake's "On the Balcony." As the painting shows, Blake painted an image and then attached pictures of modern culture such as the *LIFE* magazine cover. This painting shows that no matter where you are you are inundated with images from companies and organizations. It was an in-your-face look at how life was changing following the Korean Conflict.[13]

While the British artists could view the increase in advertising from afar, those living in the United States were directly affected by it. Modern artists wanting to distance themselves from existing artistic methods began to use modern elements of life in fine art. A

well-known pop artist in the United States was Andy Warhol. He used basic elements of modern life in attempts to slow down and actually look at what people were doing, eating, and reading. This was a motif used by Andy Warhol to show what life was about in an ironic way. One painting is actually 32 separate canvases that are placed together on a wall. These paintings are of all the different types of soup that were once cooked fresh in a kitchen and now bought canned at a store. This could have been used to show viewers that life was more about mass production than family time spent cooking.[14]

At times the artists adapted something they saw to express their message. Using political cartoons, comic strips, and comic books as a backdrop, many artists created images that appeared as comic panels. In reality they were a parody of how U.S. citizens were spending their time. This art method affected how people viewed their surroundings and assisted in ushering in a set of methods primarily in the United States that turned away from materialistic trappings. In addition to the reality-based methods such as pop art and the super-reality methods seen in psychedelic art, artists in the United States started to gravitate towards nature. Nature was becoming important to many as people started to move away from cities into rural areas and attempted to reconnect to nature. Land art was a method that connected not only the artist to nature but the viewer as well. Land artists believed that art was becoming plastic and fake toward the end of the 1960s and wanted to do something different. The result was using nature as a canvas and the paint to create works of art. Artists used natural land formations along with rocks, water, and other organic material to create something new. This new method coincided with a push for more naturalistic living.

During the late 1950s a new generation of filmmakers began to take off from Italian neo-realism and created the *la nouvelle vague* (the New Wave). This method of filmmaking rejected the classic French film form and instead focused on the growing feeling of interconnectedness that younger generations believed in. Due to changing political, social, and cultural elements in France, filmmakers used this to their advantage and moved even farther away from classical methods of filmmaking. There were those who chose to assist in the social and political turmoil created by films that promoted change and defiance. Overall the movies that gained popularity in France were of four major genres. These genres, while similar to those before the New Wave started, were different in how they were filmed. Dramas, thrillers, horror, and comedies were all popular during the New Wave. Filmmakers specialized in removing the viewer from reality while, during the early 1950s, it was customary to attempt to keep the viewer connected to reality. This difference is that New Wave directors used illusion and a weak narrative. The directors relied on the movie to tell their story while classic French films relied on the narrative to guide the film, rather than the acting and scenery. While the New Wave unofficially ended in 1964, the ramifications of what the filmmakers produced continued on into the late 1960s and early 1970s in France and around the world. Following the end of the New Wave, many new directors were coming into the industry looking for work and wanting to create films from their perspective. This vision was of an anti-conformist, liberal attitude that fit in with the established New Wave filmmakers. Many of the films had political underpinnings if not an overt theme that spoke

to national or international activists. Many of the films also included varying amounts of nudity as the sexual revolution began to take hold.

Great Britain in the mid–1950s started losing ground to Hollywood in production and audience numbers. Realizing that the large postwar productions were no longer cost effective, directors began to move towards comedies. There was also a new form of military-themed movies that were aimed at civilians and not the soldiers who fought in the battles. The hope was that civilians could see the movies and have a better understanding of what occurred. Satirical reviews of British culture and life also were gaining popularity. These satires were created with television in mind. All of the movies were created with breaks to allow for commercials and changed the length to accommodate the average person's attention span. In addition to satires, with censorship being largely removed by the British government, many directors started to venture into the horror genre. Horror movies gained a large following early on, and directors created new movies and also re-filmed classic horror movies in color.

The start of the 1960s showed a drastic change in which genres of movies were created and how films were made. With an increasing desire by the United States audience for all that was British, the British film industry saw a large spike in demand. With this demand came an influx of producers and directors to England with hopes of becoming famous. With such a large group of creators, movies were being made more cheaply, which allowed a faster production time than the large studio films. Films regarding the Beatles were immensely popular internationally, while nationally, movies that gave a satirical look at the British upper class and those that depicted the change in sexual attitudes garnered the most revenue. Of all the directors in Great Britain, one stood out as taking risks and many times being censored for them. Stanley Kubrick created films that pushed the envelope for both content and visual aspect. Kubrick did not sit idly by while other filmmakers were experimenting with different elements. This was specifically seen in *Spartacus*, where he shot a homosexual scene that was censored prior to distribution. Kubrick was also known for his early 1970s movie *A Clockwork Orange*, which was highly controversial; this may have also helped it become extremely popular.[15]

One genre of movies, extremely popular in Great Britain but not in the United States, took a satirical look at the U.S. military during the 1960s. These movies were based on poems, novels, and plays that looked at war in a variety of ways. Many of the movies were directly related to the United States' Cold War with the Soviet Union. These movies showed the underlining hostility towards and disagreement with the constant state of war that Great Britain and the United States were involved in. Great Britain was at the height of its film production in the late 1960s and early 1970s. Shortly after the new decade, however, British film producing began to slow down due to not being able to compete with the United States made films. The years following the Korean War and on to the end of the Vietnam conflict were a rollercoaster for the United States film industry. The United States lost and then regained some of its dominance in the industry during this time. As a reaction to the decline in film, television adapted to take the place of film studios. When the cost of film-making reduced to a more reasonable amount, the United States regained some if not all

of its 1950s prestige. During the mid–1950s, movies were traditional and conservative in nature. Towards the late 1950s, however, new filmmakers were coming into the business who wanted to separate themselves from the older generation. This prompted a change in movies that continued until the mid–1970s. The change was that movies were targeted for the younger generation as the primary audience. For that reason, sex, drugs, and music were popular themes seen on the big screen.

During the 1960s, movies were taking such a drastic turn with explicit sexuality and violence that the film industry was forced to impose ratings on the movies. While movies on the big screen were becoming more popular with young adults, television was able to create shows for children and older populations to enjoy. The 1960s ushered in cartoons' being shown during prime time, which was a huge success. *The Flintstones* was the second cartoon to be shown during prime time, and because of its popularity, *The Jetsons* and *Mr. Magoo* soon followed. Due to the expense of making films, most films that were made were low budget and therefore were made quickly. Due to the increase in psychedelic drugs, films during this time were likely created by new directors trying to break into the industry and market the psychedelic theme. Of the films that were not created specifically for the drug users, many were based on the increasing strife that was occurring in the United States. Protests were filmed and made into movies to show a larger audience what was happening.

While this increased the amount of films being seen overall, the success of the U.S. film industry was second to that of Great Britain. Great Britain could still continue to make movies on a budget that were popular, in addition to the British craze in the United States during the 1960s. Everyone wanted to be British or to at least own something that was. This all turned around during the early 1970s with the introduction of exploitation films. Exploitation films were mainly filmed in urban African American neighborhoods. While the main audience was supposedly young African Americans, many movies expanded on stereotypes. In addition to these films, there was an explosion of military films and television shows specifically addressing the Vietnam conflict. While there were both dramatic and satirical films regarding the army, it was the satirical films that drew the largest audiences.

The years following the Korean conflict and encompassing the Vietnam conflict saw a drastic change in how individuals saw themselves and each other. Younger generations grew up in a different culture that produced new art, music, movies, and attitudes. Thought of by some as the generation who changed the most, these individuals were just attempting to find a place for themselves among all of the conflicts and civil rights issues. These individuals affected not only their personal surroundings but ushered in change that reverberated through all three countries.

# 12

# Skulls

The United States, not seeing North and South Vietnam coming to a resolution, independently began to send military representatives and consultants to the peninsula in 1950. These representatives' goals were to bring about a peaceful resolution between the two countries. Due to the ideological differences of the two governments, a peaceful conclusion was deemed impossible and the U.S. military began to send supplies and troops to Vietnam. In the beginning the desire was to resolve the conflict quickly, as the United States was also involved in Korea.

France had been involved in the Indochina area for many decades, and Vietnam was a French colony. France was supportive of the United States entering and used this as an opportunity to reduce its forces and lessen casualties. After the defeat at the Battle of Dien Bien Phu, the French government was ready to accept defeat and withdrew on May 7, 1954. By late 1954 very few French soldiers remained in Vietnam. Those that did either became ex-patriots or hoped to repay the North Vietnamese by way of signing up with the U.S. military.

The United States was not the only country that believed that for the good of the world, the communist forces of North Vietnam should be removed from power. Organizations from many neighboring countries joined with the United States.[1] By the early 1960s it was clear that the U.S. military presence was escalating in the country. It was not until 1965 that the United States started to deploy combat units to Vietnam to confront North Vietnam. Once large-scale deployments began, many in the United States began to wonder if conflict was the best way forward.

Due to conflicts occurring elsewhere in the world, Great Britain did not participate in the Vietnam War. After the creation of the Suez Canal, ownership was jointly held by France and Egypt until 1875. When Egypt began to falter financially, the logical choice was to sell its portion to the British. Soon after that Great Britain not only took de facto control of the Suez Canal but also of Egypt.[2] After World War II Great Britain no longer controlled Egypt but did have a large military presence in country, along with an agreement of a full lease on the Suez Canal. This lease along with the creation of Israel contributed to the escalation of hostilities from 1948 to 1951. Great Britain along with the United Nations was instrumental in the creation of a new country primarily for European Jews. The Egyptians, being mainly Muslim, disagreed with this decision and began to attack and seize ships going to and from the Israeli ports. To make matters worse, in 1951 Egypt abrogated the treaty

## 12. Skulls

that allowed Britain control of the Suez for another twenty years. On October 29, 1956, Israel along with Great Britain and France began to launch operations against Egypt. Due to the unequal strength of the opposing forces, it took less than two weeks for the conflict to be over. Due to this short conflict, not many British planes other than those already stationed in Kenya and Egypt were able to assist. The planes that did assist were mostly used for supply and transportation. For this reason many of the planes retained their Mau Mau artwork for supply flights.

Towards the end of the Mau Mau emergency in 1957 came an insurgency by Cypriot guerrillas for Cypriot freedom from Great Britain. Great Britain had previously used Egypt as the location for its Middle Eastern headquarters. Following the withdrawal of the British from Egypt, Cyprus became the new headquarters. This did not sit well with the Cypriots. It was not long before the National Organisation of Cypriot Fighters began to attack Great Britain on Cyprus.[3] While Great Britain had control over the area, Turkey and Greece were fighting over who should have control over Cyprus. British soldiers did nothing when confrontations between the Turkish and Greek Cypriots began. The goal for the guerrillas was to gain independence from Great Britain. In 1960 this goal was achieved, and Great Britain allowed Cyprus its independence. The fighting was over for Great Britain but continued between the Greek and Turkish residents of Cyprus. The end of the Mau Mau emergency along with the Korean Conflict did not end Britain's colonial troubles. Due to the large size of the British military, not many enlisted soldiers were recalled to service for each conflict. For officers each conflict directly or indirectly affected them and their families. While a small contingent remained, the majority of combat was over. France was leaving Indochina and the United States was starting to increase its military presence in Vietnam. Great Britain had no desire to become involved in the Indochina conflict and was regrouping when a string of conflicts began in 1962. These battles stretched not only the military's capabilities but also the general population's patience as war continued.

The Dhofar Liberation Front (DLF) began to form and with the assistance of the Saudi Arabians began to obtain weapons and vehicles. The goal was to oust the presiding government from Dhofar and install a Saudi-friendly government. With a small militant force, the Omani government was at a disadvantage. Once the three liberation fronts organized and came under attack, both British and Omani held oil fields plus other economic areas. Great Britain supported the Omani government with supplies and funds in an attempt to confront and control the guerrilla fighters. By 1970 British officials realized that if a new leader was not placed into power, Dhofar along with all of Oman was likely to fall. It was at this time that Great Britain gave the Omani sultan asylum in London and his son became the new leader. While this did assist the negotiations, it was another five years before peace was restored. The conflict strained many governmental relations in the region, and this continued to have an impact until the early 1980s. During the time that Great Britain was supplying Oman with materials and funds for the Dhofar Rebellion, four new conflicts arose for the British military.

Chronologically the conflicts that plagued the British military were the Indonesia-Malaysia confrontation, the Brunei Revolt, the Aden Emergency, and the infamous "troubles"

in Northern Ireland. All four of these conflicts stretched both ground and air forces thin. As in past conflicts, the countries believed that Great Britain was using its power and influence in disadvantageous ways for the country involved.

The Indonesia-Malaysia conflict and the Brunei Rebellion arose when Great Britain wanted to consolidate power and resources by creating a new Malaysian Federation. This new federation if formed was to include North Borneo, the Federation of Malaysia, and Singapore. Aside from North Borneo, of the countries were either completely independent or self-governing. This decision was created out of necessity by Great Britain. Prior to this plan by Malaysia, Indonesia was striving to destabilize the neighboring countries. Indonesia was opposed to this move, which increased economic and military power for the three conjoined countries. The leader of Brunei also opposed this move because he believed that rejoining under any form of British control was unacceptable. Given the large oil fields and the historical ethnic issues, Brunei's leader agreed to the merger if only all three northern provinces were organized under him. Great Britain along with Malaysia did not agree to this, because the power shift placed Brunei in a position to resist Malaysia and Great Britain if necessary. Those in opposition to the agreement began to strike out against proposed member states, and in 1963 Indonesia came out as saying that a new policy for crushing the proposed state of Malaysia was enacted and going to be carried out.[4]

Great Britain, fearing that the member countries would fall without assistance, agreed to send soldiers and supplies. Soldiers that were already stationed in the Far East Command were easily moved and proved to be useful in the conflict. By using planes already stationed in the region for the Malayan emergency along with the Korean Conflict, Britain was able to quickly move supplies and soldiers into position. The RAF sent nineteen squadrons from Singapore to assist in the fighting. These crews were not new to the area, and the planes sported the attitude of those stationed in Singapore. Paintings of English landmarks along with Singaporean references were commonly seen. In hopes that the conflict would be short-lived, the British began to use secret agents along with psychological operations to employ propaganda that had been used briefly in earlier conflicts.

With a larger military and economic backing, the member states along with Great Britain, Australia, and New Zealand were able to force Indonesia to withdraw from the conflict. Although the war lasted for four years, the death rate was very low. This gave Great Britain and the member states an advantage coming into the negotiation talks with Indonesia. Having the larger military force, Great Britain could have killed many, but instead chose psychological tactics to decrease the mortality rate. It was not until 1965 that Indonesia finally agreed to the formation of Malaysia and to resume diplomatic talks with the neighboring countries. The Brunei Revolt continued to smolder until 1966. It was at this point that the sultan of Brunei realized the Malaysian Federation could not provide Brunei with what they required for admission. Therefore Brunei did not enter the federation, and Great Britain was able to send troops and supplies to other ongoing conflicts.

War continued in the Middle East, not just in Oman but also in Yemen during the Aden Emergency. Yemen was once a country used extensively by Great Britain as a route between the Suez Canal and India. After India gained complete independence from Great

## 12. Skulls

Britain, Yemen was no longer as important. For that reason Great Britain mainly forgot about the country until 1963, when anti–British groups began to appear in Yemen as in many other Middle Eastern countries. In the beginning, two Arabic nationalist groups began to fight among themselves as well as attacking the British troops still stationed in Yemen. The National Liberation Front along with the Front for the Liberation of Occupied South Yemen desired the same objectives. However, how they went about these goals was different and caused strife. By 1965 Great Britain had moved in nine squadrons to the Yemen RAF Base. The aircraft that were routed to Yemen came not only from ongoing conflicts but also from Great Britain.

These small conflicts brought about new attitudes toward war and new nose art. Much of the art created during this time period was by soldiers who were tired and wanted to return home. Although few active rebellions broke out among the British military ranks, the artwork proved that the sentiment was present. The battles that raged in Yemen were similar to other conflicts that occurred during the same time. Likewise, these conflicts were not quickly resolved, and the Aden Emergency continued on until 1967 when Great Britain left the country. There was no formal resolution, and an agreement was not made between Great Britain and the guerrilla groups. In 1967 it seemed that most of Great Britain's conflicts were resolved or close to being over.

It was in the late 1960s that the independence movement shifted from distant colonies to those much closer to home. The United Kingdom had been formed in 1801 when the Kingdom of Great Britain merged with the Kingdom of Ireland.[5] Irish nationalists began to fight for independence during World War I. This rebellion led to the creation of the Irish Free State in 1923. Following 1937, the Irish Free State enacted a new constitution and was renamed Ireland. During World War II Ireland maintained a cordial relationship with the United Kingdom while maintaining neutrality. Protestant Northern Ireland remained part of the United Kingdom. Conflict began to occur between northern and southern Ireland. Northern Ireland was composed of two social groups: Protestants and Catholics. These groups consisted of those who considered themselves Irish and those who considered themselves British. Starting in 1969 the Catholic minority, perceiving a heightened level of discrimination by the Protestant majority, turned to violence. The minority consisted of small organizations that formed in hopes of gaining a complete Irish independence from Great Britain.

One group, the Provisional Irish Republic Army (IRA), started a campaign to reunite all of Ireland under one government and therefore have complete autonomy from the United Kingdom. The United Kingdom sent troops to maintain peace during this time. This was not possible, and Great Britain slowly started to combat the nationalist minority. Due to the location and extent of the conflict, the United Kingdom did not use airplanes other than for moving supplies between Ireland and Great Britain. This conflict strained the relationships between Ireland and Great Britain in addition to affecting the attitudes of British citizens.

Great Britain was constantly in conflict, while France was engaged in minimal conflicts. The French military in Vietnam may have been decimated; this did not stop the French government from continuing to engage in conflict. Following the French retreat in 1954 the

Part Six. 1954–1973: The Political War

only other conflict that French troops were involved in was the Suez Canal crisis of 1956. The Suez Canal long stood as a symbol of French partnership with Egypt and allowed the French to travel from the Mediterranean Sea to the Red Sea. This allowed open commerce and military movement. The Canal Zone was originally owned by both the French and Egyptian governments. In 1875 the Egyptian government was forced to sell its portion to the British during a hard economic time. In 1882 Great Britain invaded Egypt and took complete control of the Suez Canal. France was able to mainly stay out of the situation until 1956, when Egypt backed out of an agreement with Great Britain. Soon France joined with Israel and Great Britain to combat the increasingly violent Egyptians for control over the canal. As the French military was relatively fresh, the military was able to provide many supplies and even aviation units. The war, while short, did include large numbers of sorties by hundreds of planes. Great Britain had been sending planes to Egypt for two years directly preceding the start of hostilities, in hopes of maintaining a positive relationship. This plan was also tactical in nature, to limit the relationship that Egypt had with the Soviet Union. Many of France's planes were still in transit from Indochina. The only planes that were easily available were F-4 Corsairs and TBM Avengers. This may have put France at a disadvantage versus Egyptian MiGs had it not been for the training advantage that French pilots had over the Egyptians.

The British and French enjoyed a strategic advantage. They developed plans to destroy large numbers of Egyptian planes on the ground. These air strikes proved extremely successful. It did not take long for the superior Anglo-French air forces to attack the remaining Egyptian air force. This conflict was not exceptionally trying on the flight crews, as combat was over in less than two weeks. Nose art briefly appeared on French planes. Some of the art was left over from the Indochina campaigns, but there were also Jewish flags along with French roundels and other artwork depicting the Suez Canal area. Egyptian motifs such as alligators and pyramids were visible. As always, designs depicting France and family were present. With the occupation lasting another four months, some of the planes remained until the complete withdrawal of French forces. Prior to returning to France, all of the artwork was stripped and the planes were painted to appear fresh.

During all of these events, the American government was embroiled in Vietnam.

As the United States Congress never specifically approved of the Vietnam Conflict and the extent of the military draft, many people were angry about what was occurring to U.S. troops and to the Vietnamese. To make matters worse, the number of press embedded in Vietnam allowed for an unprecedented look at what was happening. Rallies were held, and men called up for the draft failed to report. This caused the soldiers who were in Vietnam to have both internal and external conflicts. The psychological trauma that many experienced caused drug use to spike among soldiers. All of these factors affected how nose art appeared on the planes.

One plausible reason for this change in painting method was that pilots were becoming better educated, and the age of pilots had increased to around thirty-two.[6] With a higher average age and more crew members married, it is not surprising that a higher level of sexual modesty appeared. Instead, many politically centered paintings appeared. Flight crews were

*12. Skulls*

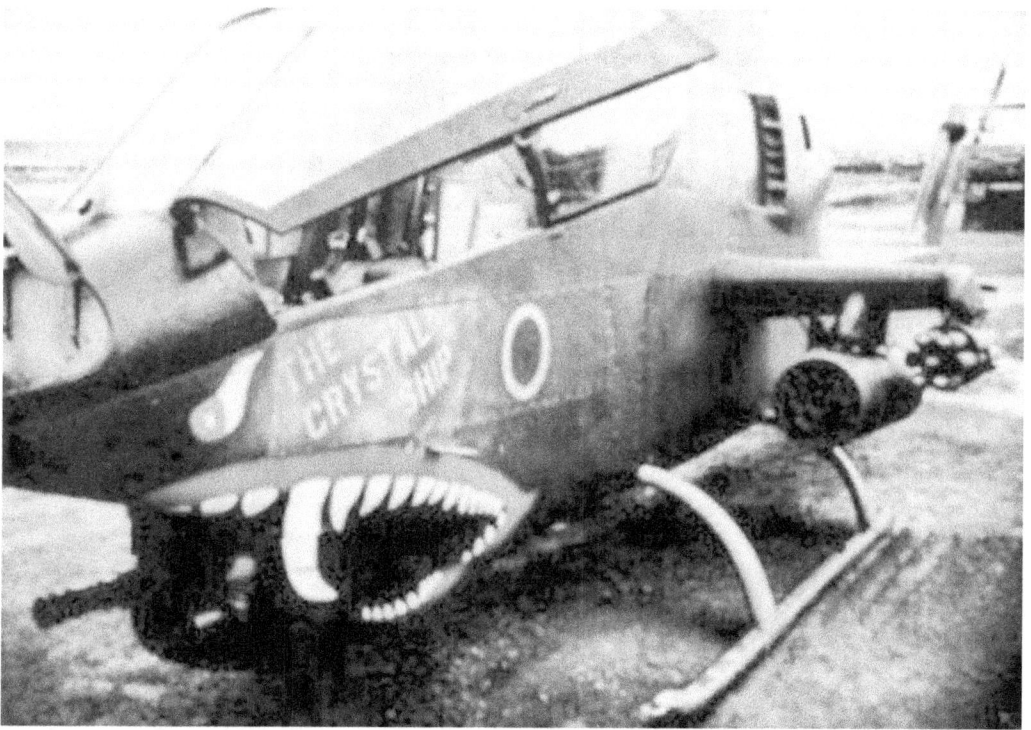

Fig. 61. This thunderbird's crew used sharks' teeth to project power. The wording "The Crystal Ship" was a song made popular by the Doors in 1967 (courtesy 9th Cavalry Regiment).

not the only group viewing the ongoing politics. The United States as a whole was taking notice of what was occurring in Vietnam.

While the Vietnam conflict ran from 1950 to 1975, nose art was primarily present from 1967 to 1970. The artwork that was painted was primarily pulled from media sources as well as the traditional images of women. Thunderbirds were well known for their female paintings, but oddly, none of the Thunderbirds in Vietnam had women painted on them. Instead the crews reverted to shark teeth and tigers to project power (fig. 61).

Many other planes were separated by color on the jet intakes instead of paintings on the nose. This allowed for the distinct identification without the time spent creating a painting on the nose.

Fighter planes and bombers were drastically different with regards to nose art. The bombers, however, still continued to incorporate women along with pilots' personal protests of the war. Other popular motifs for bombers were cultural elements such as bands, movies, clothing, and popular TV shows. *I Dream of Jeannie*, *Led Zeppelin*, and *Bonnie and Clyde* therefore were popular depictions for the time. The psychedelic movement had deeply ingrained itself in the late 1960s and early 1970s (fig. 62).

Cartoons that were popular in the United States were portrayed on some planes, but compared to World War II and the Korean Conflict, the numbers were lower. The ever-

Part Six. 1954–1973: The Political War

popular Pink Panther even graced the front of a helicopter.[7] One plane paid homage to James Bond. This UH1H was titled *Pussy Galore*. It was named after a female character in *Goldfinger*, a movie that debuted in 1959.[8]

The planes, having primarily older flight crews, the designs reflected this maturity. Also seen was a political awareness regarding the conflict. This political awareness appeared clearly in nose art.

Skulls became popular, along with statements showing the dissatisfaction many draftees felt. These individuals believed that the United States was not meant to be fighting in Vietnam. The artwork in figure 63, painted on a helicopter, shows how skulls had become an important part of nose art during Vietnam. Even the insignia of this unit, the 170th Assault Helicopter Company, otherwise known as the "Buccaneers," conjured up a sense of foreboding.

Even those that had enlisted to fight held some resentment regarding the procedures and other general aspects of the war. Attitudes that the soldiers were confronted with on leave back in the United States cemented the negative feelings.

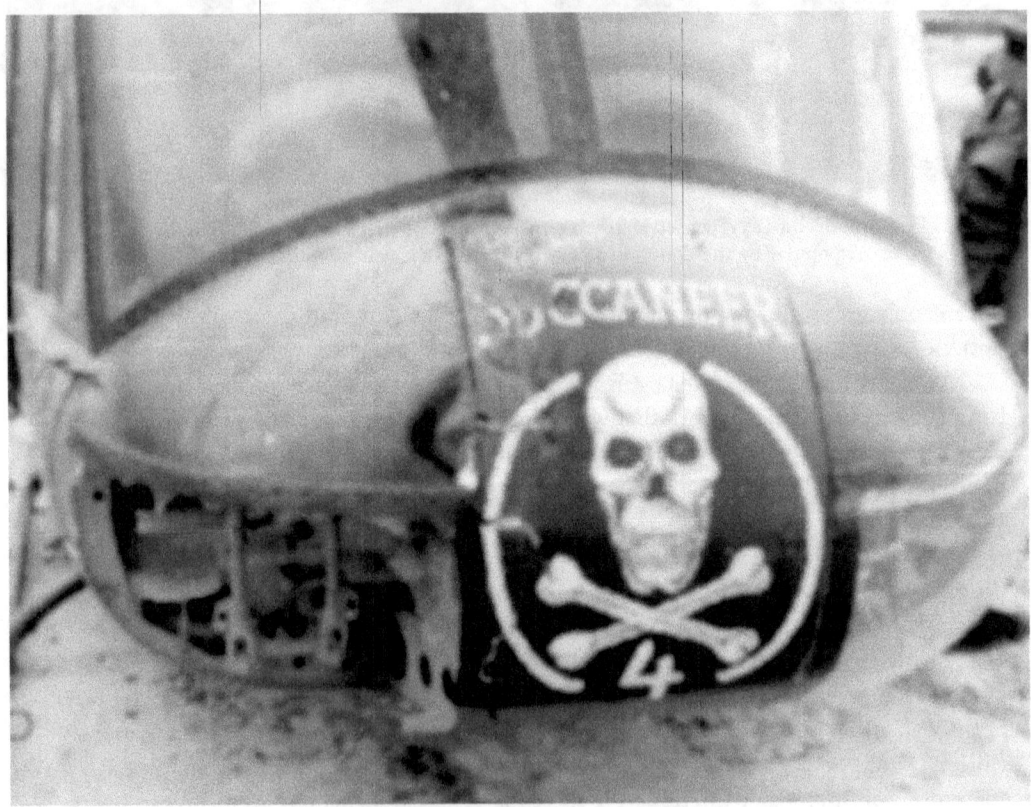

Fig. 63. This image is the iconic skull and crossbones that began to be seen more during Vietnam on helicopters and planes. This one is specifically a "Buccaneer," which was the name for the 170th Assault Helicopter Company (courtesy 170th AHC).

## 12. Skulls

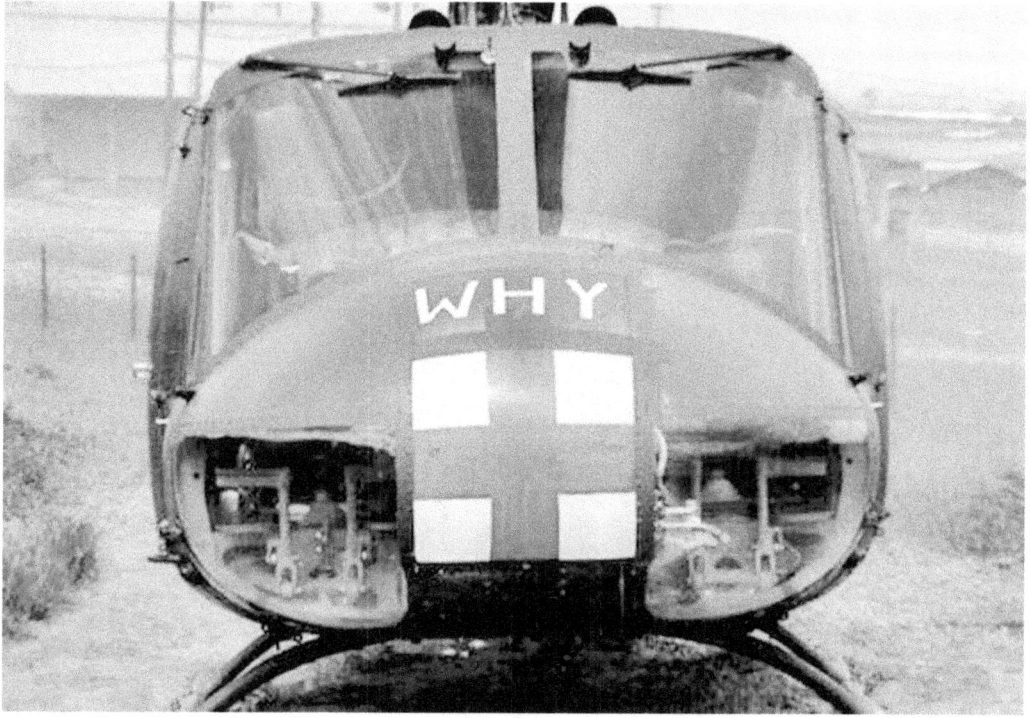

Fig. 64. A simple "Why?" represents much more than a simple question. Many, including those in Vietnam, questioned why the United States was there (courtesy Vietnam Veterans of America).

Individuals on leave were treated poorly and called terms that were taken from journalists' accounts of the combat. The artwork that the crews painted was not only bleak but also directly depictive of what was occurring both in the United States and in Southeast Asia. *Protestor's Protector*, *The Liquidator*, and *Sam Seducer* were paintings expressing the nature of the conflict. The activities the pilots were asked to embark on and the apathy they faced in Vietnam created an environment in which protesting was seen as commonplace. Even the simple question as to why the United States was fighting in this seemingly civil conflict was incorporated on the helicopter in figure 64.

During Vietnam, one interesting aspect of nose art was seen on army helicopters. Due to the size and shape of the helicopters, most of the paintings were located on the nose. The helicopter nose, unlike a bomber, had space available on the front of the aircraft, not on the side. Many of the paintings consisted of cartoons and political statements. "Little Annie Fannie," which was frequently featured in *Playboy* magazine, adorned many noses (fig. 65).

No matter what the reason behind the artwork, in 1970 virtually all nose art came to a stop. In November 1970, United States Chief of Staff General John D. Ryan arrived in Southeast Asia to inspect the planes. At this point artwork flourished on almost every plane.[9] Six months before he was to arrive, the USAF sent out a general order explaining

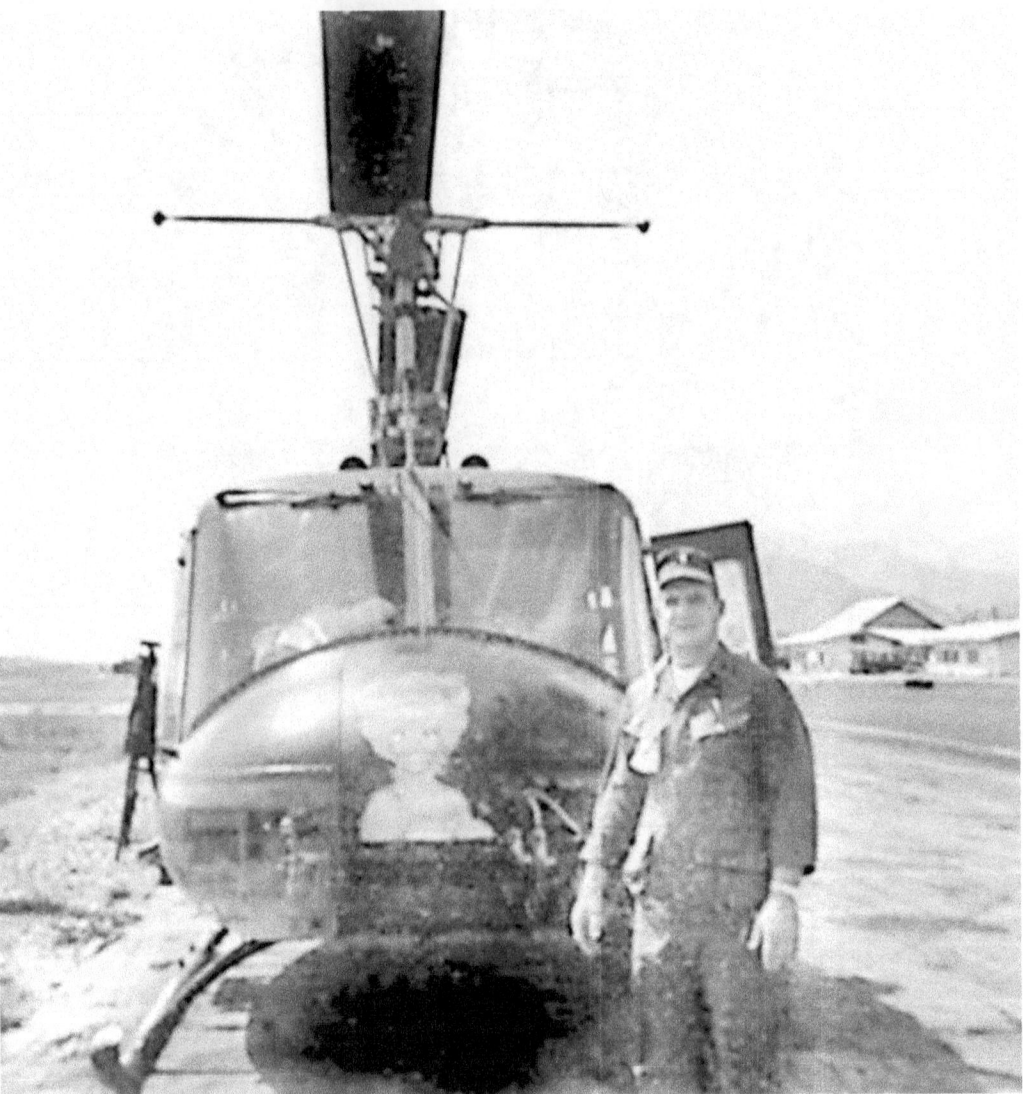

Fig. 65. Annie Fannie, a cartoon character made popular in *Playboy* was frequently painted on the nose of helicopters (courtesy Vietnam Helicopter Pilot's Association).

that all artwork must be removed. The week that Ryan was to arrive, flight crews were busy painting over all the artwork. While it was a policy that no artwork existed, it required an important visit to force the USAF to comply. The ironic thing was that Ryan never walked any flight lines, never saw the planes and did not talk to anyone about the policies regarding nose art.[10]

With the war supposedly winding down and the effect that removing all the artwork had on morale, it was not feasible to repaint all of the planes. The memory of nose art con-

## 12. Skulls

tinued to play an important role to those individuals held as prisoners of war. In his book *A P.O.W.'s Story: 2801 Days in Hanoi*, Col. Larry Guarino writes about how nose art created a sense of invisibility and comfort on those long trips.[11] His recollection was that without his plane and the artwork on it, the attitude that he carried as a pilot might not have been the same.

The Vietnam conflict was the longest that the United States had participated in during the 20th century. With the length and level of isolation, it is not surprising that flight crews and pilots thought of planes as part of the family and without their planes felt naked. In addition to their isolation in the war zone, when crews returned home they encountered sneers and negative remarks. The distance from the United States compounded with the attitudes of the U.S. citizens made many pilots feel that without their planes and flight crews they were nothing.

# The Future of Nose Art

Since the Vietnam conflict there has been a decline in military nose artwork. This is due to multiple factors that hindered the creation or implementation of nose art on planes. The biggest was that nose artwork was banned and had been since World War II during peace times. There were exceptions such as in air shows and for the Blue Angels, but for the most part nose artwork seemed a thing of the past.

It wasn't until the United States went to Iraq in 1990 that a resurgence of artwork began. One A-10 Warthog that was used extensively during the short conflict reflected pre-

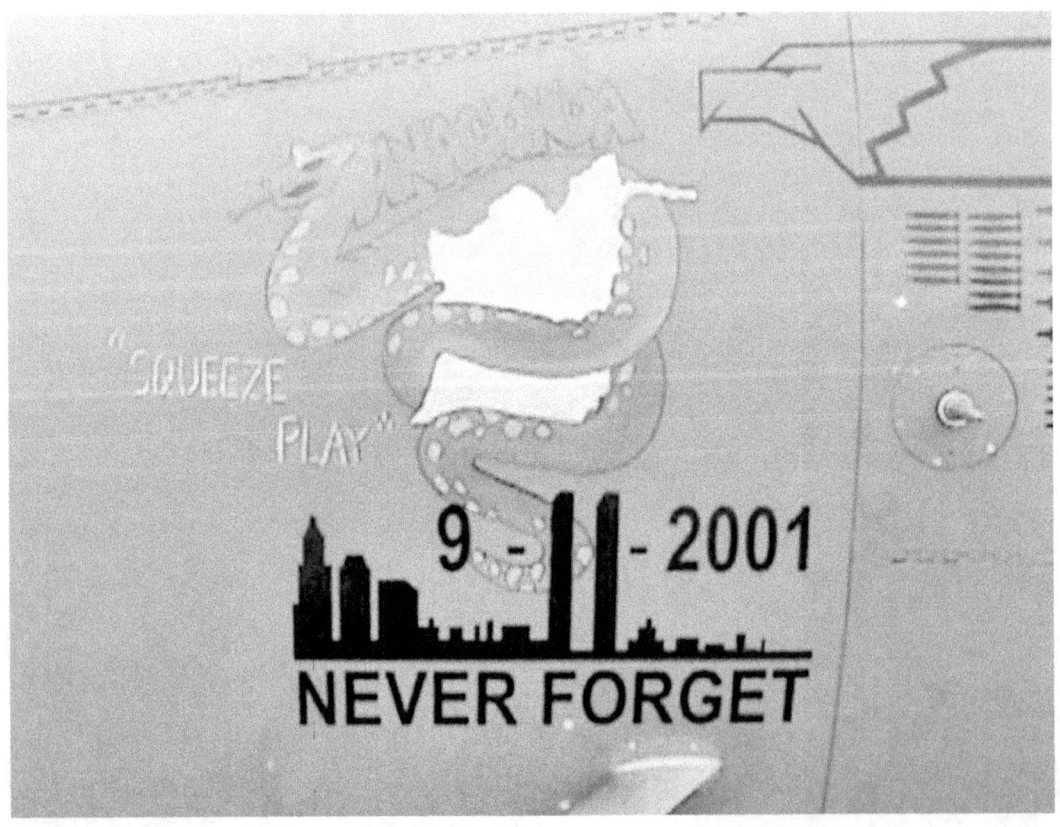

## The Future of Nose Art

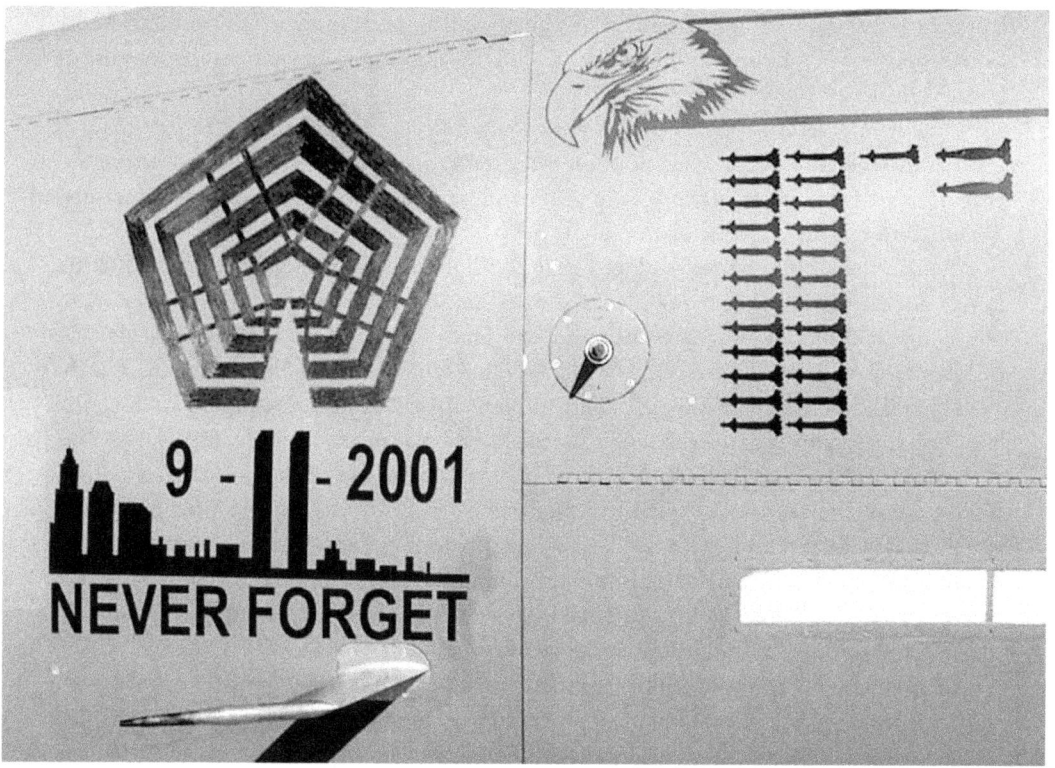

Fig. 69. Here is another image depicting the World Trade Center along with the Pentagon, which was also attacked on September 11, 2001 (photograph by Brad Messer, U.S. Air Force).

vious conflicts by not only showing the success rate but also having a design on the nose. As this conflict was a joint one, the creator of this art took it a step further by adding the flags for the allied Joint Forces (fig. 66). Many of the 2951st CLSS's planes had something adorning their nose.

Due to the Gulf War being in a Muslim country, there was an attempt at prohibiting naked women in nose art. For the most part the aircrews abided by this directive; however, there were those crews that saw this as a rule to be broken. When this conflict ended after less than a year it appeared that nose art would again be shelved by the military. The majority of the nose art seen on the A-10 Warthogs were typical artwork consisting of cartoons, sharks' teeth, and nationalistic symbols such as the eagle or the U.S. flag.

It was not just the United States that brushed off the paint brushes for the Gulf War. Great Britain as part of the Joint Task Force also sent planes to aid in fighting. The British

*Opposite*: Fig. 68. Following September 11, 2001, the United States engaged the enemy with force. Many planes had the imagery of the New York World Trade Center twin towers along with an image. This image, for example, was of an anaconda squeezing Afghanistan along with the words "Squeeze Play" (photograph by Brad Messer, U.S. Air Force).

had no trouble painted naked women on the planes, as seen on this S2B from the 208th Squadron (fig. 67). Tamnavoulin, which is written to the right of the image, is a brand of Scotch whiskey.

Following the Gulf War, nose artwork again decreased during peace times. It wasn't until 2001 when the World Trade Center was attacked and the United States went to war that nose art came back. Nationalistic pride and personal representations were seen frequently, and not just on U.S. planes.

When the United States deployed to the Middle East following September 11, 2001, it was not surprising that many planes showed nationalistic imagery. There were many planes that had similar images to remember the Trade Centers. One F-15 in particular (fig. 68) depicted what the United States was doing in Afghanistan. As one can see there is the "9–11–2001" with "Never Forget," and the New York skyline prior to the attack. Also attacked during this was the Pentagon, as displayed on another F-15 (fig. 69).

Most of the paintings created by the United States did not include sexualized women. This was not the case with the British planes, and in 2007 the RAF banned pin-ups to ensure that women serving with the RAF would not be offended. What is interesting is that of 2007 when the ban was enacted, there had been no complaints regarding the nose art. It was not just the British women that the RAF were concerned with, however, but how the pin-ups and the RAF would be perceived in Muslim countries.[1]

As the United States continues to wage war in the Middle East, nose art is making a return not just with deployed units but also stateside. In 2013 the Oregon National Guard unveiled new F-15 nose art. This artwork was part of a celebration of Oregon cities, and different planes displayed representations of cities and towns in Oregon.[2]

Regardless of what leaders and governments may say, as long as there are planes engaging in combat, and men and women flying those planes, there will be nose art. What will change in the future is that there will be more artwork on UAVs and other unmanned mechanisms of war. There are still men and women attached to them, be they repair and maintenance personnel or designers. Nose art is here to stay, and I for one look forward to what the future holds.

# Conclusion

War is an ugly time that is difficult for all involved, whether active combatants or family members left at home. Many want to forget the war and what occurred during it. There are aspects of war, however, that evoke warm memories and beauty in an otherwise hostile place. One of these aspects is nose art. Whether it is created to remember home or as a way to voice political opinions, nose art affects all those who draw it and see it during conflict.

To understand more about nose art and the motivations of painters and crew members, it was hypothesized that civilian and military culture affected what was painted. After all, these soldiers and sailors were not just service men and women but also citizens of their respective countries. I have attempted to prove that culture did affect what was painted on aircraft. While many think that a service member is unaware of what is going on domestically, this was proven wrong by artwork directly referring to new cultural movements. An examination of four periods of conflict was used to provide a thorough review of nose artwork. These conflicts spanned more than six decades, involved multiple countries, and showed the diverse nature of warfare. During the twentieth century, war transformed from men on horses with guns and simple fragile aircraft to heavy machinery and planes large enough to carry helicopters. These conflicts changed how people saw and fought war in numerous ways. With the invention and implementation of aircraft during World War I, a whole new dimension was brought about that was simultaneously frightening and exhilarating.

Change during periods of conflict affect only soldiers, but also the countries involved in the war. Whether citizens were fighting or the country had to change economic or political policies due to war, conflict affected all aspects of civilian life. Those individuals that remained at home had the burden of supporting those at war as well as maintaining a life at home. Each conflict produced its own set of challenges as well as solutions for how to navigate civilian life while supporting a nation at war. Not all changes that were made during times of war were easily undone once the soldiers returned. There are instances of cultural change that occurred very early on in the twentieth century that are still seen today. For example, women began to protest during and directly after World War I for increased freedom. With men away at war, there needed to be more opportunity for women in the work place and as part of governmental and political systems. This movement for freedom can be seen in the culture of all the conflicts examined.

Other elements of change came and went due to the artistic and societal changes that occurred when large populations of men and later women left and returned. Music, movies,

## Conclusion

art, and clothing were all elements that were directly or indirectly affected by war. Many elements of culture, while fluid, did not return to prewar standards for a long time following a conflict. This can be seen specifically following the Korean conflict, when many wanted to return to World War II ideals. With demographic and overall changes to the societal structures, the return was short-lived. During periods of conflict, strife was often seen between civilian and military culture due to the very nature of conflict. Military culture is historically strict and uniform, while civilian culture is lax and abstract. Military and civilian culture both adapted to outside influences during periods of peace and of conflict at a drastically different pace. As shown in this book, nose art was one aspect of military culture that was directly affected by civilian societal changes. As civilian culture changed, so did nose art on aircraft.

Nose art began as a way for countries with fledgling air corps to tell adversary from ally. It soon became much more, allowing pilots and ground crews to show the individuality often taken away when in a military service. Nose art was used to vent frustrations, to remember those left at home, or to feel a bond with the unit. At the beginning the phenomenon was small and more of a gimmick. As the wars continued and aircraft went to the forefront, nose art took on a life of its own.

By the start of World War II nose art had become a reflection of society. With an increase of sexualized artwork and images came a progression of women being painted on planes. With an escalation of cartoons and comics came an increase of comic and cartoon representations on noses. When something became popular in one country, similar designs start to be seen on the other countries' planes. This was exactly what occurred with Mickey Mouse and Bugs Bunny. Politically, service members from all three countries understood and shared nose art depicting the common enemy. What World War II accomplished towards bringing nose art from all three countries together, the following years undid. Due to the differences in location, nose art continued to be painted using geographic references. During the Korean War, imagery began to be more sexualized. Politically charged paintings were briefly seen towards the end of the Korean Conflict. On the social front, Rock music and jeans were popular and showed on the planes.

Vietnam took what started in Korea and expanded upon it. Nose art became very political because the war and the world during this time were politically charged. Artwork started to show the true feelings of the soldiers at war. With the constant fighting that was taking place around the world, it was not surprising that artwork took a more political view. It was also during this time that the governments began to take a closer look at nose artwork, therefore even though the conflicts were long, the amount of time that nose art was displayed was relatively short.

Looking at three countries' influences on each other and from outside gives a more rounded view of the relationship between culture and nose art. Patterns started to emerge by the time that the Korean War started. These patterns were that music and movies played a strong role in what was painted. Another trend was that countries mimicked each other by painting similar designs. By examining how nose art changed from World War I to Vietnam, this paper demonstrates that when attitudes and culture were affected, so too was the

## Conclusion

art that was painted on aircraft. There were many ways that civilian culture was introduced to soldiers in the field, but what is really interesting is that at times the change in art was almost simultaneous to the cultural changes. Politics collide, television shows emerge, music adapts, and all of these things changed how servicemen and -women related to each other and specifically how they related to their missions and their planes. It is not what was painted on the plane that was important but how the change came about.

To prove that culture affects military nose art as military nose art affects culture, a larger review of multiple countries was needed. By looking at the United States, France, and Great Britain from both cultural and military points of view as well as by comparing the changes over multiple decades, I detected a pattern. To bring about some form of completion, I have included a summary to highlight what the strongest elements are that prove my hypothesis that civilian culture affects military culture and that military culture affects civilian culture.

War fosters patriotism, as shown by the plane artwork that depicted nationalistic symbols. These symbols strengthened both civilian and military resolve for the war. As elements of modesty and sexuality changed, so did the representations painted on planes. Two intertwining elements of culture are seen in the relationship between movies depicting war, starring popular figures, whose figures then began to appear as artwork for service members. Wars fostered propaganda, which then at times affected nose art, which in turn at times affected how propaganda was used. Changes in fashion over the years directly affected how human representations appeared on the planes. The activities of soldiers in Vietnam inflamed many in the civilian population, which then resulted in negative nose art connotations.

The above are just a few examples of how nose art affected and was affected by civilian life and culture. While the overlap is not surprising, what is surprising is the similarity between the United States and fellow countries, Great Britain and France with regards to how civilian culture affected nose art. Many books only talk about the United States and nose art, and these books are mainly picture books in which to admire the art. When a direct comparison is made between culture and nose art, it is apparent that more dynamics were present than just pilots' deciding to decorate their planes for amusement. These three countries were not the only ones that produced nose art, nor were they the most robust in specific conflicts. This look at how culture influenced nose art, however, has only dug slightly into the world that is nose art. Since the study of nose art is still in its infancy, there is more to explore with regards to nose art internationally and locally.

Culture is not bound by land or linguists, and can be seen transferring between countries. This cultural diaspora is shown by the popularity of British music in the United States and French clothing in Great Britain. This exchange of cultural elements did not stop at clothing and music but included movies and cartoons. Therefore, seeing Mickey Mouse, an American-made character, adorning the side of French and British planes was almost expected. Although language barriers existed, these three countries were all connected by similar concerns. Economics, politics, and military issues were all important domestically as well as internationally. Although life was difficult, such as during the Great Depression,

common elements such as cartoons and movies united the citizens of all three countries. Therefore, much of service members' artwork had similar foundations. A common enemy, similar motivations, and the desire to be home all contributed to a feeling of interconnectedness between service members of all three countries. These men and women left their families to fight a war, during both supported and vilified conflicts. This connection extended over national boundaries and sometimes oceans. One thing is sure: all of these service members felt similar emotions and saw similar cultural representations. Therefore no matter the conflict or the country, artwork depicting homesickness and nationalism was widespread.

Domestic culture and wartime situations are not as different as they may appear, as elements of war easily were integrated into domestic cultural applications and, obviously, military culture took many cues from its domestic counterpart. Unless the military existed in a vacuum without civilian interference, there was bound to be crossover; however, the crossover seen between the three countries and spanning conflict periods exhibits the true nature of culture and community. This crossover shows that even with extensive training and wearing military colors, service members are still an integral part of their communities and their nations.

# Chapter Notes

## Introduction

1. Gary M. Valant, *Vintage Aircraft: Nose Art* (Saint Paul, MN: MBI, 2001); Jeffrey L. Ethell and Clarence Simonsen, *Aircraft Nose Art: From World War I to Today* (St. Paul, MN: Zenith, 1991); and J.P. Wood, *Nose Art: 80 Years of Aviation Artwork* (New York: Barnes & Noble, 1999).
2. Gary Valant, *Vintage Aircraft Nose Art: Ready for Duty* (St. Paul, MN: Motorbooks, 1988), 10.
3. Ibid., 11.
4. Following Ethell's death, his family created a Web site, accessed February 7, 2011, www.JeffreyEthell.com.
5. Wood, *Nose Art*, 4.
6. Dominic Strinati, *An Introduction to Theories of Popular Culture* (London: Taylor and Francis, 2004); Valerie M. Hudson, *Culture and Foreign Policy* (Boulder, CO: Lynne Rienner, 1997); and Bayla Singer, *Like Sex with Gods* (College Station: Texas A&M University Press, 2003).
7. Strinati, *Introduction to Theories*, xii.
8. Ibid., xiii.
9. Ibid.
10. Hudson, *Culture*, 3.
11. Bayla Singer, *Like Sex with Gods* (College Station: Texas A&M University Press, 2003).

## Chapter 1

1. Brian Moynahan, *The French Century: An Illustrated History of Modern France* (Paris: Flammarion, 2007), 41.
2. Ibid., 42.
3. "European Expansion: Africa 1910," *Encyclopedia Britannica*, 11th ed. (New York, 1911).
4. Abraham Lincoln, "House Divided," June 16, 1858 (Springfield: Illinois State Historical Society, 1958; Washington, D.C.: Library of Congress, Jefferson Building Reading Room).
5. George D. Lillibridge, "Images of American Society: A History of the United States," vol. 1 (New York: Houghton Mifflin, 1976), 230.
6. Lillibridge, "Images," 195.
7. Francois Baudot, *Fashion: The Twentieth Century*, 2nd ed. (New York: Universe, 2006), 34.
8. Ibid., 45.
9. Ibid., 98.
10. Frances Trollope, "Strange Fashions of American Women," *Domestic Manners of the Americans*, spring 1831, accessed December 1, 2010, http://xroads.virginia.edu/~HYPER/DETOC/fem/appear.htm#trollope.
11. Ibid.
12. Ibid.
13. Edouard Manet, *Le dejeuner sur l'herbe*, 1863 (Paris Cedex 7: Musee d'Orsay).
14. Charles Harrison, *English Art and Modernism, 1900–1939* (New Haven, CT: Yale University Press, 1994), 150.
15. Martin J. Heade, *Rio de Janeiro Bay*, 1864 (Washington, D.C.: National Gallery of Art).
16. Brian Moynahan, *The French Century: An Illustrated History of Modern France* (Paris: Flammarion, 2007), 43.
17. John Betjeman, *Victorian and Edwardian London from Old Photographs* (New York: Viking, 1969), 72.
18. Moynahan, *French Century*, 45.
19. Betjeman, *Victorian and Edwardian London*, 54.
20. Charles Musser, *The Emergence of Cinema: The American Screen to 1907*, History of American Cinema (Berkeley: University of California Press, 1994), 186.

## Chapter 2

1. James Tobin, *To Conquer the Air: The Wright Brothers and the Great Race for Flight* (New York: Free Press, 2004), 65.
2. Ibid., 66.
3. Ibid., 71.
4. R. G. Grant, *Flight: 100 Years of Aviation* (New York: D.K., 2002), 28.
5. Tobin, *To Conquer*, 76.
6. Ibid., 86.
7. Ibid., 195.
8. Grant, *Flight*, 30.
9. Ibid., 32.
10. Ibid., 44.
11. Ibid., 40.

## Chapter 3

1. Mary S. Allen, *The Pioneer Policewoman* (London: Chatto & Windus, 1925), 20.
2. Dave Grossman, *On Killing: The Psychological Cost of Learning to Kill in War and Society* (New York: Back Bay, 1995), 175.
3. David Wilson, *Red Cross or Iron Cross*, 1917 (Georgetown University Library, Special Collections, British Posters).
4. Robert Nichols, *Ardours and Endurances; also, A Faun's Holiday and Poems and Phantasies* (London: Chatto & Windus, 1917), 44.
5. O, "Command of the Air," 1916, in *The Muse in Arms*, Edward Bolland Osborn ed. (London: John Murray, 1917). While Osborn was the editor of the book, "O" is the author given for "Command of the Air." It is unsure what his real name is.
6. Ibid., 108.
7. Ibid., 106.
8. Ibid., 109.
9. James Ciment, and Thaddeus Russell, eds., *The Home Front Encyclopedia: United States, Britain, and Canada*, vol. 1 (Santa Barbara, CA: ABC-CLIO, 2006), 312.
10. Daniel D. Hill, *Advertising to the American Woman 1900–1999* (Columbus: Ohio State University Press, 2002), 137.

## Chapter 4

1. "Roundels," *Gorrell's History: AEF Air Service* (College Park, MD: National Archives and Records Administration), RG 18, M990, C-668.
2. "PC Bridge Bans Pin-ups on RAF Jets—in Case They Offend Women and Muslims," *Daily Mail*, June 5, 2007.
3. J. P Wood, *Nose Art: 80 Years of Aviation Artwork* (New York: Barnes and Noble, 1999), 9.
4. Peter Kilduff, *Richthofen: Beyond the Legend of the Red Baron* (New York: John Wiley, 1993), 69.
5. Ibid., 71.
6. Ethell and Simonsen, *Aircraft Nose Art*, 19.
7. Ibid.
8. "Insignia," *Gorrell's History: AEF Air Service*, 179.
9. Ralph Linton, "Totemism and the A.E.F.," *American Anthropologist* 26, no. 2 (1924): 299.

## Chapter 5

1. United States Congress, "19th Amendment to the U.S. Constitution," accessed August 1, 2011, http://www.ourdocuments.gov/doc.php?doc=63.
2. Mansel G. Blackford, *The Rise of Modern Business in Great Britain, the United States, and Japan*, 2nd ed. (Chapel Hill: University of North Carolina Press, 1998), 99.
3. The Fashion Institute of Design and Merchandising Museum (FDIM Museum) in Los Angeles has a fashion collection ranging from 1800 to the present. This collection was used as an overview of how fashion had changed and is changing.
4. *Fabulous! FIDM Museum Acquisitions, 2000–2010* (Los Angeles: FIDM Museum and Galleries), "1930s" exhibit.
5. Betty Kirke, *Madeleine Vionnet* (San Francisco: Chronicle, 1998), 107.
6. FIDM Museum.
7. Berry Lee Pearson, *Sounds So Good to Me: The Bluesman's Story* (Philadelphia: University of Pennsylvania Press, 1984), 65.

## Chapter 6

1. Paul Preston, *The Spanish Civil War: Reaction, Revolution and Revenge* (New York: W. W. Norton, 1986), 135–37.
2. Neal Gabler, *Walt Disney: The Triumph of the American Imagination* (New York: Vintage, 2007), 39.
3. "'Steamboat Willie,' Museum of Modern Art, accessed October 31, 2010, at http://www.moma.org/collection/works/89284.
4. A. J. Nicholls, *Weimar and the Rise of Hitler*, 2nd ed. (New York: St. Martin's, 1968), 129.
5. Deborah Dwork and Robert Jan van Pelt, *Holocaust: A History* (New York: W. W. Norton, 2002), 58.
6. Nicholls, *Weimar*, 72.

## Chapter 7

1. Carol Harris, "Women Under Fire in World War II," accessed August 10, 2011, http://www.bbc.co.uk/history/british/Britain_wwtwo/women_at_war_01.shtml.
2. The National Archives, "Women in World War II: Introduction," accessed August 10, 2011, http://www.nationalarchives.gov.uk/womeninuniform/wwii_intro.htm.
3. Lawrence Wilbur, "Longing won't bring him back sooner," 1944, National DNS-44-PA-389.
4. Brenda Polan, and Roger Tredre, *The Great Fashion Designers* (Oxford: Berg, 2009), 73.
5. Woody Guthrie, "So long it's been good to know yuh," accessed August 10, 2011, http://www.woodyguthrie.org/Lyrics/Lyrics.htm#sz.
6. "Weapons on the Wall," University of St Andrews, accessed on November 23, 2010. http://arts.st-andrews.ac.uk/events/0611/presentations/Teaching%20website/.
7. "Better Pot-Luck Than Humble Pie—Please Don't Waste Food!" University of St. Andrews, accessed November 23, 2010, http://www.st-andrews.ac.uk/~pv/pv/courses/posters/images5/potluckx.html.
8. "Pictures Are Better Than Words," 1943, accessed March 15, 2011, http://www.military-propaganda-posters.com/british-world-war-propaganda-posters/vintage-british-poster-pictures-better-than-words-2/.

9. "America: It Can Happen Here!" circa 1941–1945, National Archives and Records Administration, Record Group 342.

## Chapter 8

1. Ronald H. Spector, *Eagle Against the Sun: The American War with Japan* (New York: Vintage, 1985), 325.
2. Ann Chennault, *Chennault and the Flying Tigers* (New York: Paul Ericksson, 963), 85.
3. Spector, *Eagle*, 325.
4. Chennault, *Chennault*, 85.
5. *Ibid.*, 158.
6. *Ibid.*, 25.
7. Jeffrey L. Ethell, *World War II Nose Art in Color* (Osceola, WI: Motorbooks, 1993), 53.
8. "Satan's Lady," 1944, 306th BG, Serial # 42–31143, accessed July 10, 2014, http://forum.armyair forces.com/AC-named-Satan39s-Lady-m89169.aspx.
9. *Ibid.*, 32.
10. Valant, *Vintage Aircraft*, 127.
11. Ethell, *World War II Nose Art*, 14.
12. *Ibid.*, 66.
13. Ethell and Simonsen, *Aircraft Nose Art*, 125.
14. *Ibid.*, 125.
15. Valant, *Vintage Aircraft*, 99.
16. Max A. Collins, *The Racy Pin-ups of World War II: For the Boys* (Portland, Oregon: Collector's Press, 2000), 107.
17. *Ibid.*, 107.
18. Valant, *Vintage Aircraft*, 114–16.
19. Ethell and Simonsen, *Aircraft Nose Art*, 105.
20. Valant, *Vintage Aircraft*, 126.
21. *Ibid.*, 86.
22. *Ibid.*, 29.
23. *Ibid.*, 31.

## Chapter 9

1. Melvin E. Page, *Colonialism: An International Social, Cultural, and Political Encyclopedia* (Santa Barbara, CA: ABC-CLIO, 2003), 86.
2. FDIM, Dior section.
3. Thomas E. Larson, *History of Rock and Roll* (Dubuque, IA: Kendell/Hunt, 2004), 110.
4. David Dicaire, *The First Generation of Country Music Stars: Biographies of 50 Artists Born Before 1940* (Jefferson, NC: McFarland, 2007), 170.
5. Larson, *History*, 30.
6. Alan L. Williams, *Republic of Images: A History of French Filmmaking* (Cambridge, MA: Harvard University Press, 1992), 276.
7. *Ibid.*, 293.
8. Richard H. Pells, *Not Like Us: How Europeans Have Loved, Hated, and Transformed American Culture Since World War II* (New York: Basic, 1997), 218.
9. Nancy Reagin, *Twilight and History* (Hoboken, NJ: John Wiley, 2010), 252.

10. Kerstin Jutting, "Grow Up 007!": *James Bond over the Decades: Formula vs. Innovation* (M.A. thesis, Universitat Potsdam, Institut fur Anglistik und Amerikanistik, 2005), 68.
11. Paix et liberte, "La Vie Exemplaire du Petit Jacques Duclos," circa 1950, Princeton University Library, Department of Rare Books and Special Collections, MC102, accessed February 9, 2011, http://diglib.princeton.edu/ead/getEad?eadid=MC102&kw=
12. Leslie Illingworth, "Britain Sends Troops to Korea to Serve with the United Nations," July 1950, accessed February 9, 2011, http://www.llgc.org.uk/index.php?id=3964.
13. Author's collection, Crescent, Oregon. I do not have the full run of this series, and I located the information concerning how long the series ran from accessed February 1, 2011, www.comicpriceguide.com.

## Chapter 10

1. Gordon A. Craig, and Alexander L. George, *Force and Statecraft: Diplomatic Problems of Our Time* (New York: Oxford University Press, 1995), 215.
2. William A. Williams, Thomas McCormick, Lloyd C. Gardner, and Walter LaFeber, eds., *America in Vietnam: A Documentary History* (New York: Anchor, 1985), 288.
3. This is from a review of multiple books on nose art from different time periods. There is a noticeable change in the depiction of women. Books reviewed for content included Ethell and Simpson, 56, 157; Wood, 105.
4. Ethell and Simonsen, *Aircraft Nose Art*, 149.
5. Valant, *Vintage Aircraft*, 178.
6. Ethell and Simonsen, *Aircraft Nose Art*, 162.

## Chapter 11

1. "America, Love It or Leave It," circa 1968, courtesy of the VHPA Museum. There were American soldiers who supported the protesting and those not unlike the painter who believed that the United States was there, and you could either love what it did or leave the country.
2. Williams et al., *America in Vietnam*, 158.
3. *Ibid.*, 225.
4. "Flower Power," 173 AHC, Serial # 65–09417, http://www.vietnamdustoff.com/noseart.html.
5. Bill Mauldin, "Two More About to Blow," 1959, Library of Congress, Prints and Photographs, Washington, D.C., call no. Mauldin 1624.
6. "Peaceful Co-Existence," *Manchester Guardian*, July 6, 1954, British Cartoon Archive, Archival Research Number LSE4670, accessed October 10, 2010, http://www.cartoons.ac.uk/.
7. Bernard Fall, *Hell in a Very Small place: The Siege of Dein Bien Phu* (Cambridge: Da Capo, 1966), 483.

8. "Go Away I Don't Believe in Ghosts," *The Times*, May 24, 1964, British Cartoon Archive, Archival Research Number 05489, accessed October 10, 2010, http://www.cartoons.ac.uk/.

9. Author's collection; additional information on its creation and publication from Comicpriceguide.com, which lists thousands of comics books by title, publisher, and year first published.

10. "Vietnam Soldiers," *The Razor* 2, no. 2 (June–July 1965): 3.

11. Ken Bloom, *The American Songbook: The Singers, the Songwriters, and the Songs* (New York: Black Dog and Leventhal, 2005), 173.

12. *Iron Butterfly*, unknown date, Vietnam Dustoff Association. Vietnam Soldiers. *The Razor*. 2.2 June–July 1965: 3. Accessed October 10, 2013, at http://www.aavw.org/special_features/cartoons_assorted_cartoon10.html.

13. Sir Peter Blake, *On the Balcony*, 1955–1957, on exhibit at Tate Britain, accessed February 9, 2011, http://www.tate.org.uk/servlet/ArtistWorks?cgroupid=999999961&artistid=763&page=1.

14. Andy Warhol, *Campbell's Soup Cans*, 1962, currently on exhibit at the Museum of Modern Art, accessed February 9, 2011, http://www.moma.org/collection/object.php?object_id=79809.

15. Timothy Corrigan and Patricia White, *The Film Experience* (Boston: Bedford/St. Martin's, 2004), 334.

## Chapter 12

1. Author interview with Robert Maves, lead investigator SEARIB, Joint POW/MIA Accounting Command, August 5, 2011.

2. Melvin E. Page, *Colonialism: An International Social, Cultural, and Political Encyclopedia* (Santa Barbara, CA: ABC-CLIO, 2003), 205.

3. Patricia D. Netzley, *The Greenhaven Encyclopedia of Terrorism* (Detroit: Greenhaven, 2007), 110.

4. Franklin B. Weinstein, *Indonesia Abandons Confrontation: An Inquiry into the Functions of Indonesian Foreign Policy* (Jakarta: First Equinox, 2009), 16.

5. Frank Welsh, *The Four Nations: A History of the United Kingdom* (New York: Yale University Press, 2003), xxii.

6. This information concerning median age came from researching Individual Personnel Deceased Files and Official Medical Personnel Files located at Joint POW/MIA Accounting Command, Hickam AFB.

7. "Pink Panther," 2nd Platoon, http://www.vhpamuseum.org/companies/117ahc/117ahc.shtml.

8. "Pussy Galore," UH1H- 65–09679, 1968, http://www.vhpamuseum.org/companies/117ahc/117ahc.shtml.

9. Ethell, *World War II Nose Art*, 153.

10. *Ibid.*, 157.

11. Col. Larry Guarino, *A P.O.W.'s Story: 2801 Days in Hanoi* (New York: Ivy, 1990), 38.

## The Future of Nose Art

1. "PC Brigade Ban Pin-ups on RAF Jets—in Case They Offend Women and Muslims," *Daily Mail*, June 5, 2007, accessed July 12, 2014, http://www.dailymail.co.uk/news/article-460054/PC-brigade-ban-pin-ups-RAF-jets—case-offend-women-Muslims.html.

2. "City Nose Art," 142nd Fighter Wing, http://www.142fw.ang.af.mil/art/mediagallery.asp?galleryID=9323.

# Bibliography

## Primary Sources

Air Force Ministry and the Central Office of Information. *Wings of the Phoenix.* London: His Majesty's Stationary Office, 1949.

*Fabulous!* Exhibit, FIDM Museum Acquisitions, 2000–2010. FIDM Museum and Galleries, Los Angeles, California.

*Gorrell's History: AEF Air Service.* RG 18, M990. National Archives and Records Administration, College Park, MD.

Guarino, Larry Col. *A P.O.W.'s Story: 2801 Days in Hanoi.* New York: Ivy, 1990.

Guthrie, Woody. "So Long It's Been Good to Know Yuh." http://www.woodyguthrie.org/Lyrics/So_Long_Its_Been_Good_WWII.htm.

Jutting, Kerstin. "'Grow Up 007!': James Bond over the Decades: Formula vs. Innovation. M.A. thesis, University of Potsdam, Institut fur Anglistik und Amerikanistik, 2005.

Lincoln, Abraham. "House Divided." June 16, 1858. Springfield: Illinois State Historical Society, 1958; Washington, D.C.: Library of Congress, Jefferson Building Reading Room.

Maves, Robert. Interview with author, August 5, 2011. "History of Vietnam." Lead investigator SEARIB, Joint POW/MIA Accounting Command, Hickam, Honolulu.

United States Congress. Senate Committee on the Judiciary. Subcommittee to Investigate the Administration of the Internal Security Act and Other Internal Security Laws. *Testimony of Robert F. Williams.* Washington, D.C.: GPO, 1970.

United States Quartermaster. "IDPF and OMPF." 1941–1950. Joint POW/MIA Accounting Command, JBPHH, HI.

"Vietnam Soldiers." *The Razor* 2.2 (June/July 1965): 3.

## Secondary Sources

Airhart, Phyllis D. *Faith Traditions and the Family.* Family, Religion, and Culture. Louisville, KY: John Knox, 1996.

Alcom, John N. *The Jolly Rogers: History of the 90th Bomb Group During World War II.* Temple City, CA: Historical Aviation Album, 1981.

Allen, Mary S. *The Pioneer Policewoman.* London: Chatto and Windus, 1925.

Appy, Christian G. *Cold War Constructions: The Political Culture of United States Imperialism, 1945–1966.* Culture, Politics, and the Cold War. Amherst: University of Massachusetts Press, 2000.

Arakaki, Leatrice R., and John R. Kuborn. *7 December 1941: The Air Force Story.* Hickam AFB, HI: Pacific Air Forces, 1991.

Avery, N. L. *B-25 Mitchell: The Magnificent Medium.* St. Paul, MN: Phalanz, 1992.

Axelrod, Alan. *Encyclopedia of the American Armed Forces.* Vol. 2, *U.S. Marine Corps, U.S. Navy.* New York: Facts on File, 2005.

Baudot, Francois. *Fashion: The Twentieth Century.* 2nd ed. New York: Universe, 2006.

Becker, Patti Clayton. *Books and Libraries in American Society During World War II: Weapons in the War of Ideas.* London: Routledge, 2004.

Betjeman, John. *Victorian and Edwardian London from Old Photographs.* New York: Viking, 1969.

Bilski, Emily. *Berlin Metropolis: Jews and the New Culture, 1890–1918.* Berkeley, CA: University of California Press, 1990.

Blackford, Mansel G. *The Rise of Modern Business in Great Britain, the United States, and Japan.* 2nd ed. Chapel Hill: University of North Carolina Press, 1998.

Blewett, Daniel K. *American Military History: A Guide to Reference and Information Sources.* Reference Sources in the Social Sciences series, no. 7. Englewood, CO: Libraries Unlimited, 1995.

Bloom, Ken. *The American Songbook: The Singers, the Songwriters, and the Songs.* New York: Black Dog and Leventhal, 2005.

Bourne, John, Peter Liddle, and Ian Whitehead, eds. *The Great War 1914–1945.* Vol. 1, *Lightning Strikes Twice.* Great Britain: HarperCollins, 2000.

Bourneman, John. *Subversions of International Order: Studies in the Political Anthropology of Culture.* New York: Albany State University of New York Press, 1998.

Boyer, Paul. *By the Bombs Early Light: American Thought and Culture at the Dawn of the Atomic Age.* New York: Pantheon, 1985.

Bradford, James C. *The Military and Conflict Between*

*Cultures: Soldiers at the Interface.* Texas A&M University Military History Series; 50. College Station, TX: Texas A&M University Press, 1997.

Brosman, Catharine Savage, ed. *Dictionary of Twentieth Century Culture: French Culture 1900–1975.* Detroit: Gale Research, 1995.

———. *French Culture, 1900–1975.* Detroit: Gale Research, 1996.

Burrows, William. *Richthofen: A True History of the Red Baron.* New York: Harcourt, Brace and World, 1969.

Campbell, John M., and Donna Campbell. *Allied Aircraft Art: Nose Art, Paint Schemes and Unusual Markings on Aircraft from Korea to Desert Storm.* West Chester, PA: Schiffer Military History, 1992.

Carl, Ann B. *A WASP Among Eagles: A Woman Military Test Pilot in World War II.* Washington, D.C.: Smithsonian Institution Press, 1999.

Chant, Christopher. *A Century of Triumph: The History of Aviation.* New York, NY: Free Press, 2002.

Chant, Christopher, and Michael J. H. Taylor. *The World's Greatest Aircraft.* Edison, NJ: Chantwell, 2007.

Chennault, Ann. *Chennault and the Flying Tigers.* New York: Paul Erickson, 1963.

Ciment, James, and Thaddeus Russell. *The Home Front Encyclopedia: United States, Britain, and Canada.* Vol. 1. Santa Barbara, CA: ABC-CLIO, 2006.

Cohen, Sarah R. *Art, Dance, and the Body in French Culture of the Ancien Régime.* New York: Cambridge University Press, 2000.

Collins, Gail. *The Amazing Journey of American Women from 1960 to Present: When Everything Changed.* New York: Back Bay, 2009.

Collins, Max Allan. *The Racy Pin-ups of World War II: For the Boys.* Portland, OR: Collectors, 2000.

Converse, Elliott Vanveltner. *Circling the Earth: United States Plans for a Postwar Overseas Military Base System, 1942–1948.* Maxwell Air Force Base, AL: Air University Press, 2005.

Cooper, Barbara T., and Mary Donaldson-Evans, eds. *Moving Forward, Holding Fast: The Dynamics of Nineteenth-Century French Culture.* Amsterdam: Rodopi, 1997.

Corrigan, Timothy, and Patricia White. *The Film Experience.* Boston: Bedford/St. Martin's, 2004.

Craig, Gordon A., and Alexander L. George. *Force and Statecraft: Diplomatic Problems of Our Time.* New York: Oxford University Press, 1995.

Cull, Nicholas John. *Selling War: The British Propaganda Campaign Against American "Neutrality" in World War II.* New York: Oxford University Press, 1996.

Dauncey, Hugh. *French Popular Culture: An Introduction.* New York: Arnold, 2003.

Davis, Larry. *Planes, Names, and Dames 1955–1975.* Carrolton, TX: Squadron/Signal, 1990.

Dawes, James. *The Language of War: Literature and Culture in the U.S. from the Civil War Through World War II.* London: Harvard University Press, 2005.

Defty, Andrew. "Close and Continuous Liaison: British Anti-Communist Propaganda and Cooperation with the United States, 1950–51." *Intelligence and National Security* 17.4 (Dec. 2002): 100–130.

Dejean, Joan. *The Essence of Style: How the French Invented High Fashion, Fine Food, Chic Cafes, Style, Sophistication, and Glamour.* New York: Simon & Schuster, 2006.

Denommé, Robert T., and Roland H. Simon. *Unfinished Revolutions: Legacies of Upheaval in Modern French Culture.* University Park: Pennsylvania State University Press, 1998.

Dicaire, David. *The First Generation of Country Music Stars: Biographies of 50 Artists Born Before 1940.* Jefferson, NC: McFarland, 2007.

Ducros, Louis. *French Society in the Eighteenth Century.* Manchester, NH: Ayer, 1971.

Dwork, Deborah, and Robert Jan van Pelt. *Holocaust: A History.* New York: W. W. Norton, 2002.

Eling, Kim. *The Politics of Cultural Policy in France.* New York: Macmillan, 1999.

Enloe, Cynthia H. *Maneuvers: The International Politics of Militarizing Women's Lives.* Berkeley: University of California Press, 2000.

Erenberg, Lewis A., and Susan E. Hirsch, eds. *The War in American Culture: Society and Consciousness During World War II.* Chicago: University of Chicago Press, 1996.

Ethell, Jeffrey L. "Nose Art." *MHQ: The Quarterly Journal of Military History* (New York: American Historical Publications) 8.3 (Spring 1996): 42–45.

———. *World War II Nose Art in Color.* Osceola, WI: Motorbooks International, 1993.

Ethell, Jeffrey L., and Clarence Simonsen. *Aircraft Nose Art: From World War I to Today.* St. Paul, MN: Zenith, 1991.

Fall, Bernard B. *Hell in a Very Small Place: The Siege of Dien Bien Phu.* Cambridge: Da Capo, 1966.

Fitzpatrick, Karen, ed. *World Art: The Essential Illustrated History.* Fulham, England: Flame Tree, 2006.

Folly, Martin H. *The United States and World War II: The Awakening Giant.* Edinburgh: Edinburgh University Press, 2002.

Forbes, Jill, and Michael Kelly, eds. *French Cultural Studies: An Introduction.* Oxford: Oxford University Press, 1995.

Foreign Policy Association, ed. *A Cartoon History of United States Foreign Policy.* New York: Random House, 1967.

Gabler, Neal. *Walt Disney: The Triumph of the American Imagination.* New York: Vintage, 2007.

Gans, Herbert J. *Popular Culture and High Culture: An Analysis and Evolution of Taste.* New York: Basic Books, 1974.

Grant, R. G. *Flight: 100 Years of Aviation.* New York: D.K., 2002.

Grossman, Dave. *On Killing: The Psychological Cost of Learning to Kill in War and Society.* New York: Back Bay, 1995.

Gumpert, Lynn, ed. *The Art of the Everyday: The Quotidian in Postwar French Culture*. New York: New York University Press, 1997.

Hallion, Richard P., ed. *The Wright Brothers: Heirs of Prometheus*. Washington, D.C.: Smithsonian Institution Press, 1978.

Harkness, Nigel, Lisa Downing, Sonya Stephens, and Timothy Unwin, eds. *Birth and Death in Nineteenth-Century French Culture*. Amsterdam: Rodopi, 2007.

Harrison, Charles. *English Art and Modernism, 1900–1939*. New Haven, CT: Yale University Press, 1994.

Haste, Cate. *Keep the Home Fires Burning*. New York: Viking, 1977.

Herbert, Melissa S. *Camouflage Isn't Only for Combat: Gender, Sexuality, and Women in the Military*. New York: New York University Press, 1998.

Hewitt, Nicholas, ed. *The Cambridge Companion to Modern French Culture*. New York: Cambridge University Press, 2003.

Hill, Daniel D. *Advertising to the American Woman, 1900–1999*. Columbus: Ohio State University Press, 2002.

Hills, Patricia. *Modern Art in the USA: Issues and Controversies of the 20th Century*. New York: Prentice Hall, 2000.

Himmelfarb, Gertrude. *The De-Moralization of Society: From Victorian Virtues to Modern Values*. New York: Alfred A. Knopf, 1995.

Hixson, Walter, ed. *The American Experience in World War II*. London: Routledge, 2002.

Horn, Pierre L., ed. *Handbook of French Popular Culture*. Santa Barbara, CA: Greenwood, 1991.

Hudson, Valerie M. *Culture and Foreign Policy*. Boulder, CO: Lynne Rienner, 1997.

Jarvis, Christina S. *The Male Body at War: American Masculinity During World War II*. DeKalb: Northern Illinois University Press, 2010.

Kennedy, David M. *Over Here: The First World War and American Society*. New York: Oxford Press, 1980.

Kerr, David S. *Caricature and French Political Culture, 1830–1848: Charles Philipon and the Illustrated Press*. New York: Oxford University Press, 2000.

Kilduff, Peter. *Richthofen: Beyond the Legend of the Red Baron*. New York: John Wiley and Sons, 1993.

Kirke, Betty. *Madeleine Vionnet*. San Francisco: Chronicle, 1998.

Larson, Thomas E. *History of Rock and Roll*. Dubuque, IA: Kendell/Hunt, 2004.

Laubner, Ellie. *Fashions of the Roaring '20s*. West Chester, PA: Schiffer, 2000.

Le Wita, Béatrix. *French Bourgeois Culture*. Trans. J. A. Underwood. New York: Cambridge University Press, 1994.

Lehning, James R. *The Melodramatic Thread: Spectacle and Political Culture in Modern France*. Bloomington: Indiana University Press, 2007.

Lillibridge, George D. *Images of American Society: A History of the United States*. Vol. 1. New York: Houghton Mifflin, 1976.

Linton, Ralph, "Totemism and the A.E.F." *American Anthropologist* 26.2 (1924): 296–300.

Loosley, David L. *The Politics of Fun: Cultural Policy and Debate in Contemporary France*. Oxford: Berg, 1997.

McCloskey, Barbara. *Artists of World War II*. Santa Barbara: Greenwood, 2005.

Merrick, Jeffrey, and Michael Sibalis. *Homosexuality in French History and Culture*. Philadelphia, PA: Haworth, 2002.

Meyer, G. J. *A World Undone: The Story of the Great War, 1914–1918*. New York: Delacorte, 2002.

Middleton, John. *Culture*. Oxford, UK: Capstone, 2002.

Moynahan, Brian. *The French Century: An Illustrated History of Modern France*. Paris: Flammarion, 2007.

Musser, Charles. *The Emergence of Cinema: The American Screen to 1907*. History of American Cinema. Berkeley: University of California Press, 1994.

Nash, Gerald D. *The Crucial Era: The Great Depression and World War II, 1929–1945*. Long Grove, IL: Waveland Press, 1998.

Netzley, Patricia D. *Terrorism*. Farmington Hills, MI: Greenhaven, 2007.

Nichols, Robert. *Ardours and Endurances; also, A Faun's Holiday and Poems and Phantasies*. London: Chatto and Windus, 1917.

Nicholls, A. J. *Weimar and the Rise of Hitler*. 2nd ed. New York: St. Martin's, 1968.

Noble, David W. *Death of a Nation: American Culture and the End of Exceptionalism*. Minneapolis: University of Minnesota Press, 2002.

O. "Command of the Air." In *The Muse in Arms*, ed. Edward Bolland Osborn. London: John Murray, 1917.

O'Neal, John C. *Changing Minds: The Shifting Perception of Culture in Eighteenth-Century France*. Newark: University of Delaware Press, 2002.

Page, Melvin E. *Colonialism: An International Social, Cultural, and Political Encyclopedia*. Santa Barbara, CA: ABC-CLIO, 2003.

"PC Brigade Bans Pin-ups on RAF Jets—In Case They Offend Women and Muslims." *Daily Mail*, June 5, 2007.

Pearson, Berry Lee, *Sounds So Good to Me: The Bluesman's Story*. Philadelphia: University of Pennsylvania Press, 1984.

Pells, Richard H. *Not Like Us: How Europeans Have Loved, Hated, and Transformed American Culture Since World War II*. New York: Basic, 1997.

Petrey, Sandy. *In the Court of the Pear King: French Culture and the Rise of Realism*. Ithaca, NY: Cornell University Press, 2005.

Polan, Brenda, and Roger Tredre. *The Great Fashion Designers*. Oxford: Berg, 2009.

Preston, Paul. *The Spanish Civil War: Reaction, Revolution, and Revenge*. New York: W. W. Norton, 1986.

Rapaille, Clotaire. *Culture Code: An Ingenious Way to*

*Understand Why People Around the World Live and Buy as They Do*. New York: Crown Business, 2007.

Rawnsley, Gary D. *Cold-War Propaganda in the 1950s*. Hampshire, UK: Palgrave Macmillan, 1998.

Reagin, Nancy. *Twilight and History*. Hoboken, NJ: John Wiley and Sons, 2010.

Rood, Karen L. *American Culture After World War II*. Farmington Hills, MI: Gale, 1994.

Ross, Kristin. *Fast Cars, Clean Bodies: Decolonization and the Reordering of French Culture*. Cambridge, MA: MIT Press, 1996.

Rotskoff, Lori. *Love on the Rocks: Men, Women, and Alcohol in Post–World War II America*. Chapel Hill: University of North Carolina Press, 2001.

Rowe, Carlos. *Literary Culture and U.S. Imperialism: From the Revolution to World War II*. New York: Oxford University Press, 2000.

Rubin, David Lee, ed. *Sun King: The Ascendancy of French Culture During the Reign of Louis XIV*. Cranbury, NJ: Associated University Presses, 1992.

Savage, William W., Jr. *Comic Books and America, 1945–1954*. Norman: University of Oklahoma Press, 1990.

Saxe, Robert Francis. *Settling Down: World War II Veterans' Challenge to the Postwar Consensus*. Hampshire, UK: Palgrave Macmillan, 2007.

Schein, Edgar H. *Organizational Culture and Leadership*. Maxwell Air Force Base, AL: Air University Press, 2005.

Sheridon, Mary S. *America: Readings in Themes and Eras*. New York: University Press of America, 1992.

Sheriff, Mary D. *Moved by Love: Inspired Artists and Deviant Women in Eighteenth-Century France*. Chicago: University of Chicago Press, 2004.

Singer, Bayla. *Like Sex with Gods*. College Station: Texas A&M University Press, 2003.

Smelser, Ronald, and Edward J. Davis II. *The Myth of the Eastern Front: The Nazi-Soviet War in American Popular Culture*. New York: Cambridge University Press, 2007.

Spector, Ronald H. *Eagle Against the Sun: The American War with Japan*. New York: Vintage, 1985.

Strinati, Dominic. *An Introduction to Theories of Popular Culture*. London: Taylor and Francis, 2004.

Thomson, Richard. *The Troubled Republic: Visual Culture and Social Debate in France, 1889–1900*. New Haven, CT: Yale University Press, 2004.

Tobin, James. *To Conquer the Air: The Wright Brothers and the Great Race for Flight*. New York: New York Free Press, 2004.

Torff, Bruce, and Robert J. Sternberg. *Understanding and Teaching the Intuitive Mind: Student and Teacher Learning*. Educational Psychology Series. Mahwah, NJ: Lawrence Erlbaum, 2000.

Torr, James D., ed. *America's Views About War*. Farmington Hills, MI: Greenhaven, 2001.

Trollope, Frances. "Strange Fashions of American Women." *Domestic Manners of the Americans*, Spring 1831. http://xroads.virginia.edu/~HYPER/DETOC/fem/appear.htm#trollope (accessed December 1, 2010).

Tucker, Spencer C., ed. *World War I: Student Encyclopedia*. Santa Barbara, CA: ABC-CLIO, 2001.

Tucker, Spencer, and Jinwung Kim. *Encyclopedia of the Korean War: A Political, Social, and Military History*. Santa Barbara, CA: ABC-CLIO, 2000.

Valant, Gary M. *Classic Vintage Nose Art*. Ann Arbor, MI: Lowe and Hould, 1997.

———. *Vintage Aircraft: Nose Art*. Saint Paul: MBI, 2001.

———. *Vintage Aircraft: Ready for Duty*. Saint Paul: Motorbooks, 1988.

Wachtel, David. *Cultural Policy and Socialist France*. Contributions in Political Science. Santa Barbara: Greenwood, 1987.

Walker, Randy. *More Painted Ladies*. Atglen, PA: Schiffer Military/Aviation History, 1994.

Wardle, Patricia. *Victorian Lace*. 2nd ed. Bedford, England: Ruth Bean, 1982.

Weinstein, Franklin B. *Indonesia Abandons Confrontation: An Inquiry into the Functions of Indonesian Foreign Policy*. Jakarta: First Equinox, 2009.

Welsh, Frank. *The Four Nations: A History of the United Kingdom*. New York: Yale University Press, 2003.

Westbrook, Robert B. *Why We Fought: Forging American's Obligations in World War II*. Washington: Smithsonian, 2004.

Westin, Alan F., Julian H. Franklin, Howard R. Swearer, et al., eds. *Views of America*. New York: Harcourt, Brace and World, 1966.

Wharton, Edith. *French Ways and Their Meaning*. Whitefish, Montana: Kessinger, 2007.

Williams, Alan L. *Republic of Images: A History of French Filmmaking*. Cambridge, MA: Harvard University Press, 1992.

Williams, William A., et al., eds. *American in Vietnam: A Documentary History*. New York: Anchor, 1985.

Wood, J. P. *Nose Art: 80 Years of Aviation Artwork*. New York: Barnes and Noble, 1999.

Zeldin, Theodore. *A History of French Passions, 1848–1945: Ambition, Love, and Politics*. Oxford: Oxford University Press, 1993.

# Index

Aden Emergency 151–53
AEF (American Expeditionary Force) 52–53; Air Service 168, 171
Africa 12, 79–80, 102–3, 167
African Americans 14, 64, 77, 127, 135–36, 145
African soldiers 122
Alchin 41
*All Shook* 114–15
American Expeditionary Force *see* AEF
American Songbook 170–71
Anti-art 43
Anti-war 43, 135, 137
Art communities 66–67
*Art informel* 119
Artistic expression 12, 14, 19, 21, 71, 92, 118, 145
Artists of comic strips and artwork 88
artwork 1–3, 5–6, 44, 52–53, 66–67, 94, 96–97, 99–100, 104–6, 118–20, 126–29, 134, 140, 145–46, 153–66; sexualized 120, 164; woman-inspired 99
Asia 12, 78, 80, 93, 104, 107, 136
Assault Helicopter Company 156
ATS 80
AVG 94
Aviation Artwork 5–6, 167–68, 174
Aznavour, Charles 112–13

Balzer 23
Bats 70–71
Baudot, Francois 167
Beatles 144, 148
Beatniks 141
BEF *see* British Expeditionary Force
Belle Époque 11, 19, 46
Big Band 64, 82, 114, 145

Black Death 50
Black Flight 49–50
Black Maria 50
Black Sheet 50
Bombers 48, 93, 117, 155–57
Brassens, Georges 112–13
British Expeditionary Force (BEF) 80
Brunei 152
Buccaneers 156
Bugs Bunny 72–73, 84–85, 102, 164

CAF 6
Cajun music 144
CAMCO *see* Central Manufacturing Company
Camouflage 71
Cartoonists 20, 39; political 12–13, 17, 39, 120, 139
Cartoons 38–39, 71, 84, 87, 91, 93–95, 97, 99, 101–3, 105–7, 123–26, 139–43, 149, 155, 157–58, 164–66
CATF *see* Chinese Air Task Force
Censorship 115
Central Manufacturing Company (CAMCO) 93
Chanel 63, 111–12
Chanson francaise 112
Chanute, Octave 22–23
Chennault, Claire 93, 169, 172
China 93–94, 124, 127–28
Chinese Air Task Force (CATF) 94
*Chow Hound Junior* 97
Churchill, Winston 88
Cinema 21, 115–16, 167, 173
Classic Rock 145
Clothing 11, 16, 18, 41–43, 57, 60–61, 63, 66, 81–82, 111–12, 120, 124–25, 136–37, 145, 164–65
Cold War 109, 112, 114, 116, 118, 120, 122, 124, 126, 128, 171

Colonization 12, 65
Comic books 100–101, 120, 141, 146–47, 170
Comic strips 85–86, 88, 147
Communism 119, 124, 129
Congress 16, 24–25, 30–31, 33–37, 42–43, 47, 58, 62, 66–67, 74, 87, 90, 167, 169, 171
Country music 82, 113–14, 169, 172
Cubism 43–44, 66–67
Curtiss, Glenn 25–26
Cyprus 151

Dada 43
Daily Sketch 139
Dance halls 44, 64, 83, 144–45
*Decollage* 146
Democratic Army 122
Detroit 170, 172
Dhofar 151
Dhofar Liberation Front *see* DLF
Dien Bien Phu 129, 140, 150, 172
Dior 111–12, 169
DLF (Dhofar Liberation Front) 151

Eagle 105, 161, 169, 172
EAM (National Liberation Front) 122
Edward, King 12, 16
Egypt 150–51, 154
*Elmer Fudd* 103–4
Elvgren, Gil 92, 99–100
*Enola Gay* 96
Ethell, Jeffrey L. 5–6, 167–170, 172
*Exposition Universelle* 11
Expression 11, 13, 15, 17, 19, 21, 53

Farm Service 35
Farman, Henry III 24–25
Fashion Designers of London 81

# Index

Ferre, Leo 112–13
Filmmaking 21, 83, 115, 147–48
Films 19, 21, 45, 65–66, 83–84, 115–16, 147–49
Fleming, Ian 118
Flight crews 5–6, 67, 70, 84, 95, 101, 108, 124–26, 154, 158–59
Flying Tigers 94, 169, 172
Folk music 20, 113, 145
Francis, Robert 174
Free French Forces 78–79
Free French Liberation 87

Gang 69, 71, 73
Gaulle 78, 134
German Empire 11–12
Gods 7, 53, 113, 167, 174
Greece 121–22, 151
Gulf War 6, 161–62

Harlem 63–64
Harter, Martin 96–97
Helicopters 145, 156–58, 163
Hitler, Adolf 72–74, 88, 91, 105–6, 124, 168, 173

Impressionism 19
India 152
Indochina 3, 128, 138, 140, 151, 154; conflict 129, 151
Indonesia 152
Indonesia-Malaysia conflict 152
Industrial improvements 13
Insignia 48, 52–53, 156, 168
IRA (Irish Republic Army) 153
Ireland 153
Irish Free State 153
Irish Republic Army (IRA) 153
*Ish-Tak-Ha-Ba* 96–97
Israel 150–51, 154
Italy 68, 72–73, 115

Jagdstaffel 11, 48
Japan 3, 90–91, 93, 96, 104–5, 121–22, 127–28, 168–69, 171, 174
Jazz 63–64, 83, 114

Kenya 123, 151
Kitty Hawk 22–24
*Knights* 1, 49
Kubrick, Stanley 148

Lafayette Escadrille 51
Langley 22–23
Laos 129
*Li'l Abner* 85
*Little Patches* 100
Lost Generation 64

*Lucifer* 117
Lumières 21

Malayan Emergency 122, 152
Malaysia 3, 122–23, 152
Manchester Guardian 139–40, 169
Mau Mau 123, 151
Mauldin, Bill 140, 169
Messer, Brad 161
*Mickey Mouse* 69, 71–73, 84–85, 101–2, 164–65
Militarizing Women 172
*Miss Hap* 98–99
Modernism 66–67, 92, 167, 173
Mods 2, 137, 163
Music 19–20, 29, 44, 63–64, 82–83, 112–15, 120, 123, 133, 137, 144–45, 149, 163–65; classical 44, 64
Mussolini, Benito 72–73, 124

National Guard 135
Native American language 96–97
Naturalism 19
Naval Flight Squadron 49–50
*Net Results* 99–100
New Wave 144, 147
Newspapers 19–20, 39, 72, 91, 118, 120, 138–40, 146
North Borneo 152
North Korea 118–19, 121, 124, 127–28
North Vietnam 129, 150
*Nouveau realisme* 146
*Nouveau roman* 138
Nurses 32, 35, 41, 107

Omani government 151
Optical art 146
Oulipo 138
*Over there* 44

Pacific 83, 99, 104
*Pacific Passion* 104
Paris 16–17, 43, 63, 81–82, 84, 167, 173
*Patched Up Piece* 97–98
Patriotism 49, 128–29, 165
Pearl Harbor 78, 91, 94, 102
People's Republic of China *see* PRC
*Piece on Earth* 126–27
*Playboy* 120, 125, 141–42, 158
Poland 74
Political cartoons 2, 20, 39, 58, 67, 103, 119–20, 126, 138, 139, 140, 142–43, 147

Pop art 146–47
PRC (People's Republic of China) 121
Presley, Elvis 114–15
Propaganda 2, 30, 32–33, 67, 83, 85, 87, 90–91, 119–20, 152, 165
Prostitution 12
Protestants 153
Prussia 11
Psychedelic art 146–47

RAF 50, 88, 152, 162
Rationing 37–38, 68, 77, 79, 81, 83, 87–89, 91, 111–12, 119
Realism 19, 39, 64–65, 173
Red Cross 35–36, 78, 168
Religion 14, 71, 87, 113, 118, 171
RFC *see* Royal Flying Corps
RNAS *see* Royal Naval Air Service
Rockers 137
Rolling Stones 144
Romanticism 19
Roundels, small tricolor 47–48
Royal Flying Corps (RFC) 51
Royal Marines and African soldiers 122
Royal Naval Air Service (RNAS) 51

Satire 119, 138, 148
Sex 7, 149, 167, 174
Sexuality 20, 134, 165, 173
Sharks 94, 155, 161
Sheep 140
Shields 5, 49
Singapore 123, 152
Singer, Bayla 7, 167
Singers 8, 170–71, 174
Skulls 1, 53, 144, 150–51, 153, 155–57, 159
Sopwith triplanes 49–50
South Korea 121, 124, 127–28
South Vietnam 129, 150
Southeast Asia 157
Soviet Union 93, 121–22, 124, 134, 148, 154
Spain 70
Spanish Civil War 66–68, 70–72, 168, 173
SPARS 107
Suez Canal 150, 154
Superman 101–2
Superstition 53, 94, 95, 128
Surrealism 19, 64–67, 92
Swimwear 61–63

T-Man 120

# Index

Technology 3, 21, 46
Television 117–18, 144, 148–49, 165
Theatre 19–20, 44, 141
Third Reich 74
Thunderbirds 155
*Till we Meet* 44
Treaty 73–74, 150
Trenches 34, 40, 43–44
Trollope, Frances 18, 167

Union Jack 48, 128
U.S. Air Force 128, 157–58

Valant, Gary 6
Vargas' artwork 100
Versailles 73–74
Vichy, France 79, 83, 102, 103, 128
Victorian era 12–13, 20, 167, 171
Viet Minh 128–29

Vintage 168–69, 172, 174
Voisin brothers 24–25
Volunteers 51–52
Von Richthofen, Baron Manfred 48
Vorticists 19

WAAC (Women's Army Auxiliary Corps) 80, 107
War artwork 6
War bonds 36
Warhol, Andy 147, 170
Warthogs 160–61
WAVES (Women Accepted for Volunteer Emergency Service) 80, 107
Western Front 65
*Willit Run* 98–99
Woman Military Test Pilot in World War II 172
Women Accepted for Volunteer Emergency Service (WAVES) 80, 107
Women's Army Auxiliary Corps (WAAC) 35, 80, 107
Women's Army Corps 107
Women's Land Army 80
Women's War Time Fund 31
Wright, Orville 5, 11, 20, 22–23, **24**, **25**, 26, 167, 173–74
Wright, Wilbur 5, 11, 20, 22–23, **24**, **25**, 26, 167, 173–74

*Yellow Fever* 104–5
Yemen 152–53
Young Women's Christian Association (YWCA) 35
*Your Cheatin Heart* 113
YWCA (Young Women's Christian Association) 35

Zoot suits 81–82

www.ingramcontent.com/pod-product-compliance
Lightning Source LLC
Chambersburg PA
CBHW081559300426
44116CB00015B/2941